READING
YouTube

Digital Formations

Steve Jones
General Editor

Vol. 64

PETER LANG
New York • Washington, D.C./Baltimore • Bern
Frankfurt • Berlin • Brussels • Vienna • Oxford

Anandam Kavoori

READING
YouTube

The Critical Viewers Guide

PETER LANG
New York • Washington, D.C./Baltimore • Bern
Frankfurt • Berlin • Brussels • Vienna • Oxford

Library of Congress Cataloging-in-Publication Data
Kavoori, Anandam P.
Reading YouTube: the critical viewers guide / Anandam Kavoori.
p. cm.
Includes bibliographical references and index.
1. YouTube (Electronic resource) 2. Online social networks.
3. Internet videos—Social aspects. 4. Cultural pluralism in mass media. I. Title.
HM742.K38 302.23'1—dc23 2011020439
ISBN 978-1-4331-0980-5 (hardcover)
ISBN 978-1-4331-0979-9 (paperback)
ISSN 1526-3169

Bibliographic information published by **Die Deutsche Nationalbibliothek.**
Die Deutsche Nationalbibliothek lists this publication in the "Deutsche
Nationalbibliografie"; detailed bibliographic data is available
on the Internet at http://dnb.d-nb.de/.

The paper in this book meets the guidelines for permanence and durability
of the Committee on Production Guidelines for Book Longevity
of the Council of Library Resources.

© 2011 Peter Lang Publishing, Inc., New York
29 Broadway, 18th floor, New York, NY 10006
www.peterlang.com

Printed in the United States of America

to
the work of participatory culture

We no longer watch films or TV,
we watch databases.
—GEERT LOVINK

CONTENTS

Section Two: Other Genres

ACKNOWLEDGMENTS

Students in my digital media criticism classes over the last five years have been equal partners in the development and conceptualization of this critical viewer's guide. They helped choose these videos, helped me think through many of the readings presented in this book, and dug up relevant background information. I cannot thank them all, but a few individuals were especially important—Maggie Sutton, Jamie Sichel, Joshua Duskin, Courtney Johnson, Eliza Mason, Russ Vann, Weston Ver Steeg, Amita Nawathe, and Anna Kitson.

I would like to especially thank my colleague, Jay Hamilton, whose insights framed many of the ideas in this book.

This book could not have been written without the referential work of Wikipedia and numerous on-line web forums, dictionaries and encyclopedia that track, critique and offer commentary on the sprawling world of stories that is YouTube. We tracked down the "facts" about each video to the best of our abilities but given the nature of open-source knowledge, there may inevitably be errors or replication of urban legends, or plain self-promotion. My apologies for any such errors, which I will be happy to correct in future editions, and on a companion website to be developed in the future. Please send all corrections to akavoori@gmail.com.

· 1 ·

INTRODUCTION

YouTube offers a rich set of provocations into larger questions regarding
continuity and change in media.
—William Uricchio

Cultural expressions are increasingly captured in the electronic hypertext
of the multimedia system.
—Manuel Castells

This book began with a simple question: How does one make sense of YouTube?
There is no reliable "sample" of videos on YouTube; no easily identifiable way
to determine its dominant thematics; no way to evaluate "quality"; no bench-
marks for establishment of impact (beyond the questionable number of times
a video has been watched), no seminal literature. For all purposes, YouTube
appears to be a new kind of media animal, with rules that are weekly emergent.
It challenges traditional relations between consumer and creator (*anybody*
can upload a video on YouTube) and begs the evaluative question: Who does
YouTube serve?

These are all important questions and may be the subject of future projects,
but this book is about a much narrower question: How does one get one's hands

around the texts of YouTube? In other words, this is a book about storytelling—
focusing on the stories of YouTube and drawing sustenance from an elemental
truth, that storytelling is at the heart of all media (and perhaps at the center
of what it is to be human). As the sociologist David Silverman puts it, "all we
have are stories. Some come from other people, some from us. What matters
is to understand how and where the stories are produced, what sort of stories
they are, and how we can put them to intelligent use in theorizing about social
life" (1998: 111).

This book emerged from a class project (entitled "Reading YouTube"),
which examines storytelling and digital culture, focusing in recent years on a
reading of YouTube stories and on developing a framework for organizing them
(details at the end of this chapter). Drawing on genre analysis and digital
media criticism, I have—with my students as equal partners—formulated *one*
way to organize the myriad of stories that are the subject of this book. This is
a guidebook—a critical viewer's guide—to *some* of the important videos on
YouTube and is by no mean an exhaustive analysis of all the important (or cat-
egorizable) videos on YouTube. Having said that, it is an important "cut" into
the bewildering complexity of YouTube and is a beginning point for students
to undertake extensions/development of the pedagogy offered here.

This book bears the imprint of its roots—extending the discussion begun
in the classroom to a larger audience of students and scholars. The bulk of the
book is made up of entries that provide a thumbnail textual analysis of a sam-
ple of videos that make up each of the genres proposed here. The format of the
entries is a combination of two elements. The first, like most guidebooks, pro-
vides brief summaries/background on specific videos/categories of genres (such
as the British Film Institute's well-known guides on various genres of film), and
the second is that of an academic encyclopedia (such as the *Encyclopedia of
Television*, edited by my colleague, Horace Newcomb), which offers a theoret-
ically informed mapping of the key issues of an entry (a concept, scholar, or tele-
vision show). Using such a hybrid format is, I believe, wholly appropriate to the
task at hand—telling the story of a *popular* medium through popular *means*—
the Internet.[1] It needs to be emphasized that this book does not undertake a
comprehensive accounting of the important videos on YouTube (an impossi-
ble task), although each video is illustrative of many other similar videos. The
goal with each section was to provide a thematic for this type of video. For
example, in the section "A Viral Childhood" I discuss some examples of child-
focused videos (*David after Dentist, Ha Ha Ha*, etc.) as a stand-in for the many
others I could have chosen.

While the bulk of this book is not theoretical in its scope (even as it undertakes theoretically informed readings), this chapter provides evidence of the conceptual language that has informed the Reading YouTube project. What follows is a mapping of some of the concepts developed during the course of this project, and the "big" picture within which the individual readings (in the rest of this book) can be contextualized. This review (and theorization) can be used by students of YouTube as an entry point for their own analysis of the stories of YouTube. Staying true to the project's new media roots, I pose these in the form of an FAQ.

YouTube: FAQ

Q: What is YouTube?

YouTube may be many things—a platform, an archive, a library, a laboratory, a medium (Snickars & Vonderau, 2009, 13). It may be a form of "complex parasitical media" (Mitchem, 2008) or "networked individualism" (Haythornthwaite & Wellman, 2002, 34), but I see it as a modern-day bard (Hartley, 2009), a storyteller for the digital age (Ryan, 2006), a provider of modern-day myths (Mosco, 2005), all rolled into one. It needs to be emphasized that the stories *on* YouTube cannot be separated from the story *of* YouTube. From the mythology of its birth, to its acquisition by Google, to its being the poster child (and first destination) for consumer-generated content.

I suggest that we see YouTube as much more than a website—it is a key element in the way we think about our on-line experience and (shared) digital culture. As Uricchio puts it, "YouTube stands as an important site for cultural aggregation...the site as a totality where variously sized videos, commentaries, tools, tracking devices and logics of heirarchization all combine into a dynamic seamless whole" (2009, 24).

While the industry narrative on YouTube grows daily with news coverage about the latest applications and self-help books on the subject (Lastufka & Dean, 2008; Miller, 2007; Jarboe & Reider, 2009), the academic literature on the subject is just emerging (Burgess & Green, 2009; Snickars & Vonderau, 2009; Lovink & Niederer, 2008; Lange, 2007[2]). While not dealing with YouTube directly, scholarly work in the area of digital culture, participatory culture, digital labor, and virtual identity, is an important element in its analysis—and runs as an unacknowledged thread throughout the book.[3]

Q: Whose stories are being told on YouTube?

Burgess and Green's (2009) survey of video sources on YouTube found that user-generated videos made up little more than half of all videos in their sample. Their study, while an important first step, does not address issues of content—a question that only a content analysis of all YouTube videos can answer (or a reliable sample of these videos). In the absence of such a study, another way to approach this question is to ask a sample of people about the videos they watch. In other words, the choice of stories (being told on YouTube) depends on whom you ask. I asked young people—and they chose (unsurprisingly) stories about young people (or those of interest to young people). In sum, the stories examined in this book by and large relate to youth culture. Even the most casual user of YouTube will recognize that many videos (especially those that are most viewed, most favorited, most responded, most discussed) reflect popular culture elements of interest to young people. In other words, "youth" in all its mediated complexity is *the* recurring element in stories on YouTube.

Two related observations about digital culture and its roots in youth culture: Firstly, I suggest we see the "work" of making videos as a form of citizenship through popular means (Mossberger, Tolbert & McNeal, 2007; Ouellette & Hay, 2008), a contradictory process that *works in the divide* between popular accounts of "generation digital" as either bold trailblazers or innocent victims (Montgomery, 2007), fundamentally informed by their identities, their attempts at self-definition through digital means (again, working in the space between mainstream media narratives and viral ones) and above all their politics of location (Buckingham, 2007). Secondly, drawing on the idea that cultural workers are firmly placed in a *popular* practice of media education (Giroux, 1992), I suggest we see digital labor as fundamentally constituted by its *attitude*. By attitude I mean precisely what the term reflects—an attitude towards work—manifest in both the institutional rhetoric of YouTube ("broadcast yourself") and in the *practices of participation*[4] (creating, posting, critiquing, remixing). It is "an attitude, not a technology" (blogger Ian Davis, quoted in Lovink, 2007), an attitude that is reinforced by its status as media outsider or as Lovink puts it, "the creative underclass, the virtual intelligentsia, the precariat, the multitude that seeks to professionalize its social position as new media workers" (Ibid.). Additionally, we may surmise that the labor that produces YouTube is free in an emotional sense: it is freely given. More structurally, YouTube presents not just a more efficient and creative means by which individuals can connect and create, but also a movement towards a change in the process of

storytelling. This is a process that mirrors the wider problematic between knowledge and new media discussed by Han (2010), who sees this process as reflexive, disjunctive and non-linear (200–213).

Q: What is a "story" on YouTube?

It depends *how* you ask the question, and I asked it a number of ways, focusing on the video, the comments, the participatory culture surrounding each video—in other words, the way the entire network *behaves*. In doing so, I drew inspiration from previous work on the structure of digital networks and media ecology (Levinson, 1999, 2009, Lovink, 2008, Uricchio, 2008), how they are used (Hess, 2009, Burgess & Green, 2009, Thiel, 2008), how they construct stories (Deuze, 2006; Burgess, 2008, Richard, 2008, Kinder, 2008, Sherman, 2008, Strangelove, 2010) and how such stories are received or have an impact (Lange, 2008, Rheingold, 2000). Over the course of the project, I realized that while conceptually it made sense to look at the entirety of this process as coherent and symbolic, for analytical purposes it was important to break it down into its component parts (Architecture, Use, Storytelling and Impact) and develop a conceptual language for each part. I now turn to a discussion of each of these separately.

Q: What is the "Architecture of YouTube?"

Simply put, it is a specific kind of web text dictated by the visual experience of a YouTube page, which has three constituents—the primary video that dominates the spatial organization of the page, the ancillary videos that appear alongside, functioning like a visual sidebar, and the comments that scroll beneath. Informed by Schaefer's (2009) analysis of YouTube as a hybrid information management system, I suggest that each of these elements has a specific function that is simultaneously textual and discursive. I briefly discuss each of these.

The first element (the primary video) is determined by "Foundationality" followed by the second element (the surrounding videos), which is determined by "Referentiality," and finally the sprawling comments, by a "Participatory" function. Foundationality refers to the video's internal constitution, whether it is about a person, event, or phenomenon. Each video works within specific parameters of semantic organization. A sports clip about a certain player is about that player and that sport, a parody video about the iPhone is about the

iPhone, a dog barking is about just that—a dog barking. This quality—admittedly essentialist in its framing—refers to the primary or foundational relevance of the video. It's calling out to the viewer a specific set of rhetorical or semantic referents that the video is shot through with. The foundational quality of the video is unwavering. It needs to be conceptually separated from thematics or style (or what I will later describe as genre), because what is at the heart of the video is a process of singular referencing that often underpins how YouTube is used. People use it to search for a place, a person, an experience or a How-To (such as a guitar lesson). It is this process, fundamentally determined by use, that structures the foundational nature of this text. This signals an important point about YouTube. The categorizations offered here (architecture, use, impact) are operational points of entry into understanding YouTube. It is their ready admixture in reality that lends them coherence. "Referentiality" refers to the discursive referents that a YouTube video calls out to, through the parallel texts that (literally) run alongside it. These are often linked semantically, through a process of reiteration. To use the example above, there may be other videos about that player or about other players in that sport, other iPhone parodies, or other dogs barking or doing something similar. What is central to understanding "referentiality" is a process of "chaining" out of its foundational narrative—a process that is—by and large—discursively limited to a set of referents that is determined by the semantic qualities of the original text. Finally, "participatory" elements can be narrowly engaged with by looking at the comments that accompany each video. These comments provide context, commentary and interpretation to the foundational text, and, as one clicks through the referential texts, to those videos as well. Let me hasten to add that this is an operational definition of "participatory," rather than an empirical one. One can easily argue that *all* of YouTube is participatory culture (from original videos to parodies to comments, blogs, etc.). Everything is about the willing, engaged absorption in the cultural work of digital/social media. But such a position does not serve the analyst well, missing out, I suggest, on the specific trajectories of use and impact that I will shortly discuss. In sum, for the purpose at hand in this book, I treated each video as being composed of these three interrelated parts, watching, reading and taking notes on each of these constituent elements.

There are a number of other architectural features that exist alongside this basic organizational rubric of an individual YouTube page. The first deals with the properties that allow a specific YouTube video to "go viral." This is indeed how most viewers have come to understand YouTube—through a link sent by

a friend, a posting on a Facebook page, or as a topic of conversation at a party, for example. There are two such architectural properties that I termed "episodic" and "formative." I informally explain them as "Storms" (episodic) and "Clouds" (formative). The episodic video goes viral immediately, there is a viral "storm" that takes place as it quickly spreads from viewer to viewer, website to website, drowning out the daily viral chatter as it gets its "15 minutes of fame" (or whatever is the viral equivalent). The formative video goes viral slowly, much like a cloud gathering steam on a hot summer day. Its impact takes shape over months until it becomes a thundercloud, looming over other videos that pop up and then die down. The two categories are not mutually exclusive; often a video may work up a small storm but then die down until it's reused in another context and eventually becomes a cloud.

The final architectural feature that characterizes YouTube is what can be termed "Digital Flow." Much like television flow where commercials, stories and news accounts flow into/across each other, YouTube videos share an architectural similarity—they are short, readily accessible, and, most importantly, part of the *same* visual experience—appearing alongside the main video, but exchanging places with it should the viewer click on any of them. In sum, this interchangeable quality and structural mutability is what distinguishes YouTube from television.[5]

Q: How is YouTube used?

I would like to offer an important pedagogical point of entry around YouTube "use" (which surfaces in most class discussions): Watching YouTube is fundamentally different from watching television or film: *You make time to watch television or film, you watch YouTube when you have little time*. The detritus of daily life—the complex mix of the weighty (college payments) and the mundane (a hangover)—is part of understanding the role of YouTube. While some students (and viewers generally) may diligently "tune in" to YouTube daily, for the vast majority, YouTube is consumed as one element of a heavy media diet. To put this more formally, YouTube, like much of digital life, is a postmodern experience—its constitutive element being its fragmentation. Teaching large lecture classes, I regularly see students typing notes on their laptops, with one window open at the latest YouTube video their friend may have sent them, my own lecture and PowerPoint presentation being just one more "window" (and certainly, not the most interesting) in their lives.

YouTube use is characterized by what can be termed "Digital Play," which

refers to a certain kind of narrative action—*playing* the medium, rather than watching it. While this is a defining feature of video games, I would like to suggest that it is also central to how people use YouTube. All YouTube videos are "deep" texts—bottomless in their multiple referents (links)—and theoretically one could spend one's life clicking through every link that YouTube allows, playing with the menu on the right side, clicking through an infinite number of videos and dozens of "directors" as you weigh all the alternatives before you. Patience is not an option in this game—if the video is poor, the sound bad, and the context problematic, it is time to play something else. This kind of use can be termed "Catalog Culture" (I would like to thank my colleague James Biddle for coining this concept and allowing me to use it.). Watching YouTube is akin to scanning and sorting through a magazine catalog: When one is flipping through a magazine catalog, the stories, advertisements and images are skimmed through, with attention resting briefly on one or more items. The defining characteristic of the process is a partial—and somewhat unfocused—consumption. If something piques one's interest, the page is turned over at the corner and then returned to at a later time. The key element in all of these acts is consumption itself—the taking in of a mediated experience. YouTube is used similarly, the videos quickly viewed and paused halfway if they show little narrative promise; the interesting ones bookmarked or linked through on-line communities and blogs. The key idea is again consumption of other stories, places and experiences.

YouTube use is not passive or one-way. Like other social media, YouTube is used to post one's own videos, take parts of other videos, and to recast the terms of the discussion through comments and posts and so forth. The concept of "produser" or "produsage" (Bruns, 2008) captures this perfectly, where the traditional distinction between "user" and "producer" is reworked, where individuals are simultaneously using and producing, rather than in the traditional mass-mediated model of consumption where users and producers were kept in diacritically opposite institutional and viewing spaces.

Q: How does one assess the impact of a YouTube video?

Mass communication scholarships dealing with issues of impact (effects research, reception analysis, media imperialism) have all had a similar point of entry—the singularity of the text (TV, Film, Newspaper) and its effects on an audience, constituted either monolithically (such as "German") or through its institutionally (and commercially driven) prescribed categories (women

between 18 and 45; Children; Hispanic adults, and so forth). Built into this relationship was a certain *fixity of relationships* across three interrelated contexts: Content, interaction and subjectivity. In terms of content there was assumption about the internal constitutiveness of texts (a Sitcom had fixed commercial breaks; Dramas were an hour long; Westerns had little comedy, and so on). Interaction was typically arrayed along lines of heavy or little impact, drawing on a specific language developed in different traditions (such as media effects or cultural studies). Subjectivity (or agency) was typically arrayed along lines prescribed through prior/existing categories of personal constitution (race, gender, class, sexuality) and through investment in the culture of media itself (in terms/categories of organization such as interpretative communities, fandom, and of course, "audience").

YouTube disturbs many of these relationships. The content of a text may draw on a number of points of origin or none at all; interaction is rarely dyadic—through comments, blogs and response videos, an interactive plurality is put into play—a process that in some cases may be in the hundreds (such as responses within on-line games). Subjectivity does not neatly coalesce into containers that traditional media analysis offers—those around identity politics and commercially fixed categories of reception. What is needed is less a retrofitting of older approaches, and more the imagination of a new language that draws on older approaches but tries to develop a language that captures some of the complexity around issues of impact that YouTube offers. In that spirit, I want to offer four concepts that help think through issues of impact: Digital Mobility (& Polysemy), Participatory Closure, Discursive Thread and Contextual Chaining.

Digital Mobility refers to the use of a YouTube video by other users. Parts of a video will be stripped, recast and molded into another video, with little sense of ownership, both personal and sociological. So you may have a clip from a *Pokémon* cartoon appearing in a satire about George Bush, or a guitar solo from an eight-year-old in Taiwan animating a cartoon made in Iceland. These examples can be multiplied a hundred times—a process that I am suggesting is marked by discursive mobility, without any (necessary) attention to points of cultural origin or narrative fidelity. This has important implications for thinking through issues of impact—as it calls into question issues of (singular) origin, internal coherence and prior assumption by audiences. Simply put, it is difficult to assess/assume points of entry for audiences. To do this one has to look at the comments and the participatory culture around each video, which is the basis for the other three concepts. Digital Polysemy refers to the gargantuan

number of video stories that YouTube hosts on its site—*the sheer volume of discourse* that is produced every minute on-line. When I began teaching television criticism in the mid-90s, I would bring in a copy of *TV Guide*, so that students could get their arms around all that TV has to offer on any given day or time slot. From this large, but still comprehensible list, a beginning point for analysis could be assumed. Emergent patterns around representations of identity and cultural politics could be mapped for each hour that the TV was on in the American home. Such a task is inconceivable for YouTube—which is inherently polysemic in its textuality—ranging across a mediated universe that is only haltingly captured in the categories that the site uses; no genre analysis of YouTube videos can be complete; no narrative formula captures more than a handful of its videos; no list of "directors" can fully capture the idea of authorship (let alone "auteurship") on YouTube. This semantic madness is self-organizing—through the digital sorting mechanisms (like postings, lists, Digg it, del.ici.ous) an order of preferred texts emerges. At its heart, YouTube is a creature of how it is used—which is polysemic as well. People use it to watch personal videos, TV bloopers, and news clips to name just three. People use it reflexively—as open-ended texts to which they add their (video) reactions. People use it across contexts and referents—the most common ones likely being those of personal publicity/expression, entertainment and politics.

The tension between endless polysemy and those that are restrictive (close-ended, discursive) can be assessed by tracking the themes that each video spawns across three interrelated sites, the content of the video (which includes references to prior videos) and the surrounding participatory culture (response videos, accompanying strip videos, comments, blogs, related websites, Wiki pages, mainstream media coverage and so forth). Such a process was undertaken for each of the videos discussed in this book, a process that I termed "thematic track analysis," whereby the primary themes and concerns across the entirety of the participatory culture were assessed around questions of impact. From this process emerged some concepts that I believe provide *one* way to assess the impact of a YouTube video: Participatory Closure, Discursive Thread and Contextual Chaining. Let me illustrate, using an example. A video about a sports figure like Tiger Woods (particularly in recent months) tends to have the discussion coalesce around a specific set of themes—superior performance and personal inadequacies. Each of these themes is what I call "discursive threads." They take his past performance (both professional and personal) and use it to provide commentary around him as a player/person. These themes often draw on related issues, or what I term "contextual chains," which in the

case of Woods revolve around sport as a phenomenon, celebrity and sport, the role of golf as a specific kind of sports discourse, and, inevitably, race and class as seen through the prism of Tiger Woods's persona as a player/person. All of these themes are mobilized across the numerous videos that feature Tiger Woods. In other words, they define the terms of the viral encounter with Tiger and inscribe a specific thematic track around his identity. Such a restrictive discursive function is what I call "participatory closure"—a process whereby there emerges a specific modality of reception around a video or person, which in effect "closes off" alternate or completely open-ended modes of interpretation.

Q: Finally, and most importantly what are the "stories" of YouTube?

The stories of YouTube, one may surmise, are limitless, but even the most casual of viewers will begin to see patterns in the most popular videos—people acting silly, a mishap by a celebrity, inadvertent fame through inadvertent actions, and so on. YouTube itself offers a mode of organization (such as "directors" or "most viewed" or "most favorited"), but this misses the wider point that the Reading YouTube project sought to address—which was to identify relatively stable forms of storytelling (or genres), such as those that exist in older forms of storytelling (the Sitcom on television; the Western in film). What follows is a brief account of YouTube genres that emerged from class discussion and reading of the emerging literature on new media genres.

A beginning point for a genre analysis of YouTube is to distinguish Internet genres from those of mainstream media like Television and Films. While hybridity and new arrangements of visual/semantic elements are on occasion undertaken in more established media, the commercial imperatives (along with audience tastes) signal that genres remain relatively stable—in fact it is their (relative) stability that enables scholars to study them over time and context (especially around concerns of identity politics). This does not hold true for the Internet. At the heart of the problem is the question of definition: "Internet genres have been volatile, they have proliferated, they have differentiated into multiple subspecies. Our understanding of genre as a recurring, typified, reproducible, stabilized enough symbolic action requires that it resist change" (Miller & Shepherd, 2009, 263).[6]

Drawing on the pioneering work of Giltrow and Stein (2009), Askehave and Nielsen (2005), Crowston and Williams (2000), Deuze (2006), Renzi

(2008), and Boler (2008), I offer the following definition of Internet genres—as they relate to YouTube—and then unpack it in the rest of this section:

> Internet genres are categories of viral affordance working through the process of highlighting and celebratory creativity to generate (relative stable) mimetic tactics of representation.

Now to define the key terms used here—"viral affordance," "highlighting," "celebratory creativity," and "mimetic tactics."

Affordance: Miller and Shepherd (2009) offer the concept of "affordances" as a way to understand Internet genres. Affordances, they suggest, represent the relation or interaction between media texts and their environment, which online include linking, instant distribution, indexing and searching, and above all, interactivity. These affordances are "directional," they make "some forms of communicative interaction possible…leading us to engage in or attempt certain kinds of rhetorical actions rather than others" (28). I see such "affordances" working across the terrain of storytelling on YouTube, allowing for certain kinds of stories—the genres—to be generated.

Highlighting: Deuze (2006) offers a schema for understanding digital culture. He suggests that all digital texts have elements of participation, remediation and bricolage. I extend this schema by identifying a process that underlies *all of them*—what I term highlighting. One of the recurring features of YouTube is the posting of the most important parts of a TV show, a personal video, a movie—in other words a media event or text. While it is based on an editing function (the stripping out of the most important moment of a show and posting it on YouTube), it is also a key pedagogical device through which YouTube distills, recasts and formalizes how other mass media is consumed. Highlighting extends to the recording of daily life in its most funny or important moments. In other words, the "highlight video" that was synonymous with television shows like *ESPN SportsCenter* has become generalized as a wider semantic category for understanding the YouTube experience. Whether it is the touchdown run or falling down the steps, what orients the viewer is *the act of being highlighted*. This sense of understanding visual culture through tightly stripped moments may create a limited frame for issues of context, intent and, more critically, identity and culture. It assumes that the part can in some sense be substituted for the whole. We may get to a point where the whole (narrative) may never be consumed. To extend this analogy, we may once have been a culture that ate entire meals, but now we appear to be constantly snacking. This is not new of

course, it has its roots in television's sound-bite culture; the difference now is that *the sound bite has become the full story.*

Celebratory Creativity: One can make the argument that YouTube is governed by a simple principle: Fame. As Losh (2008) puts it, "the information architecture of YouTube is one that foregrounds celebrity and spectacle by design, even as it deploys a rhetoric of response, comment and community" (111). It is safe to assume that it is the *idea* of celebrity, of being/becoming famous that is an important element of why people put up their videos—a process referred variously as "nichecasting," "narrowcasting" (Cook, 2008) or "egocasting" (Christine Rosen, quoted in Miller & Shepherd, 2009). Whatever term one chooses, what centers it is an attitude, a sense of anticipation in the posting of one's videos—the indeterminate nature of the medium can make *anyone* a star. I call this process celebratory creativity.[1] Certainly, the videos discussed in the Phenom chapter of this book are evidence of just such a process—where an unknown like Tay Zonday can take *Chocolate Rain* all the way to the *Jimmy Kimmel Show* and other mass media outlets. Celebratory creativity deals with viral desire (and all the work that went before and after it)—with the moment of being famous for a little (YouTube) time.

Perhaps the best example of how celebratory creativity is entrenched as part of YouTube lore is a promotional event, YouTube Live, which took place on November 22, 2008, which brought together a range of famous YouTube people. The promotional video for the event provides a virtual template for thinking through issues of celebrity creativity on YouTube. Clips of famous YouTube artists are edited together with a high-octane rock band playing in the background. The artists appearing (on the show) include, as the text puts it, "guitar virtuosos, B-Boys, Mad Scientists, underground athletes, free huggers and Internet-born stars." In each case, famous YouTube people in each of these categories are shown, followed by the date of the show. The video is an interesting attempt at assembling the chaotic texts of YouTube into some semblance of order and structure—and it bears noting that the order that was chosen was the language of celebrity.

Mimetic Tactics: At the end of the day, a key question around generic stability has to be asked of all YouTube "stories"—what are they *mainly* about? While smacking of reductionism, this is an entirely legitimate exercise—each YouTube video resonates in a cultural realm—they work as mimetic tactics. Mimetic refers to two interrelated processes—the first a technical process by which a digital file or hyperlink (with its contents, in the case of YouTube, almost always a video) spreads rapidly through the Internet via email, blogs,

social media, forums, etc. The second is the set of discourses that stick to it, and give it agency, or what Renzi (2008) defines as a "tactic." Drawing on the work of Garcia and Lovink (1997), she uses it in the context of media of crises, criticism and opposition inclusive of a Foucauldian reading of how such media tactics work in the "mutual relation between systems of truth and modalities of power" (Renzi, 2008,73). I extend this in the context of YouTube to the use of such videos as *tactics of representation*, around a dizzying range of contexts—obesity, childhood, race relations, sexuality, presidential politics, performativity (music, dance, film)—to name just a few (they also make up the foci of many sections of this book).

Finally, to the task at hand. Using the panoply of concepts outlined above,[8] the following genres were identified: The Phenom, The Short, The Mirror, The Morph, The Witness, The Word and The Experiment. What follows is a sketch of the overall characteristics followed by individual chapters.

The Phenom

The Phenom (short for the Phenomenon) has as its defining characteristic a vast viral impact. In each case, the thematic, stylistic or narrative treatment of the subject is less important than its sheer discursive import—it is watched by millions. It is returned to as part of the collective memory of YouTube, listed in its all-time favorites, benchmarked in the most-viewed, inserted into personal web pages, and referenced in mainstream media discourse. In other words, the video becomes part of the ongoing narrative of YouTube as a new form of mediated experience. Put another way, these videos become the language through which YouTube becomes YouTube. Equally importantly, these videos display discursive mutability on YouTube through a continually expansive process of imitation and remixing. Such reflexivity—a defining postmodern value—has many variants for The Phenom, which includes a directly iterative style (through exact rendition), a reflexive (interpretative) style and a critical style (through satire).

The Short

The Short is simply what it suggests—a short film—with some differences. The Short in film culture is typically defined as a short film that follows the narrative conventions and dramatic possibilities that an abbreviated narrative offers—a focus on characters rather than complex events, on the personal as opposed to the historical or sociological. YouTube teems with such narratives, including an "official" category in its annual awards. These films typically fol-

low many of the same structural and discursive trajectories of short films in mainstream circles (notably short film festivals) but also offer new ways to organize storytelling.

The Mirror

The Mirror is a popular and recurring video on YouTube—the posing, placement and recording of the self over time, with the central idea of keeping a public memory of personal change (and continuity) available on-line. While video diaries do some of this, it is present in its most segmented form in the way that people have kept still-picture diaries of their faces. I theorize the Mirror as a genre drawing on the tradition of symbolic interactionism, especially the concept of the "looking glass self" (Charles Cooley) and Erving Goffman's notion of "the presentation of self in everyday life."

The Morph

The Morph is a genre on YouTube that recasts a common editing function (available on most software) into a defining tactic of storytelling. It involves "morphing" different images—typically those of the human face or body. The Morph is delineated from the Mirror in its undertaking of a fundamentally different rhetorical action—one of manipulation rather than a record of the self. I theorize the Morph as a postmodern rhetorical practice using the representational strategy of bricolage.

The Witness

The Witness refers to the intersection of mobile video technologies with concerns of reportage—commonly referred to as I-Witness News. Properly delineated from other more selective, random, and often trivial recordings of daily life, I theorize the Witness as a rhetorical tactic grounded in empiricism and functioning within the discourse of "Journalism." It is an engagement with both subjectivity and reality—developing its own language but also being cast into the existing frameworks of mainstream visual journalism.

The Word

The Word is a YouTube genre where there is little textual commonality across different examples of the genre, rather the commonality comes from the singular resonance of a set of words (phrases, song titles, conversations) across different on-line realms (videos, blogs, forums) and eventually into the parlance

of popular culture. I theorize such expressions (such as "All you base belong to us") as an example of what Michel Foucault calls "discourse"—a process of semantic coherence that works within the realms of power and subjectivity.

The Experiment

The Experiment offers examples of exactly what its title suggests—an experiment, using a range of contexts—science, entertainment, sports, performativity and the odd. Mobilized in a dazzling array of ways, the experiment has become a staple of YouTube, a digital way of experiencing the combination of elements, substances, and objects arranged in a visually compelling way—where a key element is the sheer fun of experimentation—and its consumption from afar, and one's terms. I theorize the Experiment as continuous with the work of Reality Television where spectacle, citizenship and performativity combine in complex, disjunctive ways.

Q: Is there anything else?

Yes, several things relating to the methodology, the organization of the book and finally, the project on which this book is based.

Methodology

Before writing each entry in this critical viewer's guide, I followed the same protocol: I watched the video at least five times and made notes about its internal constitution (visuals, dialogue, music, narrative) and from those notes identified some of the important themes of the video. I then read/viewed all the participatory culture surrounding the video (including response videos, parodies, remixes, mashups, comments, blogs, Wikipages) and any reporting in mainstream media. Finally, I applied the conceptual language developed in this chapter (focusing especially on participatory closure, contextual chaining, and discursive threads) and came up with a brief summary description of what I felt was the overall "message" of the video as it resonated through viral space. A more extended version of this summary became the entry for that video in the critical viewer's guide. This process was not even across all the entries. For some videos (such as those discussed in the Icons section of the Phenom chapter) there was a surfeit of participatory culture, and the entry became a multiple page reading, while for other videos there was very little material and the entry was a paragraph, or just a few lines, appearing often in combination with other (similar) videos. The writing of each entry typically follows the same format: A brief

description of "what"—the video's topic and theme along with any background information (coverage in mainstream media or viral discussion)—followed by a theoretically informed reading of the video.

Organization of the Book

This book has two sections. The first section deals with a single genre (the Phenom) and the second with the remaining genres (the Word, the Experiment, the Short, the Witness, the Morph). There is an important reason for this imbalance. As I have suggested above (and will reiterate at various point throughout this book), *YouTube is grounded by the language of celebrity*—this celebrity is centrally mobilized through the process of becoming a YouTube "Phenomenon." So, while all the other genres are important to the way in which YouTube works, it is the idea/goal/practice of *becoming* a viral "Phenomenon" that is at the heart of YouTube. In the first section ("Fame"), I foreground the complex ways in which such phenomena become operationalized. In the second chapter ("The Phenom"), I briefly theorize how a YouTube phenomenon can be approached. The third chapter (the longest chapter) is entitled Icons. If YouTube is about becoming famous, then these are the people who have made YouTube famous. They constitute a sampling of the "stars" of YouTube. When I give talks on YouTube, I ask for names of YouTube celebrities that everybody has heard of—and almost always some of these names appear. They are, simply put, icons, signaling the arrival of YouTube as a new form of mediated experience. The importance of these icons in understanding YouTube is the reason for the length of the entries here (and consequently of the chapter). The subsequent chapters in this section discuss fame based on thematic areas around which YouTube celebrity culture is often organized (so for example, the chapter "Where the Domesticated Things Are" deals with animal videos, a recurring hit on YouTube, while "A Viral Childhood" deals with children that become YouTube phenomena through some action/act like playing, fighting, singing, dancing, etc.). These thematic areas are not exhaustive, but rather illustrative of the depth of YouTube as it gets used around a range of topics. In sum, this entire section, which makes up the bulk of the book, is evidence of how a single genre (the Phenom) is the most important category for understanding the role of storytelling on YouTube. Each chapter in this section provides examples (a full list of all the YouTube phenomena would be an impossible task) under each of these thematic areas.

The second section ("Other Genres") is more abbreviated, since my goals

here were to first theorize each genre and then provide illustrative examples of videos for each of these genres. Each chapter has a brief theoretical setup before individual entries—or in some chapters a number of entries combined together—are discussed. For example, I briefly discuss how the Mirror as a genre exemplifies ideas first developed in the field of Symbolic Interactionism, or how the Word may be usefully interrogated using a Foucauldian lens. This set-up can be used as a conceptual add-on to the overall framework being offered in this chapter (architecture, use, impact, etc.) and as a complement to understanding how each genre may function specifically.

This viewer's guide is written primarily for classroom use—at both the undergraduate and graduate level—for courses in digital culture, new media, and computer-mediated communication. It can also be used as a text in classes on textual analysis or qualitative methods. The goals were to write clearly while retaining depth, in addition to developing a conceptual language (presented in this chapter) for students to use as they engage with the complex, interactive texts of YouTube and digital culture more generally (see Appendix B for additional suggestions).

Project Background

The Reading YouTube project began as a class assignment in the 2006–2007 academic year when it became clear that YouTube was emerging as a major player in the digital media landscape. I teach a course on digital media criticism, and one of the goals of the class is to interrogate—from a critical, cultural and media literacy perspective—the latest New Media phenomenon. Over the years we have examined everything from the rise of the Internet to the latest iPhone to *Halo 3*. The class assignment at this point was simple—students were asked to find examples of YouTube phenomena, and we watched them in class and discussed them with an eye to interrogating their cultural impact and historical antecedents. It soon became apparent that we were dealing with a generative process that was not slowing down or going away, so I launched a more sustained and formal research and media literacy project focused on the content of the videos that were being uploaded, with the eventual goal of creating a taxonomy of storytelling on YouTube. In the fall of 2008, I began systematic data collection along with having YouTube-specific class assignments. I embarked on four interrelated tasks: (a) Students were asked to keep a YouTube diary project throughout the semester, where they kept an account of YouTube videos they had watched and those that had been forwarded to them

by others; (b) A survey of YouTube use was conducted by students in my class, using a rolling sample (each student was responsible for surveying five other students). The goal was not quantitative sampling, or finding an exhaustive list of videos, but identifying the kind of narratives that were popular amongst a small subset of viewers—primarily white students at a university in the American South; (c) I tracked YouTube video phenomena as they occurred on a weekly basis and collected all supplementary material (such as mainstream media coverage, blogs, commentaries, etc.); (d) I conducted in-class discussions (methodologically modeled on focus groups) and kept notes.

By the end of that year, I emerged with a basic template to understanding how YouTube stories worked. Firstly, the stories appeared as a self-organizing, polysemic mode of textualization. Secondly, there was an emergent pattern of discursive mobility and cultural transference. Thirdly, in many cases there appeared to be a reiteration of modernist ideologies (race, class, gender, sexuality, ethnicity and national identity) recast in a new medium, and fourthly, a narrative style that centered play and performance as its defining characteristic.

This was all very well and good, but nevertheless unsatisfactory. As a long-time student of media genres (I have published on Television News, Film and Entertainment over the last 15 years), I turned to this tried-and-trusted category of organizing YouTube. I reminded myself that genres (on TV and Film) were not god-given categories, but emerged from the histories of those media forms—from a mix of technological constraints, institutional imperatives, individual innovation and audience choice. Class projects and in-class discussion confirmed that certain kinds of stories were being told over and over again, that certain stylistic and textual elements were being formalized and a certain fixity in narrative forms was emerging.

In the summer of 2008, I took time off from immersion in the videos and drew on my reading of genre criticism and literature to develop the taxonomy offered in this book. I had a simple methodological maxim: *Take what works and invent the rest.* I took the invention part to heart. This came at a cost. The genres offered here do not rest on a body of existing literature or institutional records (such as radio historians draw on when they study early radio history). As a colleague of mine pointed out, the "institutional records" of YouTube videos lie in the detritus of teenage bedrooms, and, she added, jokingly in their "scrambled minds."

Another colleague of mine, Elle Roushanzamir, had two other maxims that she said I must follow. Firstly, *nothing is ever really new*. YouTube may be the latest media phenomena, but it is strongly influenced by the media histories that

came before it. Much like TV drew on Radio, so, I surmised, the narratives of YouTube would draw on the histories of Television, Film and, increasingly, Gaming. Jenkins's (2009) essay was an important inspiration as well, pointing out how the histories of YouTube need to be historicized in the context of garage cinema and do-it-yourself newsrooms. Secondly, *the more complex a thing is, the more simple it is.* This was a little harder to accept—on the face of it many of the videos on YouTube are just so…*weird* (drunken squirrels, men jumping into shorts, a song about genitalia) that you have to feel that this is an entirely new kind of narrative animal…but in time order emerged, and I emerged, Moses-like, armed with a typology of YouTube genres. Starting in the fall of 2008 (and continuing every semester after that), I changed the class assignment to a simple one: Students were asked to find examples of videos that exemplify each of the genres. Each week we focused on only one genre. From these numerous videos, I chose some for a closer look—and they make up this book.

Notes

1. As Burgess and Green (2009) put it, "all contributors to content to YouTube are potential participants in a common space; one that supports a diverse range of uses and motivations but that has a coherent logic—what we refer to as the YouTubeness of YouTube" (57).
2. Strangelove's recent book (2010) is an important new entry to the literature. It discusses some of the videos chosen here—their mutual choice a confirmation that our choice of these videos (which were made much before Strangelove's book) was appropriate. It is also important to note that his analysis is largely thematic while the Reading YouTube project is focused more on a close textual reading.
3. Class readings over the years have drawn on Levinson (1999, 2009), Wellman and Haythornthwaite (2002), Hillis (1999), Ulmer, (1995), Corneliussen and Rettberg, (2008), Foster (2005), Gere (2002/2008), Howard and Jones (2004), Strate, Jacobson and Gibson (2003), Jenkins (2006), Boler (2008), Lister, Dovey, Giddings, Grant and Kelly (2003/2009), Best and Kellner (2001) and Wardrip-Fruin and Montfort (2003).
4. Having said that, the future of the Internet as a forum for deliberative (and democratic) expression is characterized by an "ambivalence of its transformative pedagogy" (Kellner & Kim, 2010, 22) and "YouTube proves that in practice the economic and cultural rearrangements that participatory culture stands for are as disruptive and uncomfortable as they might be potentially liberating" (Burgess & Green, 2009, 10).
5. It is important to note that such flow reworks both the equation between source and receiver and the content of the message. As Manovich puts it "we see new kinds of communication where content, opinion and conversation often cannot be clearly separated" (2008, 40). He adds that such conversation can take place through text or images, for example responding to a video with a new video (Ibid, 41).

6. Miller and Shepherd (2009) put this in the context of blogs, "the forms and features of the blog that had initially fused around the unfolding display of personal identity were rapidly put to (numerous other uses)…with a rapidity equal to that of their initial adoption. Blogs become not a single discursive phenomenon but a multiplicity" (263). In a similar vein, Burgess and Green (2009) argue that YouTube is a "particularly unstable object of study marked by dynamic change, a diversity of content and a similar quotidian frequency or everydayness" (6).

7. Celebratory creativity is an extension of what Jean Burgess calls "vernacular creativity." In an interview with Henry Jenkins she offers the following definition of vernacular creativity:

> I use the concept to talk about everyday creative practices like storytelling, family photographing, scrap booking, journaling and so on that pre-exist the digital age and yet are co-evolving with digital technologies and networks in really interesting ways. So the documentation of everyday life and the public sharing of that documentation, as in sharing photos on Flickr, or autobiographical blogging; these are forms of vernacular creativity, remediated in digital contexts. These are also cultural practices that perhaps we don't normally think of as creative, because we've become so used to thinking of creativity as a special property of genius-like individuals, rather than as a general human—some would say—evolutionary process. . .Vernacular creativity is ordinary. (http://henry jenkins.org/2007/10/vernacular_cretivity_an_inter.html, accessed March 8, 2009). See also Hauser (1999) and Hess (2007).

8. To summarize, these include Architecture (foundationality, relationality, referentiality, participatory coalescing, and flow), Use (play, catalog culture), Impact (mobility, participatory closure, discursive thread and contextual chaining), and storytelling/genre analysis (affordance, highlighting, celebratory creativity and mimetic tactics).

SECTION ONE

FAME

· 2 ·

THE PHENOM

Stardom isn't a profession, it's an accident.
—Lauren Bacall

On the web everyone is famous to fifteen people.
—David Weinberger

LOL, retard, coz U not Phenom…way gay vid.
—Comment on a YouTube page

Introduction

If there is a word that has introduced YouTube into popular consciousness then it must be "phenomena"—as in YouTube phenomena (or what I refer to as "Phenom"). News accounts, blogs, tweets, email, forwarded links and just plain word of mouth tell us about the latest viral star, the Phenom of the day or week. First, some thoughts regarding the language, mechanism and discourse of on-line celebrity culture.

The *language* of celebrity culture on-line shares important characteristics with fame in mainstream culture—the manufacturing of self (Adler & Adler, 1989) the emergence of a "star" system (Dyer, 1998), the manufacturing of pseudo events (Boorstein, 1962) and the centering of entertainment (Glynn, 2000). However, there are important differences that need to be noted as we develop a language for understanding on-line celebrity.

Firstly, on-line celebrity does not develop through the force of institutional authority (press agents, publicity and public relations staff) but from individual agency and effort—in other words, on-line celebrity typically has a point of origin in the development and production of a digital self. Secondly, celebrity culture on-line is a collective enactment—a complex set of connections across bulletin boards, fan narratives and response videos, vlogs, blogs and commentaries all have to come into play before any YouTube video can go viral, in other words become a phenomenon. Thirdly, while historically, celebrity culture on-line was structurally independent of star formation in mainstream media, when stars were created through the cultivation, distribution and placement of celebrity texts in institutionalized settings like talk shows and advertisements, now a convergence effect is taking place and stories/stars circulate using Twitter feeds, social media updates, bulletin boards, and of course mainstream media.

The *mechanism* of celebrity culture on-line can be usefully examined by looking at "Citizen Journalism" as a form of mediated discourse. Hundreds of news stories by independent citizens are filed daily, but only a handful become YouTube phenoms. The process by which an individual video becomes "viral" is instrumental in understanding celebrity. Typically, five kinds of content producers become active in this process—the original producer (it can be through a blog, a vlog, mobile camera video or a reworking of older content), news outlets (either independent or mainstream) who may reference and embed that video, participatory news sites (such as NowPublic, Third Report, OhmyNews, DigitalJournal, GroundReport), that look out for precisely such stories and recirculate them, contributory media sites (Slashdot, Kur05hin, Newsvine) and "older" on-line media such as personal web pages (including broadcast sites), mailing lists, enewsletters and of course email. This is an operational principle in the making of any YouTube phenom. Beyond participation, beyond sharing and remaking, it is *the sheer commitment to the work of (viral) community* that needs to be emphasized. It is in this real sense that on-line celebrity culture is a collective enactment.

The *discursive range* of celebrity culture on-line—or who gets to be a star—

remains largely unexamined but I have (deliberately) chosen examples to discuss in this chapter that map key issues. I have focused on stars across issues and contexts and topical areas, the stars themselves are less important than the themes they animate. There are some general characteristics that can be mentioned at the outset. Firstly, celebrity culture is often centered on remediation—it takes practices, stories and plots from mainstream popular culture and reworks them—sometimes reinforcing the discursive goals of the original, sometimes reanimating them, and on occasion subverting them. Secondly, celebrity culture operates in a minor scale—by which I mean that it functions synedochically, using individuals to paint a wider narrative around topical areas (obesity, for example) or identity politics (race, gender, etc.) or industry contexts (such as other media). Thirdly, there is at work a process of discursive intertextuality that is astounding in scope. For example, a celebrity on-line series such as *Ask a Ninja* may draw on a range of allusions—music videos, slapstick comedy, slasher movies, Armageddon, terrorism, and ethnicity.

In many ways the entirety of this section (and perhaps the entire book) is an engagement with celebrity, and what follows is an overview of how it is approached in the individual chapters, which are organized around specific thematic areas in which YouTube phenoms often (and regularly) appear.

The Icons chapter is a reading of a sample of the most important viral videos of all time. These are the videos that most people can easily recall—they are part of the history of YouTube, its ruling pantheon. The primary criteria I used in choosing these were the range of issues each video appeared to animate. In other words, other videos that shared similar characteristics were not discussed. The topics I chose were obesity/fandom (*Star Wars Kid*), viral history (*Numa Numa*), race/awkwardness (*Chocolate Rain*), age/obscurity (Paul Potts/Susan Boyle), travel/ineptitude (*Where the Hell Is Matt?*), friendship/music (*Free Hugs*), sexuality/hyperbole (*Leave Brittany Alone*), dance/viral fame (Soulja Boy), entertainment/terrorism (*Achmed the Dead Terrorist*, the dead terrorist), and geek identity/fandom (*Tron Guy*). This is an incomplete list but is a beginning point for an understanding of the leading viral celebrities on-line. I saw this exercise functioning much like the well-known Pork & Beans video featuring a number of leading Internet celebrities or the *South Park* episode where many of these characters play themselves.

The "A Viral Childhood" chapter examines the ways in which YouTube is shaping the participatory experience of watching babies—laughing, singing, biting, talking—in a word, *enacting* childhood for our consumption. The "Where the Domesticated Things Are" chapter examines videos that use pets (and on

occasion animals in the wild) as a stand-in for a range of themes—performa-tivity, humor, and (sometimes subversive) politics. The "Viral Dance" and "Let's Get Physical" chapters look at how the human body is the site for the development of a range of stories where many parts of the body (and their movement) become mobilized in the work of celebrity culture—from back-flips to sports action to dance itself. The "Media, Media On the Wall" chapter takes a look at how media forms, practices and narratives (especially video games) are the site of storytelling on YouTube. The "There's Music in the Machine" chapter looks at how music and celebrity intersect on YouTube. The "Lights, Politics, YouTube" chapter looks at the use of YouTube in the political process, by examining the viral candidacy of Barack Obama. Finally, the "The Identity Game" chapter examines a sample of videos on YouTube that echoes concerns of race, gender, sexuality and ethnicity.

· 3 ·

ICONS

Star Wars Kid: The *Star Wars Kid* video began its life as a private video taped by a Canadian teenager wielding a golf ball retriever as a lightsaber in the manner of the *Star Wars* character, Darth Maul. The video was taped in a high school studio and inadvertently left there. It was retrieved by some of the teenager's classmates who found it amusing and decided to play a prank on their classmate by placing it on the Kazaa network. Andy Baio, an independent journalist and programmer, gave the file its official name *Star Wars Kid*, and posted it on his website, from where it spread rapidly through a range of sites (news, blogs, message boards). Baio presents a case study (inclusive of data charts and graphs) of the spread of the video on his website (http://waxy.org) from January to October 2003, which at its peak had over a million page views in a single day. The story was covered by over 80 mainstream media outlets including the *New York Times*, *USA Today*, Associated Press, NPR, *International Herald Tribune*, *Newsweek*, *Forbes*, BBC News, *Variety*, *Globe and Mail*, amongst many others. Television shows such as *The Venture Bros*, *American Dad*, *Arrested Development* and *South Park* have mined it for humor. In 2006, Stephen Colbert used a lightsaber in the manner of the *Star Wars Kid* on his show, and invited the audience to send in their submissions. The contest culminated with *Star Wars* creator George Lucas appearing on the show with his version of the video.

Media discussion of the video has focused on the impact the unwanted publicity had on the teenager and specifically on the lawsuit that his family filed in 2003 against the families of four of his schoolmates, which was eventually settled out of court. One newspaper account described how other students got on tables and chanted taunts at him and quoted the teenager as saying: "there was about 100 people in those halls, It was total chaos…any opportunity was good enough to shout *Star Wars Kid*" (Ha, 2006, 1). Messages posted to the video reiterated this experience virally ("what a freak," ;"God, what a geek,"; "this kid is high on double quarter pounders,"; "ha ha, what a stupid fat noob,"; "what a fat retard," ; "fat + weird = Star Wars Freak"). In time, this type of viral commentary itself became the dominant frame for on-line discussion of the video. Blogs and message boards especially focused on this frame, as one such interaction suggests:

> Rob: He's a 15 year old geeky, nerdy kid. Adolescence is rough enough, rougher for a pudgy, geeky, nerd kid, and 1000 times rougher now for his being known worldwide as the object of mockery. See what I mean? Expecting an insecure, adolescent geeky boy to revel in his fame is unrealistic. Sensitivity and empathy are in order. The kid did not ask for this.

> Tom: I certainly feel for the kid, I just don't think he should earn thousands of dollars for a high school prank. All of us at one time or another was made fun of or had a joke played on us. Sometimes we laughed along, and sometimes pretended to laugh along but inside we cried. Its part of growing up. (http://blog.tmcnet.com/blog/tom-keating/personal-and-humor/star-wars-kid-settles-lawsuit) accessed, 3/22/09).

While this media frame (personal acts, public accountability via the Internet) is an important component to understanding *Star Wars Kid*, it misses the central role of fandom and performativity that the video mobilizes. To understand this, we need to focus on the textual dynamics of the original video. The teenager appears in the video as an overweight, clumsy and maladroit wielder of the retriever/lightsaber, twirling and twisting in a series of awkward moves. This image is at the heart of the video's appeal, which can be read for its reductive reliance on common constructs of adolescence—angst, obsession and immaturity. These constructs are then intersected with the discourses that underlie those of fandom (especially in an iconic series such as *Star Wars*), including aesthetics (especially technological and digital innovation in the case of the *Star Wars* enterprise), mobilization (of ideas around celebrity culture) and

performance (specifically, the lightsaber as an iconic representation of the marriage between technology and art). The distribution and ready consumption of the *Star Wars Kid* emanates from the disjunction between these two sets of discourses—and helps explain much of its popularity. A repeated viewing of the video supports such a reading, especially in its narrative development. The video, which runs 1:48, has four distinct breaks, where the teenager moves off camera, presumably to catch his breath and regroup. In each case, the tempo and pacing of the performance speeds up, with the teenager making "swish" sounds (like those made by a lightsaber) and occasional grunts. At two places in the video, he peers into the camera, looking grim and determined before moving out of view. In the final segment of the video (beginning at 1:28), he lunges in a frenzy of action, almost falling over before finishing the (imagined) fight. Centering the narrative is the auterial signature the teenager constructs—dressed in a bulky, long-sleeved, pin-striped shirt, with unkempt, somewhat baggy pants, he wields the lightsaber with a clear purposefulness of mind—intimidating his imagined foes, whirling in a (presumably) imposing dance, and taking his enemies down. It is important to view the *Star Wars Kid* video alongside the original *Star Wars* video, to juxtapose the teenager's facial expression with that of Darth Maul's spiked, streaked, black countenance; to find trajectories of performance and inspiration in the epic fight between Darth Maul and Qui-Gon; and finally, to see the end point—the resolution of the fight in the original film, and the narrative closure that the end of the *Star Wars Kid* video provides—where the lunging, out-of-breath performance speaks to the fulfillment of an inner monologue about identity and fandom. While youthful awkwardness is an intrinsic part of this meme's appeal, it also relies on the common elements of fan culture—styling one's hair, choosing a shoe, developing a gait, and today, watching key moments of a star's performance over and over again on YouTube. Such a reading is validated by the scores of spoofs and mashups of the *Star Wars Kid* with other *Star Wars* characters that litter YouTube, including a memorable duel between the Kid and an (animated) Yoda. In a similar vein, an episode of *South Park* featuring the Star Wars Kid has a number of such inside jokes, including "Star Wars Kid, Episode III (a reference to the film series), lines by different characters—"On no, not him" (referring to the ubiquitous presence of the meme), "How come we can't hear him" (the original video is virtually silent, except for the occasional grunt and the noise of the lightsaber made by the teenager), and "fat boy," "bad ass" (referencing the numerous comments posted on the original video). Most critically, the show inserts the *original video clip* into the screen (in place of using an

animated *Star Wars Kid*) with the *South Park* characters placed in the audience. The narrative pauses as the camera focuses in on the Star Wars Kid's face in a tight grimace, up close to the camera. In the final sequence, a green lightsaber is superimposed on the Star Wars Kid's golf ball retriever—and he reaches into the movie theatre and proceeds to behead Kenny, evoking the anticipated response: "Oh, my god, he killed Kenny."

Numa Numa features the "The Numa Numa Guy" (Gary Brolsma) lip-synching to a Romanian song, by the band O-Zone called Dragostea Din Tei, with a refrain that goes "Nu mă, Nu mă iei." The song was first posted on the website newgrounds.com on December 6, 2004. By 2008, the video had been viewed more than 18 million times on the newgrounds.com website. Brolsma has been featured on ABC's *Good Morning America*, NBC's *The Tonight Show*, VH1's *Best Week Ever* and the BBC. The song was also incorporated into an episode of *South Park* called "Canada on Strike". Since the making of *Numa Numa*, Gary Brolsma has made subsequent videos, including *Numa 3* in 2007, and also launched the New Numa Contest with a prize of $45,000. The *New York Times* carried an article on February 26, 2005, profiling the singer (under three pictures of him singing in the video) and discussing his status as a reluctant celebrity (the title of the story was "Internet fame is a cruel mistress for a Numa Numa dancer"). These themes (and the process of making the video) are reiterated in an interview on Brolsma's website, newnuma.com:

Brolsma:	I've always been a fan of making little video clips to entertain friends, by making mini-documentaries on stupid things or just plain old goofing around. Honestly the original Numa Numa dance was exactly that. I'm just a regular guy that sits in front of his computer bored out of his mind messing around on the Internet looking at funny videos and other websites to pass the time. The video took only one take and about 15 minutes to put it all together. A lot people ask me if I planned the video out or took multiple tries with it. The real answer is no. I threw the video out on newgrounds just for the heck of it. Little did I know it would explode in the views and would touch so many people (http://www.newnuma.com/story.html, accessed 3/22/09).

What makes *Numa Numa* so popular? For one, The "Numa Numa Guy" does not need a name—in fact, biographical detail and contextual relevance are secondary—what stands out is the rhetorical force of his karaoke performance. Wearing headphones, lip-synching, swaying in rhythm, bobbing up and down in his chair, throwing himself towards (and away) from his webcam, working himself into a paroxysm of energy and enjoyment. There appear to be two sin-

gularly reductive phenomena at work: a willing disposition to perform, and a catchy, upbeat, and intoxicating song that plays suitor to such a disposition. The two merge together in ways that clearly articulate the possibilities of the new medium—the idea of collective recognition through presentation of a virtual self, and, simultaneously, a sense of personal agency, where the webcam becomes the tool for the manifestation of what in another age was certainly street theatre and locker-room clowning. The class clown, the courtroom jester, the shy but talented kid sitting in the back of the room, all of these ways of being become manifest in the Numa Numa song, coalescing many of these discourses through the new medium. But more than anything else, the song's impact is segmented with the performer's authenticity—his being in the (webcam) moment, a moment marked by undiluted joy. Such a reading has become part of the mythology of the Numa Numa guy. Viewer comments repeatedly describe the video as "sweet," "fun," "cool," "I love this video," "the best video ever," and so forth. Part of the video's appeal lies in the specifics of Brolsma's performativity. A story in *The Believer* commented that the video "single handedly justifies the existence of webcams. It is a movie of someone who is having the time of his life, wants to share his joy with everyone, and doesn't care what anyone else thinks." Viewer comments reiterate such a view ("Oh god. This made my day. It makes me happy to see somebody doing something and not caring what anybody else thinks," "This guy rocks, imagine the courage it took to do this. No one else can match him.") in addition to focusing on the specific elements of Brolsma's karaoke performance ("I think he is so funny when he goes with his hand in the air and makes that triangle mouth," "I love the part with the eyebrow...ha ha ha...").

Perhaps what stands out when you read viewers' comments today is the reflexive engagement with Internet fame and popularity that the Numa Numa guy represents ("this is the guy who started it all, the pioneer, the visionary," "no one else can match him. All the others look novice and awkward in comparison.") along with the pleasure that comes with repeated viewings ("this is the funniest thing...and I've seen this thing a lot of times—at least twelve times a year for five years," "I've seen this guy so many times. I think he is so funny") along with a sense of the video's placement in the history of consumer-generated content ("This is the original internet video. In one shining archetypical moment it symbolizes the very best and the absolute worst qualities of the internet," "wow this video is so old and well known and it is still getting posts of people never seeing it before," "he's one of the most widely known faces on the web.") My favorite comment (that summed up the central importance of the

Numa Numa meme) was "What a legend! The original and still the best…Numa Numa is going to be the song I play at my wedding."

While there are dozens and dozens of renditions of the Numa Numa song, I will discuss two of them. The first (with over five million views) features two young (white) teenage boys in Derby, United Kingdom (au.You Tube.com/user/syncesta). The boys lip sync the song Brolsma-style, making cute, comical gestures at the screen, alternating on the verses, then at the end they both sing the refrain, jumping and dancing in joy. Part of the video's appeal is the sheer physicality of the performance—the boys play off each other, bump heads, rub shoulders and take turns leaning into the camera. There is discursive continuity between the "original" Brolsma performance and the Derby boys—this is a reading/rendition of Numa Numa that is normatively and pedagogically identical with Brolsma. While some viewers reiterated common hate-speak around gay identity, the majority were focused on the cuteness, lovability and fun that the boys were having (the same frame as the original). In addition, comments spoke to their personal/sexual appeal ("the right boy is omin hot!" "when I see you I have to scream! You soo cute! I love you two" "there sooo freeking cute" "omg uguyzz r hot").

The second video was a rendition of Numa Numa by an actor playing Bin Laden. It appeared on the German TV show, *Switch*. Here the reading of the song is again animated by the same discursive frame as the original—the terrorist laughs, gestures, dances, with pure joy. This video can easily be read as a satire, a critique, or even as a cynical engagement with the absurdities of our contemporary postmodern culture that recycles everything, even terrorist acts, as humor material. However, viewer comments ("ha ha so funny"; "he has the perfect face for doing this video"; "this is so funny, I cant stop laughing!!") resist such a reading and instead offer a reiteration of what can be seen as the discursive energy of the original—pure, unproblematic fun—staying relevant in this rendition of Numa Numa. This, in itself, is of course a commentary on the power of New Media possibilities, where the force of religious fundamentalism is reworked within the space of viral celebration. Osama Bin Laden has little success, we may surmise, going up against the buoyancy of Brolsma's optimism and Numa Numa.

"Chocolate Rain" is a song sung by Tay Zonday (a 20-something African-American man), which has achieved cult status on YouTube, with nearly 35 million views, and was the winner in the Music category in the 2007 YouTube awards. First posted on April 22, 2007, on YouTube, the song's popularity is usually traced to its posting on 4chan.org, an image board, and its subsequent dis-

tribution through cross-postings. Often regarded as the quintessential Internet meme, it has inspired numerous parodies, tributes, and re-mixes of the song. In the mainstream media, the song has been spoofed by musicians like John Mayer and Tré Cool. Two important spoofs on YouTube are *Vanilla Snow*, and *Chocolate Rain by Chad Vader*. Zonday has performed the song on *Jimmy Kimmel Live* and on the BBC Radio 1 *Chris Moyles Show*. In an episode of VH1's *Best Week Ever*, he performed a parody of the song, called "Summer Break," which was made with professional musicians. Over the course of its life (long, by Internet standards) it has become part of the constantly brewing pot of popular culture—Tina Fey's character on *30 Rock* refers to a character as Chocolate Rain; a *South Park* episode featured Zonday; a *Mad TV* music video had a Hillary Clinton impersonator who wants Obama to pour Chocolate Rain on her. Chocolate Rain also appears in the dialogue of shows like *The Office*, *It's Always Sunny in Philadelphia*, *Last Laugh*, with Lewis Black, and *SpongeBob SquarePants*. Comedy.com created a pastiche of how famous directors would have made the video. The song has been incorporated into popular music, with references to it by the Dave Matthews Band, Weezer and Guitar Hero World Tour.

Chocolate Rain is a quietly stated but powerful narrative about race and identity in urban America. It is centrally defined by the sonic construct of the singer, who has an unusually deep and mature voice. The song is characterized by a drum loop and by the soft but nuanced rendition of the song's title and refrain, "Chocolate Rain." While the lyrics are important to a reading of the song, the text of Zonday himself is central to the video's popularity. His appeal can be summarized in one word: simplicity. There are no wild gesticulations, no hamming it up, just a quiet, bespectacled, African-American man sporting an immaculately white T-shirt, singing steadily into a microphone. Throughout the song, he moves away from the microphone, and the following words appear "I move away from the mic to breathe in." In time, these words and Zonday's persona have become trademarks in the viral construct of this song/performer.

While the visuality of the performer and the unexpected maturity of his voice are at the heart of the song's appeal, the lyrics are central as well. Most interpretations of the song suggest a reading focused on race relations in America. Such a reading becomes obvious when the (often-stated) suggestion of replacing the words "Chocolate Rain" with "Racism" is undertaken. This is also the gist of Tonzay's own commentary on the song (in an interview on *The Opie and Anthony Show*). Some of the key lyrics in the song argue for an understanding of racism as a structural (rather than personal) issue in American soci-

ety. These include those referring to the decline of urban communities
("Chocolate Rain, raised your neighborhood insurance"), the incarceration of
young African-American males ("Chocolate Rain, the prisons make you won-
der where it went"), and the fact that racism is an issue that few want to sys-
tematically engage with ("Chocolate Rain, every February washed away"). In
addition to substituting racism for Chocolate Rain, another (recurrent) inter-
pretation of the song offered on-line suggests that Chocolate Rain is another
word for defecation—where that act itself represents how the minority popu-
lation are treated in America.

Viewer comments have a discursive force and energy that rivals the impor-
tance of this video in on-line culture. There are two recurring and intertwined
themes—the first, congruent with the thematics of the song—reiterating/cri-
tiquing ideas about race and racism in America and the second, a singular focus
on the persona of Tay Zonday himself.

The comments on race and racism range from repeated obscenity-filled dia-
tribes with extensive use of the N word to equally passionate defenses of the
song and the concerns it raises. The sequence of interactions usually develops
along the following lines—puzzlement about what the song means, followed by
explanations and comments and discussion. Here is one example, from differ-
ent postings on the song over a week:

> "This song makes no freaking sense. The song would be just a little bit more good if
> the lyrics made sense! I don't have chocolate in my veins and there is nothing wrong
> with my neighborhood insurance and everyone crosses the street. Is there something
> I'm missing in this song that connects it all?"

> "the lyrics are just random bullocks"

> "its about racism"

> "you would have to be mentally retarded not to understand the meanings of these lyrics.
> Obviously you are. "

> "I guess this gay little ditty is about whiny black people blaming racism...Christ get
> over it already. I bet 100 years from now they'll be still finding excuses."

Outside of hate-speak around race, the on-line persona of Zonday appears to
have struck an especially rich—and negative—chord, with hundreds of com-
ments focusing on "categories" that define him ("robot," "doofy," "turd burgler,"
to mention the most polite terms), showing an interest—along lines established
by mainstream celebrity culture—in his life and relationships ("I don't think
it coincidental that there is complete lack of friends in any of Tay's videos. It

must be hard to make friends when your very presence makes people want to kill you. Add into that Tay would also start to spew out these shitty songs in front of you"), and above all his performativity ("aag my ears bleed" ;"it sounds like a dying animal"; "ear rape").

Understanding the impact of *Chocolate Rain* would be incomplete without addressing the innumerable videos that have emerged spoofing, critiquing and deconstructing the song. For example, *Vanilla Snow* can be read as a counterpoint to the discursive construct of race and racism that *Chocolate Rain* seeks to address. *Vanilla Snow* (an obvious play on Vanilla Ice) features a white musician, parodying the pedagogical intent of the original, substituting issues of substance (racism, discrimination) with arcane references and disjunctive contexts. It includes lyrics such as "Vanilla Snow, open doors with hot spaghettios," "Vanilla Snow chimney sweeping prada marmalade," and ends with "Vanilla Snow, blah, blah, blah blah." The rhetorical intent is clear—the presumed self-importance (of the original) and the sites of its discursive engagement are replaced with declarations of irrelevant minutiae and unproblematized hilarity. It seems to be offering viewers a reflexive intent not only with the subject matter of the original but, I would suggest, a counterpoint—placing ideas of pleasure over political correctness. It is, in my reading, a political statement about both the song (and its iconic status), and new media itself, allowing for an on-line display of what, in an earlier age, may have been the shrug or the look away. *Vanilla Snow* can be read as an expression of sardonic (and racialized) dismay in viral form. Viewer comments suggest that this is an appropriate reading ("thank you! Someone had to do that and you nailed it," "perfect parody," "this is way better than Chocolate Rain ! Kudos!" "Enough with friggin Chocolate Rain").

Susan Boyle and Paul Potts became viral stars when clips of their musical performances on *Britain's Got Talent* became some of the most watched videos of all time. Boyle sang "I Dreamed a Dream" from *Les Misérables*, and Potts, a tenor, sang an operatic aria, "Nessun Dorma," from Puccini's *Turandot*. Potts went on to win the entire competition in 2007, while Boyle did not. Some commentators have called her "Paula Potts" a reference to both their vocal talents and to their emergence on the same show. Both performers made waves in America, with news coverage in most of the major newspapers and several high-profile TV appearances. Potts, for example appeared on NPR's *Day to Day*, NBC's *Today* and *The Oprah Winfrey Show*, while Boyle appeared on CBS's *Early Show*, ABC's *Good Morning America* and *Larry King Live*. Boyle, who appeared two years after Potts, had more of an international impact, with stories in

China, Germany, Israel and the Middle East (something that was absent with Potts), an indication perhaps of the growth of the Internet as a media form and the relevance of viral distribution in assessing celebrity impact globally. Potts used his appearance on the show and its vast viral appeal to help him release his debut album, *One Chance*, which claimed the number one spot in the UK album chart for one week. He has subsequently performed concerts across Europe, Asia and Australia. Boyle's impact is still evolving, but she has benefited greatly from the emergence of social media as a key element in media marketing (something still in its infancy with Potts), with the active use and mobilization (by fans) of the video (and blogs, commentaries, discussion) on Facebook, MySpace, Twitter and of course, YouTube itself.

Interrogating the viral impact of Susan Boyle and Paul Potts needs to be framed within the narrative and textual universe of television generally and within the specifics of the talent show as a genre. Both videos closely adhere to the conventions of character development (of the singer, the interrogators and the audience) through close ups, action-reaction shots, matching shots, and the juxtaposition of context-setting wide shots, with liberal use of pans/boom cameras to display audience reception. Embedded within this visual style is the overarching narrative frame of the genre—the presentation of the self for public consumption (which it shares with reality television), the over-determined nature of the outcome (with failure, rather than success as its constitutive element), the thematics of personal angst and alienation (a spinster living alone with her cat; a cell phone salesman with a dream) and the televisual characters of the judges acting as bookends—the emotional and indulgent Amanda Holden, the analytical but sympathetic Piers Morgan, and, of course, Simon Cowell, a discursive endpoint in himself—a study in practiced cynicism and televisual reflexivity.

Each of these elements is plotted into the closely edited narrative arc of the talent show. The genre's rising action features the individual complete with all of his/her presumed frailties (Potts, with a hangdog expression; Boyle in a frumpy dress), the judges and the audiences responding on cue with expressions of incredulity, humor, cynicism and sarcasm (in the case of Potts, focused on his plans to sing opera, and in Boyle's case on her ambitions to become the next Elaine Paige). The genre's narrative arc moves rapidly from exposition to climax, as the singer begins to sing. What stands out in repeated viewings of both videos is the centrality of this moment. It is literally a moment of awakening and transformation. The camera develops this through close-ups of the judges coming to terms with the singer and with their own expectations. For the audi-

ence, the beginning of the song inaugurates their most important role in the genre—shaping the end point of the story's narrative arc—through uninhibited expressions of adulation and acceptance (or otherwise).

I would like to suggest that understanding both these videos (and the many others like it) should be focused on this diacritical moment, a moment characterized fundamentally by *narrative liminality*. This narrowly focused point in time (rarely more than 5–7 seconds long) is inhabited *only* by the singer/performer. It is a place (when successful) of a symbolic rebirth, from the ordinary to the extraordinary, from obsolescence to relevance—all within the confines of the industry the genre serves—television and its celebrity culture.

Perusing the comments on both videos suggests that this is an appropriate reading. The comments focus in on the narrative pleasures that come from experiencing this moment of narrative liminality in the performances, speaking repeatedly of the very personal, physiological and emotional experience of watching the performances. The description of choice for Potts is "chilling" and for Boyle "goose bumps." In both cases, there appeared to be a common response—crying (to give examples from Potts: "I cried from the bottom of my heart," "couldn't help but cry," "overcome with emotion once he started singing. Joys like make you realize you are human. Beautiful, just beautiful"). This centering of emotion as the determinative frame for understanding, I suggest, fulfills the liminal function of such a text, working across national (comments from Ecuador, Norway, Wales, Australia, Japan, and the United States for Potts), cultural, and gender lines (this was especially interesting in the case of Potts, as the following comments attest: "Unbelievable!!!I am a hockey player, hunter and that made me want to have a tear," "I'm a guy and I work on a building site so I'm not a pussy. The first time I heard this song, a tear was actually brought to my eye, and I'm not ashamed," "I'm a boxer, 6'4, 220 pounds, have a shaved head, one tough guy, and I cried like a little girl. Amazing").

While media commentary and viral discussion use popular phrases like "diamond in the rough"; "don't judge a book by its cover,"; "a frog that turned into a prince," and so on, I would suggest that these are primarily derivative—they emerge *after* the sheer experientiality of the event, one which is marked by performativity rather than narrative, even as the latter propels the fate of these Internet memes. What remains to be explained, however, is why it's *these* specific performances and not others—there are hundreds of similar videos being loaded on YouTube. Answering such a question necessitates engaging with issues of narrative—which in the case of Potts appears (in the comments) to

be a sustained comparison with Pavarotti (with Boyle, it's Elaine Paige)—but equally, with the storyline of the performers' lives and the specific disjuncture they present to audiences, telling a wider story about common lives lived unassumingly or providing a parable about following one's dreams (a staple of comments for both singers) and in both cases, the chance (indeed possibility) of fame.

The *Where the Hell Is Matt?* viral phenomenon revolves around three videos featuring a 32-year-old white man dancing a silly dance in a variety of settings and countries. The first video (a rough amateur effort) became a viral hit, and the maker, Matthew Harding, a self-described "deadbeat," was approached by Stride Gum to shoot another video. The second video produced an even bigger audience and led to the sponsoring by Stride of a third video featuring dancers from each country, joining Matt in his goofy dance. The 2008 video was shot on location in 42 countries, over 14 months.

Where the Hell Is Matt? can be read as a text about global travel, but I would suggest that while it *is* that, there is much more discursive work going on, too. Fundamentally, I see this video as a modern-day parable about personal and collective transformation through performativity. There are three interrelated elements that privilege such a reading.

The first is the viral construct of Matt himself, who presents himself as an average person taking an extraordinary journey, with little more than a hope and a shingle (or dollar) to his name. Matt's website furthers such a reading, with its self-effacing introduction: "Matt is a 32-year-old deadbeat from Connecticut who used to think that all he ever wanted to do in life was make and play video games" (he goes on to detail how travel and making the video changed him). The result is especially evident in the first video where the attention is squarely on Matt, who dresses identically in most shots, maintaining the same awkward-but-wide smile across several different continents. What changes, of course, is the landscape and the monuments that he places himself in front of. Reading across these multiple referents and locations, what stands out is not cultural differences in themselves but their placement within the performance that Matt puts together. In other words, Matt's persona creates a discursive continuity that flattens the differences between these different cultures and places them in identical spaces as they become part of a rapidly changing landscape that plays suitor to Matt and his dance.

The second element is the dance itself. Matt's dance can be described as studiously awkward—and simply fun. This dance is at the heart of the video's cultural work as a text about personal/collective transformation, especially the

2008 video which is less about using Matt's persona (a discursive frame already established by the first video) as it is about expanding that persona through a movement towards the collective—in this case, an explicit focus on asking people across the world to dance with him. As it explains on his website: "In 2007, Matt went back to Stride with another idea. He realized his bad dancing wasn't actually all that interesting, and that other people were much better at being bad at it. He showed them his inbox, which was overflowing with emails from all over the planet. He told them he wanted to travel around the world one more time and invite the people who'd written him to come out and dance too" (http://www.wherethehellismatt.com/about.html; accessed, 7/30/09).

The result is the 2008 video, which extends this discursive strategy through two specific techniques, the repeated movement of the "dancers" from outside the stage/settings (monuments, plazas, fountains, pillars, boulders) towards the center, with this physical movement paralleling a rhetorical movement from the margins to the middle, a place where Matt himself is located, on occasion alone, but often in the background, lost in the maze of dancers who surround him. He becomes literally, and metaphorically, the center, where the dancers (and cultures they represent) meet, locked together in an exhibition of awkward, exuberant celebration.

Finally, the music that is overlaid in both videos speaks in subtle ways to the collective impulses of the video. The music in both videos is composed by Garry Schyman but features songs from what is generally referred to as the "world music" genre—a loose categorization of global folk music, often described as humanistic, authentic and meditative. In the first video, the song "Sweet Lullaby" is performed by Eric Mouquet and Michel Sanchez, who make up the French band, Deep Forest, and in the second, the song "Praan" is sung by Palbasha Siddique. I will focus on the second song, since this is the subject of considerable discussion of the video on-line. The song, which has lyrics in Bengali by Rabindranath Tagore (perhaps best known for having written the national anthems of both India and Bangladesh), presents a mystical, humanist vision for the dance. The lyrics read: "I will not easily forget the life that stirs in my soul, hidden amidst death that infinite life. I hear you in the thunder, a simple tune, a tune to which I will arise." In the main, however, it is the "sound" of the music and the singer that presents this humanist vision—it is an uplifting, yet pathos-filled rendition, that rises and falls in a crescendo with the dancers, who fill the stage repeatedly in different settings across the world.

Responses to both videos are squarely focused on the effects of communitarian participation, detailing the positive, affirming values of Matt's (and his

friends') performativity. Some examples illustrate the depth of the video's impact: "That's so beautiful, it made me cry. What an inspiration for the world community"; "I'm pretty sure this is the best thing I've seen on the Internet. How can anything that goofy be that moving?" ; "Videos like this reinstate my faith in mankind," ;"I am a very jaded and cynical person, but this one video gives me more hope for the human race than anything else I have seen or heard in a very long time,"; "love it, love it, love it! Particularly all the people joining in and having a great time. People being people." Mixed in with this wider celebration of the communitarian impulse in this video are comments about the value and pleasure of travel itself, reflecting the review given to the video by Time.com (will "give you a serious case of wanderlust"). Some examples: "this is the happiest video ever—still want to be at your desk?"; "I'd love to go to the places you have been"; "some amazing experiences there, like Zambia, Los Angeles and Singapore" and "its just a beautiful thing to experience all those cultures within four minutes."

The Free Hugs phenomenon began with the story of a young man, "Juan Mann" (he has not released his real name), who was returning to Australia without any friends or family to greet him (and give him a hug). Reflecting back to the moment, Mann said, "I came back from London in January 2004 and I was the only person I knew and I was lonely. I needed to feel happy. I went out to a party one night and a completely random person came up to me and gave me a hug. I felt like a King!" (interview with Jenna Good, from the on-line magazine, Who. http:/au.lifestyle.yahoo.com/b/who-magazine/115/spreading the love; accessed October 10, 2008). In the weeks ahead he would walk with a "Free Hugs" sign in one of Sydney's downtown areas. A video tracking his attempts at getting hugs was posted on YouTube. The narrative features the process of being rejected by most passersby and eventually finding a number of people who hugged him. The video and its accompanying song (by the band Sick Puppies) was an enormous hit, making Juan Mann a celebrity, with appearances on television and radio shows, and spawning a global phenomenon with videos of people conducting their own Free Hugs campaigns. Mann's MySpace page has numerous videos, links and future projects, and he has appeared on a number of media outlets, including *The Oprah Winfrey Show*, where he spoke of his suddenly acquired fame, "this has grown beyond anything I ever thought was possible. What started out as a way for me to get a smile out of strangers has turned into this social theory of peace and humanity." Mann has recently published a book, *The Illustrated Guide to Free Hugs*, with artwork by Krista Brennan, an Australian artist, and he now functions as the original

node in a rapidly expanding movement that can be termed "free huggers." There are numerous "free huggers" on the Internet, with videos from every continent and most major European cities. In the United States, there are "free huggers" in each state. For example, in the Atlanta area, a free hugger called Jason Hunter has a successful website showing numerous Free Hugs videos and participation in area rallies for cancer and other issues. He also sells a range of Free Hugs products (especially T-shirts) and has an interesting "how to hug" section with different techniques and styles of hugging.

Making sense of the Free Hugs phenomenon must center on an understanding of celebrity through the idea of participation, where people's obvious joy at reaching out and touching people is complemented by the visual recording of these actions—in other words, the actualization of the Free Hugs is mobilized through the prism of becoming famous—whereby a visual record is central to the actual act of hugging. When you give a free hug, what you get in return is free celebrity—to be part of this global process of becoming and belonging. There are now videos of Free Hugs from most parts of the world. The Free Hugs campaign has become a language of both self-expression and a collectivization of desire, captured in the language of celebrity and recast through the medium of YouTube. This is part of the mythology around the video, with numerous comments focusing on the sheer experientiality of this process ("hugs are amazing," "hugglez," "I love this video, makes me tear up"). The Free Hugs phenomenon is also entering a wider set of institutional practices, most notably a French health campaign (sponsored by the National Institute for Prevention and Education) to combat discrimination against people with AIDS, which used the Free Hugs concept to create two short documentaries on the subject. Free huggers also enter into news/social media discourse with accounts of harassment by authorities in China, arrests at Wal-Mart, and official approval in many metropolitan areas.

The meme *Guitar* features a South Korean guitarist, Juntwo (real name Lim Jeong-Hyun), known for playing a masterful rock version of Pachelbel's "Canon". In the video, Hyun's face is blurred and hidden behind a large hat. The popularity of the video was fuelled in some part by a fierce viral debate about the origins of the player and his country. Since he revealed his identify, stories about his life and music have appeared on CNN, *20/20*, National Public Radio and in The *New York Times*, in addition to Korean outlets like CBC Radio and *South KBS News*. The popularity of the video has led to several new songs on YouTube from Hyun, including a rock version of Vivaldi's "Summer," "Santa Claus Is Coming to Town" and a holiday card to his fans. His website

lists numerous appearances including the KOROS concert, the YouTube live festival in 2008. He is also featured in Weezer's song, "Pork and Beans," along with other Internet phenomena.

There are a number of elements that speak to the appeal of the video, but first and foremost, it functions as extraordinary pop art. Watching the video (many times), one is left with an undeniable impression—that this an arresting piece of viral culture, standing out in the digital realm, much as Andy Warhol's convention-defining posters did for an earlier era. In making such a claim for *Guitar*, three sets of images/discourses converge in this video, speaking to its considerable appeal. Firstly, there is the persona of Juntwo. He appears silhouetted against the light, his face hidden behind an oversized cap. He never looks up, but appears thoroughly immersed in the performance. This persona of a shy but talented kid is at the heart of this video's emotive appeal. Many teenagers (and garage bands) use/construct this persona, but the quality of their playing is rarely extraordinary. Juntwo, on the other hand, is the real thing. His rapid finger work, the fluidity of his hands, the stillness of his head and body, all make for a mesmerizing experience. Secondly, there is the actual sound of the performance. The rock embellishment of Pachelbel's "Canon" is sweeping, rounded and arresting. The guitar "gently weeps," taking the listener along for the ride. There are two specific sections, one mid-way through the performance, and the other right at the beginning, where the persona and the sonic effect merge, and one is left with an unambiguous reading of this video—virtuosity. Viewer comments are uniformly celebratory and verge on the exuberant ("I love what you do with your fingers,"; "this is so incredible, I watch it every day,"; "Amazing"; "u could go up against Jimi Hendrix"). Finally, the appeal of the video lies in its history—it sparked an extended viral debate about the origins of the player, his country of origin, his style, the reasons for not revealing his name, attempts by other guitar players to claim the video and so forth.

Leave Britney Alone is a video posted by a teenager, Chris Crocker (a pseudonym). It features Crocker responding to criticism of Britney Spears's lackluster MTV VMA appearance. The video is marked by the repeated renditions of "leave Britney alone" along with an expletive-ridden tirade against Britney's critics (for example:"leave her alone, you're lucky she even performed for you bastards"). Crocker's Internet fame has led to a career, a large fan following (along with equally large legions of critics), appearances on TV and radio, a deal with ABC to appear on a reality show and negotiations with MTV's gay-themed channel.

Leave Britney Alone is a study in performative excess and the deliberate posi-

tioning of the self in digital celebrity culture, but it is much more (and less). Through repeated viewings of the video, what stands out are two interrelated elements that have given the video its considerable afterlife. The first is Crocker's practiced emotion—where each toss of his blond hair (against the yellow, satin-like curtain), every rack of sorrow- filled shoulders, moves the narrative forward, fueled by an expected outcome—the repetitive refrain, "Leave Britney Alone." The second element is Crocker's own liminality as a digital subject. It is manifest in a number of ways—but especially focused on the performer's gender. It takes a close viewing to confirm an Adam's apple. A number of comments reflect this ambiguity, fuelling the confusion the video evokes for viewers. Added to this is the question of intentionality, a theme that has become part of the video's mythology. This has become the defining diacritical sign of the video. A related question is that of motive. What possesses a fan to make such a plea? What are the performer's "real" goals? And of course, the unasked question—"what can you do with fame acquired in such a manner?" Viewer comments reflect these concerns, focusing especially on the question of authenticity—a concern raised repeatedly in radio and TV interviews focused on the fact that this was Crocker's second take (rather than a spontaneous outburst). The bulk of the comments, however, focus on hate-speak with numerous references to "faggot" and threats ("someone please shoot this faggot"). Crocker's other videos and his interviews have focused on gay rights and activism. While there are numerous parodies and remixes of the video, one stands out—a stand up routine by the comedian Seth Green who wails about "Leave Chris Crocker alone" while taking time in-between wails to apply eyeliner—a clear indictment of the original's performativity. Generally speaking, *Leave Britney Alone* epitomizes the work of postmodern digital culture, where narrative excess is often a virtue, where the lines between authenticity and performativity are blurred, and where celebrity culture is centered in disjunctive ways, creating ways for marginal texts like Crocker to work in the divide.

Soulja Boy is a rapper who went from obscurity to stardom with his "Crank That" song/dance video. The video features Soulja Boy and others dancing a very stylized, thematically structured dance, characterized by finger snapping and criss-cross foot movement. Soulja Boy (real name: De Andre Ramone Way) opened a YouTube account in January 2006 (he has posted over 100 videos) and recorded "Crank That" in March 2007. In a few months it had become a viral sensation. By summer 2007, it was the number one hit on the Billboard Hot 100 and subsequently won the Best Hip-Hop Dance award at the 2007 BET Hip-Hop Awards. He is signed to a major label, Interscope, and has

appeared at numerous rap music shows and toured with major hip-hop and rap stars (such as Chris Brown, Bow Wow, Sean Kingston, Lil Mama, Shop Boyz). There are numerous parodies of the video—including SpongeBob, Spiderman, Super Mario, Batman, Barney, Dora the Explorer, Bambi, Winnie the Pooh and the Lion King, among others.

The popularity of Soulja Boy's song "Crank That" is usually explained through its somewhat atonal but accessible performance. Reviewing the song, the *Washington Post* said, "with Soulja Boy's rudimentary, shouted rhymes, spare steel drum hook and snapping fingers, the song is irresistibly catchy" (http://www.washingtonpost.com/wp-dyn/content/article/2007/12/20/ AR2007122000913.html Accessed 9/15/10). While the specifics of tone/rhyme and lyrics are important, I suggest the video be examined more as a testimonial about the power of viral connectivity and mobilization and its role as a text in the cultural wars within rap music and its user communities. Both the original video and the subsequent "instructional video" are aimed at reaching a wide viral audience. In the original video, scenes of the dances appear on cell phones, laptops and video games. This, it appears, is a deliberate narrative decision—placing the performer outside the margins of mainstream rap, and highlighting the idea of its digital roots—a process that places it within a wider set of on-line referents that are invoked in the video—creating avatars in on-line communities, downloading ring tones, choosing music software, and, of course, performing on-line and in real life at the same time. This is undertaken through segues between floor dances and the dancers on cell phones and laptops. I suggest that it is the sheer embeddedness of digital culture in daily life that is at the heart of this video's appeal. The instructional video sets up the dance in easy, step-by-step instructions. It manufactures community, as the song is played in teenagers' bedrooms, at parties, and of course through numerous tribute and participatory videos (the *Washington Post* counted approximately 40,000 such videos) of the dance. While each element of the video/dance/song undertakes this task, I want to suggest that one specific step—where Soulja Boy imitates Superman (through flinging his chest into the air in a breast stroke flying motion)—fulfills this most fully. There are numerous videos of people dancing to "Crank That," but even more of them "flying" Superman style. This is in many ways the iconic marker of this song/video—shot through with a subaltern strategy, reworking an icon of (white) mainstream pop culture in ways that signify race-based identities, through the realms of performance, song and viral culture. Feeding into such a reading is the mythology that has grown around this video—which typically focuses on a normative analysis of the

dance/song—asking whether Soulja Boy's music "marks a revival of rap's bust a move style and a move away from the gloom and doom of gangsta rap" or whether "'Crank That' is just ring tone rap" (http://www.washington post.com/wp-dyn/content/article/2007 accessed 12/20/08) and not worthy of serious engagement. Soulja Boy, in turn offers his own analysis, simultaneously self-effacing and analytical: "Ah, man, it was just something I was doing in the bedroom of my house and having fun. It's rhythm, man, its action-packed, its crunk. When the beat comes on, it just makes you wanna move. If not, you're dead" (Ibid.).

Jeff Dunham, one of the most successful American ventriloquists and stand-up comedians, created the character of Achmed the Dead Terrorist with numerous videos. I will focus my comments on the first video where the character is introduced (*Achmed the Dead Terrorist*), which is one of the most watched videos of all time with nearly 200 million views). Understanding this character discursively needs to begin with an assertion of the restrictive context provided by most news accounts of terrorism. In the years since 9/11, news accounts have been saturated with frequent accounts of suicide bombers, but there has been little attempt to present the social, political and ideological context in which these acts occur. Such a task has been left to in-depth magazine articles, niche documentaries on the subject, and films such as *Paradise Now* and *The Terrorist*, which are typically not watched by the majority of American audiences, who get their news from television. In this news vacuum, a character such as Achmed provides an accessible, but what I will suggest is a largely regressive, reading of the roots and conditions of terrorism.

Achmed is a puppet (of a skeleton), with huge malevolent eyes, a turban on his head, and large black eyebrows, that is crafted to look menacing and ludicrous at the same time. He lives in Dunham's suitcase along with another of his puppets, Walter, and Achmed frequently complains about the situation, pointing out that "Saddam's gas was nothing compared to Walter's farts." Achmed the Terrorist can be read as one element in a wider rhetorical tactic in the war on terrorism. Achmed is singularly ineffective ("I am a horrible suicide bomber, I had premature detonation") and provides a political commentary on the means and ends of terrorism. Such inefficacy is complemented by Achmed's banter with the audience, characterized most frequently with hyper-voluble assertions of "Silence, I kill you"—appearing even sillier with each rendition, and in the introductory sketch, with an increasing sense of his own appeal to American audiences—telling Dunham that he is making people laugh and enjoying this. This is an important rhetorical strategy, moving terrorism into

the realm of populism and performativity. The suicide bomber, for example becomes a site for the playing out of a common desire—fame—in the case of Achmed, born out of plain stupidity as seen in the following exchange:

Dunham: "Do you guys have any motto? We are looking for a few good men?"

Achmed: "We are looking for some idiots with no future."

Such an account needs to be compared with the reality that has emerged from in-depth narratives about the background and motivations of suicide bombers, who often come from the middle class, often with families and responsibilities and with a range of compelling personal, political, cultural and psychological reasons for killing themselves. Similarly, when Dunham asks Achmed where they get recruits, he has a tongue-in-cheek answer: "the suicide hot line." In addition, the sketch treads familiar ground in its reference to 72 virgins, Osama Bin Laden, and Jews and other minorities. While Dunham insists that Achmed is not a Muslim (in the introductory act, Dunham asks Achmed if he is Muslim, to which he replies, "No, look at my ass, it says Made in China"), it needs little effort to read the obvious diacritical signs of the character, such as the name Achmed, the turban on his head and the fact that when he curses, he says "Goddamm it, I mean Allah dammit." In 2008, a commercial for a ring tone featuring the character was banned in South Africa after complaints that the ad portrayed all Muslims as terrorists. The video *Jingle Bombs* (one of the many Achmed videos) furthers such a reading, with its location in the Middle East ("Dashing through the sand, with a box strapped to my back, for Christmas in Iraq"), and a reiteration of key themes and players ("Jingle Bombs, Jingle Bombs, Where are all the virgins that Bin-Laden promised me?").

Tron Guy is an Internet celebrity whose persona is anchored in ideas around fan culture and fandom—and I will suggest in the visceral physicality of the character. One of the earliest examples of an Internet phenomena, he became part of Internet chatter (especially forums, blogs and cross-postings) when his appearance in costume (characterized by an electroluminescence effect), inspired by the movie *Tron*, spread across the net from initial postings on Slashdot and Fark. He went on to have a number of appearances on the late-night talk show, *Jimmy Kimmel Live* and was featured in a music video called *We Are the Web* and on *Tosh.0*.

Understanding the appeal of the Tron Guy needs to begin with the importance of fandom and (inadvertent) celebrity on YouTube. The Internet spews vast amounts of fan culture—tribute videos, remixes, mashups of celebrities,

accounts of fan conventions, clips of shows, personal video diaries, dress-up parties, to name just a few. What makes one video, then, stand out from this mass of content on-line? I would suggest that the appeal lies not in the importance of the film or the character, since *Tron* is a relatively obscure sci/futuristic narrative and hardly holds a candle to the fan fiction that *Star Wars* generates. Rather the appeal derives fundamentally from the sheer physicality of the Tron Guy's appearance and his undeniable commitment to his on-line persona. This physicality has at its roots a fundamental contradiction—a white, middle-aged, somewhat heavy, average-looking man, dressed in a tight-fitting, futuristic, superhero-type costume. Such a contradiction would not in itself be enough—or would only be the basis for ridicule and commentary (of which there is a considerable amount on-line)—but, I suggest, there is more at work here. *Tron Guy's* popularity lies in the gaze he generates for on-line viewers. There is a voyeuristic pleasure in the (personal) spectacle he offers. The pictures on his website detail the making and fitting of his costume and through a variety of poses (front, back, sideways) in the tight fitting costume, he invites attention to his various bulging parts—especially the buttocks, stomach and crotch. While most scholarly work on the "gaze" has focused on the objectification of women, where sexual imagery of women invites voyeuristic attention to specific body parts (breasts, waist, legs), *Tron Guy's* images invite a different understanding of the gaze—working through notions of the repulsive rather than the attractive. An important component of *Tron Guy* is the character's willing disposition to present himself in this manner. In his interviews on *Jimmy Kimmel,* he offers a studied seriousness and a sense of ownership and even gratitude for what the *Tron Guy* video has brought to his otherwise nondescript life as a computer programmer.

· 4 ·

A VIRAL CHILDHOOD

YouTube is littered with the texts of childhood—babies crying, babies laughing, toddlers taking their first steps, birthday parties for children of all ages, adolescent angst (and anger), and teen vlogs to name just a few. Functioning in equal part as personal diary, family album and cultural bookends, the thousands of such videos speak to the coming of age of a new kind of childhood, where the experience and recording of childhood is not restricted anymore to the magic circle of family and friends and is instead part of a public, mediated performance that can be termed "viral childhood." While it is impossible to fully theorize all the constitutive elements of a viral childhood on YouTube, I will suggest some key themes through a reading of some iconic childhood videos (*Ha Ha Ha, Charlie Bit My Finger, He's Gonna Kick My Ass, David after Dentist*) and those where children are placed square and center in a wider cultural narrative (*Break Dancing Baby Kick, Dancing Baby 1996* and *Immersion*).

Ha Ha Ha, with nearly a billion views, features a baby (a boy it appears) laughing with complete abandon and consummate timing to the sounds made by an adult (presumably his father). The sounds are "bing" and "dong," to which the baby responds with an irrepressible smile followed by a loud laugh that changes to a chortle as he winds down, followed immediately by another round of laughter, echoing each vocal cue by the father. There is a liturgi-

cal quality to the baby's laughter, both in the narrative cues/responses of baby/father and in the performative arc of the laugh, which rises and falls with each cue. In the middle of the video, there is a pause—an intermission if you will—as the baby swallows, catches his breath, and starts to get annoyed at the lack of cues from the father. Once the father resumes the narrative, with another "bing," the baby continues laughing.

Ha Ha Ha is a performance that lends itself to an unproblematic reading—childhood as a space of unmitigated joy and wonder. It takes very little to make this child happy—just the loving attention of a parent and a simple melodic sound. Viewer responses overwhelmingly support such a reading ("adorable," and "cute," being the two most common appellations used) along with a range of presumptive effects—"this baby mama and papa are so happy to have them in their lives," "laughing is contagious," "every time I am sad or depressed, I watch this video." Such a reading is complemented by responses that speak to a discourse of childhood as pure, innocent, happy and unproblematic. The baby in question is referred to as "blessed," and a "blessing." Others speak to how watching this video is a family experience ("My family loves this," "My sister loves this and she is only one"). However, in the end this is a video that speaks powerfully to a singular reductive act—that of laughing itself. This is part of the video's mythology and appeal online ("No words can describe this laugh," "Laughing made my day. This will forever be my favorite YouTube"), evidenced in numerous comments which were simply a reiteration of its defining words—Ha Ha Ha.

Charlie Bit My Finger is perhaps *the* defining video for understanding viral childhood—its iconic status lies as much in its number of comments and hits, as in the extensive participatory culture it has spawned, with remixes, enactments and critiques on-line. First the specifics of the video: It features two British boys on a sofa: three-year-old Harry, and his baby brother, Charlie. Harry begins the video speaking to the camera: "Charlie bit me," he says, in a somewhat amused tone, suggesting that this was a simple nip, nothing much to it than that. He then proceeds to place his finger squarely inside Charlie's mouth, to perhaps see what else Charlie might do or at the very least to experience the bite again. This time, Charlie proceeds to bite—long, hard and purposefully—as brother Harry's expression changes from mild amusement to chagrin to pain and near anger at his brother's efforts. He manages to extricate his finger, falls back on the sofa, rubbing his finger behind his head (and on the soft sofa) and telling his brother "That really hurt Charlie" before delivering the definitive line of the video: "Charlie bit my finger." At this point, Charlie turns to the

camera, cracks a big smile, and laughs with a delightful sense of having accomplished something pleasurable even as he acknowledges that he has just done something mischievous.

Understanding the appeal of this video must begin with its iconic status as a construct of viral childhood. There are innumerable references to the importance of this video, ranging from the expected references to "cute" and "adorable," to a veritable cottage industry of videos that replicate the original, critique it, rework it, and remix it using hip-hop and other musical forms. As one comment put it, "these must be the most famous kids on the planet," and a number of news accounts/interviews with the parents attest to the price of fame—the exact location of the family is usually not discussed (they live in a suburb of London) and their privacy needs are emphasized. The video's importance is also signaled by the debate it generates—there are numerous exchanges between fans and critics of the video in the comments section, taking form and sustenance from the specifics of the protagonists actions ("dude, if it hurts don't shove your finger in the kids mouth") and consequences ("he is going to grow up gay, sticking his finger in guys mouths"). There was one memorable sequence of comments where a number of people tried to come up with increasing levels of hyperbole in discussing why they did *not* like the video. Here are two examples/comments by different viewers:

> "I'd rather stick a suction pipe down my throat than watch this video again."

> "I'd rather grate my nipples off with a rusty cheese grate than watch this video."

Such exchanges notwithstanding, much of the video's appeal lies, I would suggest, in its narrative arc and synedochical expression of a range of human emotions. Viewer comments reflect the considerable pleasure on-line audiences take in specific moments in narrative development ("I liked it at 0:18 when the baby makes that noise. It was awesome," "This is so cute, I Love his face at 0:23 so adorable"), language and dialogue (numerous comments repeat lines from the video, such as "ouch Charlie that really hurt," "and it still hurts") and the persona of the major characters, especially the baby Charlie ("I like it when Charlie ALMOST looks like he is sorry but cracks a HUGE smile and giggles— and Charlie tries to bite him through the blanket," "I like it how Charlie giggles after the long stream of silence," "the way he knows he has done something bad and just laughs") and finally, identity (numerous comments pointed to the British accent—"love that accent"—as an endearing feature of the video). Such themes are also emergent in TV interviews and commentaries on the video. As

one journalist put it, the video's appeal lies in its range of human emotions: "Joy, trust, doubt, happiness, fear, grief and joy again. It's a human journey in 30 seconds" (YouTube video: "*Charlie Bit Me: The first TV interview with Richard and Judy*").

Charlie Bit My Finger is also important for examining issues of the viral performance of childhood—the video has spawned considerable mainstream media discussion of the children and their lives—there are a number of interviews with TV outlets both in the UK and overseas available on YouTube, with the specifics of most interviews focusing on a reflexive engagement with the *Charlie Bit My Finger* video. There appears in the children an emergent sense of their role in creating a media history around this video, which becomes a point of origin in the online creation of self. The family becomes part of the (ongoing) mobilization of such a viral identity, with the creation of a website which can be accessed from YouTube (Harryandcharlieblogspot.com) where there are blogs about family vacations, and numerous pictures of the children (the couple have a third child, Jasper). The website has pictures of family occasions (beach trips, parties) and daily life ("driving jasper" and "the accident"). The recording and posting of daily life seems especially relevant to understanding the viral performance of childhood. *Driving Jasper* features older brother Harry pushing his younger brother's car round and round the backyard, an eye firmly planted on the camera; while the *The Accident* features Charlie eating his lunch, accidentally biting his tongue on the food, and crying for his mother. These mundane records of raising children, I would suggest, are now elevated to a viral performance aimed equally at the family members who might view them and at the numerous subscribers that visit the site, looking both at the videos and the commercial content on the site (T-shirts saying "Charlie Bit My Finger"). The most compelling video on the site is a "Calendar compilation 2010," which has pictures of the children, along with a quiz about each of the children and their family (for example, it asks where the godparents of the children live. Knowledgeable viewers—who would have watched interviews with the parents and children—would know that they live in America and that *Charlie Bit My Finger* was first posted on YouTube so that they could see it).

In line with the thematics of *Charlie Bit My Finger* are two other iconic representations of a childhood online—*He's Gonna Kick My Ass* and *Asian Baby Sings Hey Jude*. The former begins with the text "When a three-year-old is asked about monsters, her answer may surprise you." It features a disarming little girl telling her mother (who sets up the narrative by asking her "tell mommy again

what he was going to say to you if he came here") a number of times that the monster "is going to come in here, he's gonna kick my ass" followed by her wish to "kick his ass." The video's popularity lies undeniably in the appeal of the little girl—the movement of her hands, the nodding of her head, the gap-toothed smile, all coalesce around her innocent use of the word "ass" and offer an unproblematic reading of childhood: irresistibly charming. The video also reads as a parable about parenting, with the mother ending the video by telling her daughter to use the word "butt" to which she replies "Oooh." *Asian Baby Sings Hey Jude* is similarly positioned—as a text about innocence, to which is added the wonder of performativity at such a young age. The young child, still in diapers, cradles a huge guitar and sings "Hey Jude," perfectly imitating the rhythms and nuances of the original, down to the last high-pitched rendition of the song's refrain ("Hey Jude"). While innocence/performativity is the primary reading of this video, ideas about ethnicity and the cross-cultural appeal of the Beatles as a musical language lie under the surface. The baby begins the song with a bow and a traditional Korean greeting ("Aneoaseo"), before launching into the song. Both these videos provide an important window to understanding viral childhood, working much like *Charlie Bit My Finger*, to mobilize an emotive frame for how children behave, act and perform for the camera and us.

David after Dentist is an iconic viral childhood video that was posted by a father who filmed his son (with a cell phone camera) after a dentist's appointment. Still feeling the effects of sedation, which include blurred vision and disorientation, the eight-year-old David proceeds to ask a series of ontological questions ("Is this real life?" "Why is this happening to me?" "Will this be forever?) and quietly stated assertions ("I don't feel anything," "I'm not tired," "I feel funny"). Added to the mix is a highly strung scream, interspersed with rolling and lolling around in his seat. A website developed after the video went viral (www.davidafterdentist.com) provides ethnographic detail by the father about the visit: "There was no coaching or editing. I just filmed what I was seeing and hearing. The deep questions David asks, show his deep thinking that we have come to know as part of his personality" (accessed, 11/09/09). The video was posted on YouTube on January 31, 2009, and by the following Tuesday had three million hits, followed by extensive mainstream media coverage including appearances on the *Today Show*, *Tyra Banks Show*, and *Bill O'Reilly*. The last appearance has become well known for a diatribe by the host against the father for not taking care of his son and focusing instead on the filming. As the father puts it, "I basically was just there to listen to Bill." Some com-

ments on the video's website reiterate such concerns, including a response by the father to a strident woman viewer who saw the father's action (filming) as singularly inappropriate. While in this limited sense, *David after Dentist* mobilizes common ideas about parenting (good/attentive versus bad/inattentive), the majority of the comments are positive and cover much the same terrain as evidenced in *Charlie Bit My Finger*. In addition, the importance of this video lies in the numerous responses that have been made to it. I now turn to a brief discussion of these, focusing on just five—*David after Donuts*, *David after Swimming*, *David after Diabetes*, *David after Drugs* and *David after Divorce*.

All the videos use the same cinematic frame—a boy/man strapped in the back seat with the camera pointing at him at an angle (presumably all were made with a cell phone camera). They all use variations of the same key phrases and exchanges but thematize them differently depending on the subject and expected audience orientation. *David after Donuts* features a young boy (between six to eight years old) who sits self-consciously in the back seat, his face smeared with jelly donut stains and ruminating on the aftereffects of too many donuts ("Why is jelly on my face? I don't feel hungry") using the donuts as props, rubbing them on his face, intoning, "I have two donuts, four donuts" and culminating in a vomiting sound as the camera moves away. In sum, it takes an experience common to all children—overeating—and uses it to generate an affective fable about the excesses of childhood. While the video is not particularly compelling, it suggests an entry point for understanding how a singular text about childhood (going to the dentist) can be used as a narrative frame for other experiences of childhood (overeating). This is a process that, I would suggest, is discursively expansive. This becomes especially evident when we consider the other videos at hand, all of which use adult figures and develop adult themes. *David after Swimming* features a large, muscular man in a full body swimsuit imitating a child. The dialogue and exchanges now extend the terms of what is being discussed, from going to the dentist and eating a donut, to the effects of a very long swim session. These include, "It smells funny" ("It's just the chlorine buddy") "Is this seamless?" ("Yes it is") "I have two paddles, I have four paddles" ("Yes you do") "I feel funny" ("It's just the Lactaid"). It is important to note that the person interacting with the swimmer mimics the tone and attitude of an indulgent, somewhat weary father. In other words, this is an adult experiencing/performing a text about childhood—it is assumed that the humor comes from the absurdity of a grown man feeling, talking and acting much like a child would after an exhausting swim.

The other three videos (*David after Diabetes*, *David after Drugs* and *David*

after Divorce) take the idea of childhood and extend it to a number of adult experiences, functioning not just to open up the range of discourses provided by the original but also equally to recast the very terms in which childhood is represented. *David after Diabetes* features an adult man fading and slumping in the back seat, reciting his lines "I feel low" ("Your blood sugar is low, have a juice box") "Do I have diabetes?" ("It's from the insulin level. Put the juice box in your mouth"). The video functions as a PSA about the needs and condition of a diabetic and by using an adult figure—once again one who acts as a child—along with a parental figure responding with directions about his condition. *David after Drugs* focuses on the effects of drug use. While not structured as a PSA, it can be read as a cautionary tale, since it features a crazed-looking young man who smokes a large joint, smashes the car window, and unleashes a profanity-filled exchange with his friend/adult figure in the front seat ("I'm so horny," "I have two balls," "Now, I am fucking high"). This video moves childhood from the site of innocent dilemmas (dentist, donuts) or conditions (diabetes) to those of youth angst, violence and drug use. Finally, *David after Divorce* completes the narrative journey of this text into the dilemmas of adulthood, featuring a man who has just signed his divorce papers (and who is reduced to drinking from a bottle in the back seat) facing the reality of his new life, brought into sharp focus with exchanges with a friend, who works as a substitute parent figure: "Is this real life?" ("Yes it's different now") "Where is my wedding ring" ("You don't wear that anymore") "Do I still have children? ("Yes, you are still their father") "Why can't I see them" ("Because she has custody, you'll see them on the weekend") "Why is this happening to me?" ("Because she is in love with someone else") "Is this going to be forever?" (No...well, probably").

I want to conclude with a discussion of the intersection between childhood and viral culture with the iconic *Dancing Baby* videos. One of the earliest Internet phenomena, it began its life as a digital file circulated between animators, film makers and Internet users before it appeared on the *Ally McBeal* show (the first appearance was in an episode in 1998, accompanying Vonda Shepard's song, "Hooked on a Feeling"). One video shows the actress playing the title role (Calista Flockhart) emerging from the bathroom after a shower, despondent and alone (a recurring motif of the show, which is often seen as the poster child for post-feminism, where all the lead characters have very successful professional lives, but woeful personal ones). The baby emerges from a doorway, and soon we have both McBeal and the baby dancing spontaneously with complete abandon and unmitigated joy. As a post-feminist text, the baby represents an

important use of viral childhood in the discursive construction of adult female identity. The baby represents (simultaneously) both a return to childhood and a specific construction of childhood—a space in which one can literally dance. Specific to the show, the baby was meant to signify the ticking of McBeal's biological clock—a recurring anxiety on many post-feminist shows. Anchored by this dominant reading in McBeal, the dancing baby morphed in a number of directions, with online parodies (*Rasta Baby, Drunken Baby, Samurai Baby*), music videos (the Rick James hit, "Give It to Me Baby"), related songs (the band Trubble released a song called "Dancing Baby/Ooga Chaka"), commercials (a Blockbuster Video advertisement), and numerous TV shows (*Millennium*, VH1's *I love the 90s*, 3rd *Rock from the Sun, The Simpsons*) and even video games, where the baby's moves are imitated by certain characters in different games (*Silent Hill 4, Quest for Glory V: Dragon Fire, Roller Typing, Zoo Tycoon*). What connects all of these references, simply put, is the viral mobilization of childhood as a discursive construct, where the baby represents both possibility and actualization of identity through a performative idiom. One advertisement in particular bears mentioning—the *Evian Dancing Babies*—an Internet phenomenon in its own right, but which clearly draws on the discursive frame of the original *Dancing Baby*. It features a troupe of babies rollerblading with considerable aplomb—they jump, twirl, slide and generally rock out—extending the language of a viral childhood inaugurated by the *Dancing Baby* video.

· 5 ·

WHERE THE DOMESTICATED
THINGS ARE

There are countless videos of animals on YouTube. People have uploaded videos of their pets playing, barking, singing, dancing, running, falling, and any number of other actions. While it would be impossible to catalogue with any certainty all the animal videos, there appears to be a general process of "domestication" through the anthropomorphization of animals. In the sample of YouTube phenomena that I examined, two elements of this process were emergent—performativity and discourse. I discuss examples from each of these elements and then turn to some important videos where animals are used symbolically.

Performativity: Videos of domestic pets engaging in creative (or destructive), play, seemingly imbued with agency and intent, are a recurring element in animal videos, mirroring wider practices in visual culture, as seen in TV shows like *America's Funniest Videos* and numerous animal-themed films, like *Benji*, *Lassie*, and *Homeward Bound* amongst many others. *Cat Flushing Toilet* is an iconic video that features what the title suggests—a number of cats flushing toilets. It is easy to offer a reading of this video as a facile engagement with irrelevance by viral audiences (a reading featured in Michael Moore's recent film, *Capitalism: A Love Story*). While there are numerous reworkings of the original video, the most popular one is the remix created by a composer, Parry

Gripp, who has achieved viral celebrity through creating music for Internet memes such as *Cat Flushing Toilet*. His version of the video features lyrics that structure an argument about the cat's actions ("He doesn't care if he is wasting water, he's a cat") and a catchy refrain ("He's a cat, flushing the toilet is a cat") that plays in your head long after you have watched the video. Interspersed between these lyrics are sounds of flushing and close-ups of the cat's face as it says "meow." Gripp specializes in animal memes (other videos that appear on his website include *Black Hamster, Chimpanzee Riding a Segway, Goodbye Kitty, Funky Gerbil, Happy Squid,* and *Squirrels*) and his work can be read as the development of an auteurial signature (around animals) in a viral context—working in the mix between popular music (he plays in a punk-pop band, Nerf Herder), faux jingles (his 2005 album *For Those About to Shop, We Salute You* is a concept album mimicking various musical styles as product commercials) and music for animal memes, discussed here. What needs to be emphasized is the mobilization of animals as a thematic in the development of his auteurial signature, a process that is neither determinative (in a mainstream marketing sense) or complete—he posts new videos regularly on YouTube and his website, typically featuring animals, keeping alive an ongoing representation about animal performativity (and agency). Other videos that enumerate similar thematics are *Shiba Inu Puppy Cam, Hamster on a Piano (and Popcorn),* and *Snowball. Shiba Inu Puppy Cam* was set up in early October 2008 by a California couple to monitor their Shiba Inu puppies while they were at work, and the live streaming video became a viral sensation. Within a few days three million viewers had spent nearly two million hours watching the puppies online. Later edited, remixed and reworked by numerous viewers, these videos can be read as a viral celebration of infancy—images of snuggling up to their mother, drinking milk, lying huddled in tight bundles, playing with toys and tearing up various things. Such videos are shot through with specific anthropomorphic ideas about performativity and expectation (cuteness, mothering, childhood) but are also evidence of the multiple disjunctures such videos can open up. In the case of the Shiba Inu puppies, it signals the introduction of the language of ethnicity to majoritarian audiences, through the names given to these animals (Ayumi, Amaya, Aki, Akoni, Ando). This emerges as a topic both on-line and in their appearances on mainstream media such as *NBC Nightly News, The Today Show,* CNN, *Bill O'Reilly,* MSNBC, ABC and Minnesota Public Radio). Coverage of the video has also served to mobilize support—the couple created a 2009 calendar to sell, the donations from which were sent to Shiba Inu rescue organizations. In a similar vein, *Hamster on a Piano (and*

Pop Corn) (which features a hamster being placed on different keyboards, sometimes against his will) opens up a discussion about animal use (and mild cruelty) for human amusement. *Snowball*, on the other hand, featuring a cockatoo dancing to a Backstreet Boys song, is a viral sensation for its simple, reductive use of animals as a stand-in for human action—the bird appears to be a "party animal," an uncomplicated "swinging sensation" who weaves and moves in tandem with the song's beat, generating innumerable remixes and creating a viral language of performativity that works *transactively* across humans and animals. Two videos that take a single animal action and transfuse it with ideas about performativity are worth noting—*Dramatic Chipmunk* and *Sneezing Panda*. The former features a prairie dog (not chipmunk as the title of the meme suggests) and consists of a five-second clip of the animal turning his head while the camera zooms in on his face, with dramatic music and thunder in the background. Originally aired on an episode of the Japanese morning show, *Hello, Morning*, it has achieved iconic status, with key remixes featuring the prairie dog brandishing a lightsaber, and posing as Austin Powers and 007 among numerous others. *Sneezing Panda* features a baby panda violently sneezing, to the consternation of her mother, and has an equally large number of remixes, which include the baby panda as a furry animation, the baby exploding, the baby shouting "Sparta" (a reference to another internet meme) and so on. Animated versions of both clips appear in (different) *South Park* episodes and are a staple of viral videos, appearing in a range of other videos (such as the *Pork and Beans* video). Both videos can be read alongside a range of similar short narratives—inclusive of yelling or jumping goats, barking dogs, sneezing cats, leaping monkeys, and snarling lions—that speak to the anthropomorphic use of such actions—to refer synecdochically to surprise, amazement, consternation, disgust, wonder and fear. It is the very segmented nature of these representations that lend themselves to the use of animals as part of the language of performativity on-line, while being simultaneously reworked through editing into related realms of popular culture, such as the film/TV references identified in the examples above. I want to end with a more detailed reading of one iconic video that deals with performativity— *Skateboarding Dog*.

The Skateboarding Dog, "Tillman," known to most people through his appearance in an iPhone commercial, features a British bulldog skateboarding with both expertise and skill. His website (http://youpet.com/pet/17789) provides detail along with requisite hyperbole:

Tillman is anything but ordinary. Tillman lives to skateboard. He is the greatest skate-
boarding dog on the planet in many of his fans opinion. He is self propelled and has
more energy than a power plant. This past year, Tillman has mastered skim boarding
on hot days and actually snowboarded this winter. Tillman has definitely become the
"extreme sports dog." He loves to shag baseballs during little league batting practice
and often acts more like a retriever rather than a bulldog because of his incredible
endurance (accessed 9/15/09).

In addition to the iPhone commercial, Tillman has appeared at the 2009 Rose
Parade Float, on *Greatest American Dog* (CBS), *Animal Planet*, National
Geographic, NBC *Nightly News*, *The Today Show*, *The Early Show*, *The Craig
Ferguson Show*, *KTLA News*, and *FOX 11 News* in the San Diego area.

The appeal of the *Skateboarding Dog* video can at first glance be simply
located at the intersection of two themes (reiterated in numerous comments)—
canine ability, bordering on virtuosity ("that is sooo kool," "this dog is bad ass
awesome," "wicked dog"), and simple human envy ("this dog skates better
than me," "omfg that dog skates better than meh, and I'm very good"), but there
is also much more discursive work going on. The video is determined by the
same narrative frame that is often used by human skateboarders—to be fast,
fearless, and tough, while remaining suitably counter-culture and cool in their
demeanor. Tillman displays all these markers—he goes as fast as he can, wig-
gles and rocks back and forth on the board with controlled mastery, and, of
course, when he hits a bump and falls off the board, he gets right back on. It is
no accident that the setting for this virtuosity is a beach in California (the orig-
inal video was shot at Venice Beach) where Tillman weaves between crowds
of onlookers and fellow skaters, his performance suitably punctuated by decla-
rations of admiration and envy. Tillman's performance has to be read as part of
the same discursive realm occupied by surfer movies, TV shows like *Baywatch*
and the wider construct of California as the site for the mobilization of plea-
sure (beaches, parties, surfing). This frame continues through other videos of
Tillman, especially those of him skim boarding (on the water) and skateboard-
ing at different beaches—the latest video at the time of writing was of Tillman
at Santa Rosa, California.

In addition to issues of pleasure/locality, the appeal of the video can be
understood in its mobilization within the celebratory discourse of consumer-
generated content (and YouTube), especially its iconic use in an iPhone adver-
tisement. Aired in 2008, the ad sets up the clip with the following introduction:
"You would be surprised by some of the stuff you find on YouTube" followed by
a clip of Tillman. The commercial ends with a wider contextual comment—

"but when it comes right down to it, maybe the biggest surprise is finding YouTube on your phone." This commercial is central to the iconic status of the skateboarding dog, because it simultaneously removes it from the realm of just another YouTube phenomenon to becoming part of the language through which YouTube has entered and become part of the conversation of digital culture. Finally, it is important to note the dog's name, "Tillman." Tillman is named in honor of Pat Tillman, the former Arizona Cardinals football player and soldier, whose family has been in the news over the years over what they have said is the misuse of their son's death by the army. The name "Tillman" carries, in equal part, the markers of this media history (which include a recent film, *Gamer*, where the central character is called Tillman), mobilizing a range of discourses—bravery and courage; betrayal and deception; truth and accountability. These discourses coalesce around an unusual player and soldier and are transferred contextually (rather than reductively) to the performance of an unusual dog skateboarder.

Discourse: Overall, the discursive framing of animal videos is squarely focused on emotion. I will briefly discuss some recurring elements using two videos as examples (*Two Talking Cats* and *Otters Holding Hands*) before engaging in more detail with a specific discursive theme—the "love for nature" as seen in the videos *Christian the Lion* and *Battle at Kruger*. *Two Talking Cats* features two cats purring, chirping, meowing and "talking" to each other, while *Otters Holding Hands* shows two otters in a zoo, floating on their backs, holding hands (or rather, paws), looking generally in love. Both videos are discursively framed through the use of contextual frames and language. In the original *Two Talking Cats*, the discussion between the cats appears to mimic the chatter between well-established couples—a theme fully explored in a popular reworking of the video, where the cats speak like humans quibbling about their personal relationship ("you don't listen") and their relationship to humans ("someone's coming, act real cute and they'll give us treats") while similar themes are explored through the human commentary on *Otters Holding Hands* (with numerous repetition of "they are holding hands" and "so cute," "so adorable"). What stands out in the participatory culture surrounding these videos is the direct referencing of human-like agency and attribution to the cats and the otters. To illustrate, one remake of *Otters Holding Hands* features the well-known Beatles' song, "I Want to Hold Your Hand," echoing issues of longing, desire and love onto the animal world. Similar thematics (talking, fighting, loving, drinking, sleeping, eating, rescuing) inform the numerous other similar videos of animals. Since space does not allow for examples of all of them, I will discuss three of

the emotions/behavior—rescuing, loving, and fighting—to fully explore how such anthropomorphic framing works. An iconic video called *Dog Rescues Dog from the Highway* shows a dog being struck by a car and lying supine on the highway as cars zip by, oblivious and uncaring about the fate of the poor animal. The camera then spots another dog running along the side of the highway, who spies the stricken dog and dashes between cars to nuzzle him, and then takes him by the scruff and slowly drags him to safety as cars continue to zip all around him. Caught on surveillance video, the final product is edited and presented as a rescue narrative.

"Love" is the leitmotif of another iconic video, *Christian the Lion*, which features a remarkable reunion between two adults who hand-raised a lion cub and then reintroduced him into the wild. Based on events that were filmed in 1972, it has the look and feel of an old wildlife documentary film. Posted more than 30 years after the event, in 2007, it became a sensation with over 12 million hits (and a planned new feature film by Sony pictures). Understanding this video requires thinking through two contextual issues—the role of the white explorer in the mobilization of love as a discourse, and the role of the lion as a symbol of wild, untamed nature. Christian, the animal in question, is associated with the animal rescue work of the English conservationists George and Joy Adamson, who are well known for their films, *Born Free* and *Living Free*, where they first introduced the lion (or more accurately the lioness, Elsa) as the subject of our collective love/desire for nature. Elsa's well-known story of being raised by empathic, knowing, white English subjects and then reintroduced into the "proper" wild African environment is part of a wider set of discourses that underlie the popularity of this video. Some of the contextual referents here include human intransigence in the domain of nature (in turn drawing on biblical narratives about Eden and the fall from grace by humans) and above all "love" as the universal language connecting humans and animals. Visually, love is captured in a single sequence—*Christian the Lion*, running up to his former human family and jumping up on their shoulders in joy.

I want to briefly consider another iconic video, *Puppy Throwing*, that works oppositionally to *Christian the Lion*. This video, featuring a Marine throwing a puppy to its death, became a viral sensation, with overwhelming displays of anger and disbelief at the Marine for killing an innocent animal. Numerous blogs and websites were set up to examine the video and the soldier in question. News accounts (ABC, CBS, CNN, Fox) focused on issues of reality (whether this was a real video or not) while the participatory culture surrounding the video revolved around an emotion—repulsion—at the purport-

ed lack of feelings on the Marine's part. It bears repeating that in both cases (*Christian the Lion* and *Puppy Throwing*), it is the idea of animal love that is at the heart of the video's appeal.

I want to conclude with *Battle at Kruger*, which focuses on the emotion of "fighting" but within a wider narrative about love for nature. *Battle at Kruger* is a relatively long wildlife YouTube video (eight minutes). Shot in September 2004, it shows a "battle" between a herd of buffalo, lions and crocodiles. The video was shot at the Kruger National Park in South Africa, hence the name "Battle at Kruger." Punctuated with comments by a number of tourists, along with commentary by the tour guide, *Battle at Kruger* was a sensation, with nearly 50 million views, and won the "best eyewitness video" in the second annual YouTube awards. Mainstream media coverage followed with a story in the June 25, 2007, issue of *Time* magazine, and in an *ABC News* bulletin in August 2007. National Geographic used the video as the basis for a documentary on the subject.

Battle at Kruger can be approached in two interrelated ways—as an overdetermined text about the workings of the "animal kingdom" and simultaneously as a narrative about digital accessibility and consumption. Both these elements, the first evoked through comments about the "kill" and the second through the acknowledgment of tourist happenstance (cameras ready), appear in the hundreds of comments to this video ("incredible footage," "truly amazing, the animal kingdom at its greatest," "my god that was unbelievable! I have been to many game parks and have never seen a kill, let alone an attempted kill, a battle and a gang war-like rescue, in the animal kingdom. An amazing privilege to see"). I want to suggest that these two ideas are central to reading this remarkable piece of nature photography, but they are proximate reasons. Underlying these themes, I suggest, is a more elemental reading of the African landscape, a reading fundamentally determined by ideas about nature and primordialism—and fundamentally mediated through the voyeuristic prism of safari tourism.

The idea of a primordial Africa, the land of the animal kingdom, where the "law of the jungle" rules, emerges from the actual narrative of the video, which follows an impressive visual arc, beginning with the two protagonists, a herd of buffalo and a pride of lions, at two ends of a stretch of savannah. The buffalo herd, led by a massive male, approaches the lions, who appear to be intimidated but then unexpectedly charge the herd, leading to mass confusion. They chase a baby buffalo into the water and begin to maul him. The water begins to churn near them, and a crocodile (followed by a second one) charges

the lions, and grabs the buffalo. There is an ensuing tug of war, before the pride wins, dragging the buffalo onto the river bank. In the meantime, there is an impressive development as the camera pans to the left to show the buffalo herd approaching the pride of lions, determined to rescue the buffalo calf. The lead buffalo charges at one of the lionesses, who runs away, followed by a second more spectacular charge, where one of the buffalos tosses a lioness into the air. Then the final act ensues, the herd corners the pride, bent on—it appears—pushing them into the water, and the waiting crocodiles. The buffalo calf, meanwhile, jumps up miraculously from the ground, and runs into the protective cover of the herd. The herd proceeds to chase the lions away, one by one, scattering them every which way.

Battle at Kruger is about the working of nature in its "natural" environment—the African landscape. Watching this video is akin to watching a National Geographic or Discovery Channel documentary, with its staple set of discursive referents around Africa—premodern, nativistic, natural and a land of animals (sans humans). It is this imagined landscape that is at the heart of (safari) tourism, and in the video this reading is provided through exclamations of wonder and amazement (by the tourists and photographers) and commentary by the South African tour guide, who repeatedly mentions, "he has never seen anything like it." One of the tourists, a woman (she is off-camera) is especially important in providing emotional punctuation throughout the eight-minute film. She frequently voices a question, wondering whether the buffalo calf has been killed or not and suggesting that it must have been. In sum, I suggest we read this iconic video as coterminous with a wider set of discourses around African primordialism and nature, a place where the animal kingdom reigns, in equal part beautiful and horrific—but which can be safely consumed from afar—across the riverbanks.

I want to conclude with two examples of popular videos that illustrate the use of animals in symbolic terms, rather than performative or discursive, working in two very different (and highly contested) realms—politics and religion. These are not single videos but rather a whole collection of videos on a specific subject, the first is usually referred to as Baidu 10 Mythical Creatures, and the second is entitled Raptor Jesus.

Baidu 10 Mythical Creatures are a form of political commentary amongst Chinese netizens protesting censorship by the Chinese authorities. They started as humorous commentary on the interactive encyclopedia, Baidu Baike, and featured the use of a number of fictive animals. The images and commentary around these images were then inserted into a range of images, videos, songs,

and fake documentaries detailing different attributes of the animals. The names of animals were chosen to circumvent keyword filters instituted by the authorities, since these names could easily pass such filters. Each animal has a double meaning, where the written word has one meaning, but the spoken word, another. It is the spoken word that was being mobilized as a political and cultural tactic, to both circumvent the filters and to display a form of on-line protest. To illustrate, Cao Ni Ma (Grass Mud Horse) can be spoken as "fuck your mother"; the Fa Ke You (French Croatian Squid) as "fuck you"; Ju Hua Ca (Chrysanthemum Silkworms) as intestinal worms in the anus, and so on with all 10 fictive animals. What is significant is not just the clever and distinctive use of a local idiom married to a digital mode of expression, but the complexity of representation, working through a range of textual modalities (song, video, documentary) to create "nets" of opposition to state-based strictures, in ways that are new and (continually) open-ended.

Raptor Jesus is an example of the creative and disjunctive use of YouTube to develop emergent (and in many cases alternate) vocabularies for thinking through and re-representing culturally contentious issues (religion, politics, abortion, gay rights) that are often restrictively coded in mainstream discourse on the subjects (such as the left/right divide). *Raptor Jesus* uses dinosaurs, which already populate the collective imagination (through films like *Jurassic Park*), and recasts them in a new cultural arena (religion). *Raptor Jesus* is a meme that consists of a raptor's head crudely photoshopped onto pictures of Jesus. Some examples include images of the Last Supper, Jesus speaking to his disciples, Raptor Jesus in disco pants, Raptor Jesus as a shrewd businessman, Raptor Jesus at the airport, Raptor Jesus giving a sermon, and numerous images of the baby Raptor Jesus being cradled by the Madonna. There is a panoply of creative content relating to the religious practices of Raptor Jesus, including chants ("Our God's a Jurassic God, He reigns from 4chan above, with wisdom, power and lulz, our God's a Jurassic God") and prayer ("Our raptor, whose art is /h/entai, shopped be thy face, thy donations cum, thy posts be done, Give us this day our daily bridget, and forgive us our trolling"). *Raptor Jesus* appears to be a critical commentary on Christianity specifically and organized religion more generally, taking liturgical (and even eschatological) elements of the religion and reworking it in the space of popular culture. For example, Christian beliefs about the second coming of Jesus and the "rapture" are spoofed through the concept of the "Velocirapture," a time when "heretics, which include Jews, Christians, Muslims and atheists and worshippers of TyrannoSatan shall be cast underfoot and disemboweled by his holy talons." The coming of Raptor Jesus,

it is suggested, is not in the distant future but "occurred last Thursday...he arrived on United Airlines Flight 47 to Dulles. He has not yet rendered judgment on the sinners of the world but instead is sitting in his basement eating Ramen, contemplating the fate of the world, and spinning a dreidel." I want to suggest that *Raptor Jesus* is more than just a critical commentary on religion, it is a halting attempt at developing an alternate vocabulary around religion, using mass-mediated ideas about the natural world—in this case, the reflexive use of the raptor, immortalized through key films as fierce, clever and highly intelligent killing machines. The raptor, usually a villain, is now recast as a savior who is not for the meek, taking charge through ripping into non-believers. Through a mix of caricature, parody and invention, the meme offers new vocabularies for the working out of the "religious" in viral culture/space. This is not to say that this is an entirely emancipatory project—many of the videos and images are explicitly homophobic, including a reference in the religious prayer: "lead us not into faggotry." It needs to be emphasized that such disjunctive trajectories are inherent in the work of digital culture, where cultural critique and bigotry often mingle unproblematically.

· 6 ·

A VIRAL DANCE

Dancing is a recurrent element of performativity on YouTube, appearing not just in clips of dance-themed television shows, but in a bewildering range of videos—personal family events (marriages, parties, etc.), local, regional, and national competitions, genre-specific dances (polka, rap, etc.) and many, many, others where dancing is part of a wider narrative. In what follows, I discuss how dancing as a discursive element is mobilized in five ways—as a thickly layered commentary (*Peanut Butter Jelly Time*), as critique (using obesity as an example), as a narrative synecdoche (*Badger, Badger, Badger*), as performativity (*Frozen Grand Central*), and as a celebration of dance itself (*The Evolution of Dance*). Naturally, there are many other ways in which dance intersects with YouTube but it would be impossible to cover it all in any full way here.

Peanut Butter Jelly Time: The *Peanut Butter Jelly Time* video (hereafter, *PBJT*) features an animated banana dancing to a club song, called "Peanut Butter Jelly Time." Originally sung by The Buckwheat Boyz, a Miami-based DJ Crew, it became an Internet sensation when it was put to video by Ryan Etrata. The song was later released on an album entitled *Peanut Butter and Jelly* by Koch records. The video and its spoofs have subsequently been reworked in episodes of *Family Guy*, *American Idol*, Disney's *The Proud Family*, and NBC's *Ed*. At the University of Georgia baseball games, the song is played between game pitching changes.

The *PBJT* video can be read as an example of the endless recursivity of consumer-generated content, where a single visual/semantic thread is used in a range of contexts without a specific meaning being attributed to it. Having said that, it is evident that *PBJT* is an exercise in studied celebration rather than commentary or performance. *PBJT* is clearly a catchy, upbeat tune playing suitor to a retro banana motif, where the focus is not on complexity of rendition or movement, but rather on what it appears readily to acknowledge—that this is a mindless ditty, working to bring a momentary smile, a raised eyebrow, a dismissive frown, in the middle of our mass-mediated daily lives. Viewers, especially those that are fans of the video, speak about returning to the video periodically to get momentary relief from the stresses of the day in a safe and avowedly unproblematized space ("in my head, it will always be "peanut butter jelly time"). A minority of viewers speak to the song's somewhat annoying loop and pacing ("how retarded," "Oh God, this is so annoying"). The video's life on mainstream media is defined by its use on *Family Guy* (the episode was entitled "The Courtship of Stewie's Father) where the video is used to cheer up the lead character, a reading that is often repeated by accompanying comments.

However, like most memes, *PBJT* has other readings as well. An entry on urban dictionary.com suggests that in the song, the "Baseball bat is a guy's dick, Peanut butter is in the ass (shit), Jelly time is KY Jelly time." This reading suggests an important methodological point—that dominant readings may not reflect points of cultural (and counter-cultural) origin, and it behooves us to search far and wide for the many (and recursive) contexts of consumer-generated content.

I use the generic title of "obesity dancing" to refer to a range of YouTube video phenomena that work through the expected trajectories of awkward performativity suggested by the title of this category of videos. These videos center spectacle, along with humor, contempt, pity, sympathy, and, above all, critique. I will briefly describe five popular ones (*Fat Kid Dancing*, *Fat Kid Dancing to Ms. New Booty*, *Fat Aerobics*, *Fat Kid 2007 Easy Rider Bike Show* and Shakira's song "Hips Don't Lie" parody) before offering a collective reading of all the videos. *Fat Kid Dancing* features a young girl, in a mid-shot, tossing and bobbing her head in a frenzied manner, a happy smile firmly plastered on her face. The video has three versions of the dance—"normal speed," "faster double," and "slow motion," each functioning to showcase details of the girl's face and upper body. The normal speed version begins with the girl slowly nodding, keeping time with the beginning of the song, and then on cue (when the beat starts up), jumping up and down with joy, her chubby arms splayed out in celebration, her

neck repeatedly bent to one side, her cheeks plumped, and her tongue lolling out with each exertion. The faster version extra extenuates this effect, with each thrust of the arm, each bobbing of the head and each emergence of the tongue providing additional comedic value. The slow-motion version invites close attention to each motion and thrust, providing less comedic effect, and more analysis—the ability of such a fat face/body to sustain such exertion. *Fat Kid Dancing to Ms. New Booty* features an obese boy with his shirt off, wearing baggy pants and dark glasses, and dancing rapper style. Filmed in one take, the boy stands in his back yard (presumably), on a mound of dirt, surrounded by plants. As the song plays, he makes a number of sexualized moves (mimicking rap videos)—kicking up his legs, thrusting his pelvis and rolling his waist. At the end of the video, his pants start to slide off, and he hitches them up, exposing his underwear. His expression remains mute and unsmiling, his eyes behind sunglasses, reiterating elements common to rap videos. *Fat Aerobics* features a gargantuan young woman whose fat arms and enormous stomach stretch in layers around her, as she begins the video with a cheerful call, "exercise time." She then proceeds to stretch, first to her left then to her right, followed by touching her toes and arching her back, making a brief pelvic thrust, followed by a set of five calisthenics, after which she wipes her brow, mocking her effort at exertion. *Fat Kid 2007 Easy Rider Bike Show* shows an obese young boy taking off his shirt and dancing on the stage at the show. He is given a bra to wear by the DJ over his large sagging breasts. The crowd laughs and claps at the performance, at the end of which the boy is given a T-shirt.

All these videos are remarkable for the visual commentary they provide on obesity. Unproblematically positioned as spectacle, they present the (physically) grotesque as a viral consumptive. In each case, the visual center of the videos is on the motion of excessive flesh—the rolls of fat jiggle up and down, the stomach sways and swings, the arms and legs bulge abnormally, the jowls and cheeks move with unaccustomed force. What adds to the effect is the clear disjunction with the expectations of "normal" sexual performance that each of these videos suggest. In sum, drawing sustenance from TV shows like *The Biggest Loser*, the focus of such videos centers discourse about the abnormal and excessive, begging questions about intentionality and agency ("how could anybody get this fat?") and effect (typical comments were "disgusting," "fat ass," "stupid"). Such a reading is suggested, regardless of the sense of agency that each of the actors introduce into the video—the willingness to dance for a T-shirt, the lack of embarrassment as the shorts fall off, the cheerfulness of the aerobic exercise, and so on.

One video that provides an alternate reading of obesity is a parody of Shakira's song, "Hips Don't Lie." The original video by Shakira is a typical mix of two elements—the kind of self-reflexive engagement with celebrity that Shakira has come to personify (the explicit representation through song and dance of her hybridity—Hispanic and Middle Eastern) and her characteristically over-determined sexual expression—typically manifest in the opening of legs, the thrusting of breasts, and an inviting, completely aroused persona. In the parody, three men provide an alternate reading of the song. The central figure is an obese white man dressed in a skirt and bra, who mimics the performative index of the original, all the while posing, patting and fondling his oversized, flapping stomach, his protruding breasts, and his wig-adorned face. Accompanying the obese man are two gangster archetypes, a white man and a Hispanic man, moving rapper style, brandishing guns and attempting to stuff large shotguns into the front of their pants. Produced and edited with knowledge of visual sequencing (close-ups followed by mid-to-long shots; a pat-on tracking shot of the obese man coming out of the water), it is a convincing narrative, squarely aimed at the sexual performance and excess of the original. Here obesity speaks the language of criticism, of rhetorical overhaul, and can be positioned within the work of postmodern culture that simultaneously champions celebrity performance and reworks it, using the twin tools of irony and parody.

Badger, Badger, Badger is a short, minute-and-a-half Flash cartoon that features images of badgers doing calisthenics, interspersed with images of a toadstool (a wide shot and a close-up) and a tracking shot of a snake. First released in September 2003, the images are accompanied by electronic music and a quickly paced, monotone repetition of "Badger, Badger, Badger." This highly addictive sequence of images and words breaks off with excited cries of "mushroom" and a (somewhat) panicky call of "a snake, it's a snake." The cartoon loops indefinitely and is one of the most recognized viral videos—listed as one of the top five Internet fads of all time by PC World. Newer versions of *Badger, Badger, Badger* include the badgers as zombies, soccer players, Santas, and characters in numerous films (*Snakes on a Plane* and *Harry Potter* to give two examples).

Central to understanding the appeal of *Badger, Badger, Badger* are three interrelated elements of postmodern viral culture—recursivity, disjunctiveness and fragmentation. The near hypnotic quality of the video is a common reading of the video—the appearance and disappearance of the badgers is analogous to the constant flow of pop-ups that characterize viral consumption. The eye begins to track the ebb and flow of the badgers, keeping time with the

beat of the song, breaking off (with mild amusement) at the toadstool and the snake, before returning to the bobbing up and down of the badgers. Watching this video in the morning almost always assures that it will play in your head for the rest of the day—I even caught myself saying "Badger, Badger, Badger" under my breath at odd moments. The disjunctive nature of the video is clearly apparent; it brings the animal world into a very human activity—exercise and calisthenics. The fact that this video loops indefinitely speaks to wider discourses about the need for daily exercise, the goals of pushing oneself, and of finding ways to stay entertained while exercising (watching TV, listening to iPods) through the thematic insertion of the toadstool and the snake. Finally, at the heart of *Badger, Badger, Badger*'s appeal is its fragmentation. Viewer comments on the video include: "random," "this is so weird," and "makes no sense." Its appeal lies precisely in its explicit embrace of the unpredictable—badgers, calisthenics, toadstools and snakes—the merging of four elements that few people would have thought about together let alone used in the same sentence.

I want to spend a few minutes discussing the creator of the *Badger, Badger, Badger* cartoon, as emblematic of the ways that auteurship is configured in digital culture. *Badger, Badger, Badger* was created by "Weebl" (real name Jonti Picking) who is a well-known Internet Flash animator. *Badger, Badger, Badger* was the meme that launched him and his auteurial signature—short animations with catchy, hum-along tunes, explicitly nonsensical and usually repeating themselves in loops. He is best known for the web series, *Weebl and Bob*, many episodes of which feature the badgers. His online success has led to a career making mainstream television advertisements, segments on TV shows (*Totally Viral* on UKTVG2), visual effects for the film *Resident Evil*, and music albums. His various videos (most can be viewed on his website http://www.weebls stuff.com) offer a language through which online authorship can be gauged—the creation of a distinct, but accessible vision—in his case, combining the animal and human world in odd, funny and disjunctive ways—coupled with participatory performativity—in this case, an addictive soundtrack.

Frozen Grand Central is a two-minute-long video showcasing an event put together by Improv Everywhere, a group that uses people to create elaborate scenes, pranks and events. Using over 200 "undercover agents," the video shows New York's Grand Central being turned into a massive stage, where the agents "freeze" in place (for five minutes), while people swirl all around them. It's a video where people play out the dichotomy between action and movement and in the process create a reflexively engaged act of participatory art. Professionally edited, it shows the agents in a range of frozen motions—eating

a yogurt, tying their shoe laces, kissing, eating a banana, walking arm in arm, kneeling before a swath of spilled papers and so on. The people around them slow down as well, looking, touching and gazing in wonder at the ongoing performance. There are narrative enigmas posed throughout the video, through comments by onlookers—"Is it a protest?" asks one, while an employee on a cleaning truck (with a thick Indian accent) talks to his superiors, complaining about the situation. At the end of the five minutes, all the agents "unfreeze" and resume what they were doing. The crowd claps in approval as the flow of daily life and routine resumes. While the video is a powerful testament about performativity, it is even more a statement about the role of media in everyday life. Some of the onlookers quickly tape the event on their cell phones and cameras, there is a clear sense of pleasure and wonder at what they are witnessing. There is a key visual at the end of the video—a young child clapping and raising her hands in acknowledgement of what has just happened. This is participatory culture fully realized—working through the realms of the real, the visual and the viral.

The Evolution of Dance is among a handful of iconic videos that has come to define YouTube as a viral experience. It features a motivational speaker from Ohio, Judson Laipply, dancing to some of the most famous songs/dances in American popular culture. This is a complex text, hard to fully describe, each step/song full of segmented meanings. To illustrate, the video begins with Presley ("Hound Dog"), Checker 9 ("The Twist"), Bee Gees ("Stayin' Alive"), Carl Douglas ("Kung Fu Fighting") before moving on to Michael Jackson ("Thriller"), Los Del Rio ("Macarena"), OutKast ("Hey Ya"), among many others. Rather than engage with all the songs/dances in the video (an impossible task), I want to suggest that the importance of the video lies in its reiteration of the role of popular culture as the defining language of American identity. The entire dance is a thick intertextual gesture by the performer, referencing the bottomless reservoir of referents that each song evokes for the viewer. Each dance, each song, each move of Laipply's resonates across the realms of media history, popular reference (in other songs, dances, movies, TV shows, cell phone ring tones and, of course, other YouTube videos) and daily life (skating rinks, senior dances, dance parties, home stereos, iPods and so on). While there are ways to organize the songs into broad categories of relevance—the traditional (in songs such as "The Twist," "YMCA," "Hokey Pokey"), the classic ("Hound Dog," "Thriller," "Stayin' Alive," "I'm Too Sexy"), and those that explicitly reference specific ethnicities ("Macarena," "Kung Fu Fighting"), racial categories ("Hey Ya," "Dirt Off Your Shoulder") and the viral ("Crank That," "I'm Too Sexy"),

but such an exercise misses the point. What Laipply puts together is a dance *about* (American) identity, where all these separate realms (traditional, popular, ethnic, racial and viral) are brought together *through* performativity. While it is hard to ignore that it is a white subject that brings about such a collectivist gesture, it is equally hard to ignore that what makes this video popular is its sheer centering of pleasure as a category of performativity.

· 7 ·

THERE'S MUSIC IN THE MACHINE

Music dominates YouTube—from the videos posted featuring leading musicians and bands (across all genres but especially hip-hop and contemporary pop) to those with teenagers banging drums in their bedroom. There are also "flavor of the week" musical videos on YouTube that deal with the performance of a music star. Typically, clips from a TV show, a movie, or a new music video, they become Internet phenomena for a short time. The primary common element in all these videos is the preexisting status of these musicians, whether they are the newest country music sensation or the latest kid on the hip-hop block. The main function of YouTube is to highlight and showcase the best, worst, or most interesting new piece of musical meat, often generated by a show like *American Idol*. On occasion, established artists use YouTube as a stand-alone medium for getting the word out about their work. Since this book focuses on consumer-generated content, I will not focus on YouTube phenomena featuring established artists but instead will discuss a small sample of emerging artists followed by a brief discussion of some artists that work in the middle.

Emerging musicians typically use YouTube as the primary vehicle towards viral and mainstream recognition. Some illustrative examples (which I will discuss) are Terra Naomi, Hurra Torpedo, *Back Dorm Boys*, Hannes Coetzee, *Prison Inmates Remake Thriller*, *Kersal Massive*, *Bert and Ernie do Gangster Rap*, *12 Days of Christmas*, *Little Superstar* and *Lemon Demon*.

Terra Naomi is a folk-rock-alternative musician who was recently signed to a record deal with Island Records but who began her journey to fame through the viral spread of her single, "Say It's Possible," first uploaded on YouTube. The video (clearly amateur in its production quality) features Naomi singing with passion, earnestness and a complete lack of artificiality. Inspired by the documentary, *An Inconvenient Truth*, the song renders, with considerable pathos and energy, a personal reading of a global condition (global warming, unsustainable growth and missed opportunities). The song has some memorable lines, speaking to the psychology of uncertainty ("and though they say it's possible, to me I don't see how it's probable") and possibility ("this could be something beautiful, combine our love into something wonderful, but times are tough I know and the pull of what we can't give up takes hold") coupled with a direct, analytical tone ("I see the course we're on spinning farther from what I know"). While it takes aim at certain quarters, such as the media ("and the truth is such a funny thing, with all these people telling me they know what's best"), the overall mood of the song is one of activism ("don't wait, act now…they know nothing about us"). The song (and Naomi) can be read as a text about personal agency in a world dominated by global corporate culture. Subsequent videos by Naomi (including a professionally produced version of "Say It's Possible") suggest that the song resonates within a digital culture that is continuous with social movements that span environmentalism, anti-war rallies, anti-globalization and new age consciousness, typically developed through narratives of personal growth and responsibility. Such a reading resonates with the ongoing narrative of Naomi's professional life, which on her website includes concerts in India, Italy and other parts of Europe. Of special note is her performance at Live Earth 2007 at Wembley Stadium in the UK before 80,000 people.

Hurra Torpedo is a 1990s band from Norway that plays songs using large kitchen appliances (especially laundry machines) and stove-top ovens. Their entry into digital culture came in 2005, when a clip of their performance of the song, "Total Eclipse of the Heart" (from a Norwegian TV show) went viral. It led to numerous remakes, especially a mockumentary based on the song, called *The Crushing Blow*, and led to invitations to numerous concerts across Europe and in the United States. They were also part of a viral ad campaign for the Ford Fusion car. I read Hurra Torpedo as a text about alterity, without any of its pejorative contexts. It is, simply, a video about being (funnily, outrageously) different. The band members wear poorly fitting, overtly outlandish jogging suits, they are clearly mocking the self-important, over-stylized superstars of rock 'n'

roll (I kept thinking of KISS as I saw the video), even as they manage to use the genre to create a pretty good song. The lead vocalist sings off-key, but is still pleasurable to listen to. The "drummer" bangs the doors of his laundry machine, with an excess of force (but clear precision) while the back-up vocalist stands for most of the song, holding up a heavy and dangerous-looking piece of metal, which he brings crashing down with clear pleasure and destructive intent. It is hard not to enjoy this as one of the more pleasurable moments of viral culture—and its reception echoes such a sentiment, pushing its status as a YouTube phenomenon.

Back Dorm Boys (also referred to as "Asian backstreet boys" or simply "two Chinese boys") are two Chinese art students in their dorm room lip syncing to songs by the Backstreet Boys and other American and Asian pop stars (there is also a third student in the background, typically playing a video game). The two students, Wei Wei (to the viewer's right) and Huang Yi Xin (to the left) first became well known through their rendition of songs like "As Long As You Love Me," "I Want it That Way" and "Get Down (You're the One For Me")" (all by the Backstreet Boys). Their viral fame has led to a media career—they have become hosts of Motorola's lip sync contests, won the "best podcaster" award from Sina.com, a leading Chinese Internet portal, and signed a contract for Taihe Rye, a leading Beijing media company, through which they have appeared in many TV commercials, including Pepsi (some of the lip sync songs also double as commercials). They have also begun to release their own music with songs like "O Yi O Yi A." They have entered the lexicon of American television, with references in NBC's *Heroes*, *South Park*, and the *Ellen DeGeneres Show*.

Back Dorm Boys can be read as a text that speaks to the work—and emergence—of a specific cultural and national ethnicity (China/Chinese) in the sprawling post-modern mix of viral culture. The boys, dressed typically in sports outfits (usually the Houston Rockets) represent both transnational expression (a love of pop, basketball, and college dorm life) and national iteration (anchored through their referential use of that icon of modern capitalist China, the basketball player Yao Ming. What stands out is the sheer exuberance and originality of their lip synching performance. It is clear that they are having fun, but there appears to be more—there is a playing with genre, with affect, and with a language that is simultaneously global and national, that marks this video from the many other largely iterative lip synch videos that exist on YouTube. I believe its resonance with global middle-class audiences, who can relate to this video through the language of American popular culture (boy

bands, video games) and through a wider recognition of the emergence of China /Chinese as the standard bearer for the new relationship between economic globalization and corporate culture. To put this another way, Back Dorm Boys do more than lip synch, they inaugurate a language for understanding the role of China/Chinese in pop culture—a place they share with TV shows like *Heroes*, numerous martial arts and Chinese historical films released every year, and news coverage of China's increasingly central role in the nervous system of the world.

Hannes Coetzee is a South African slide guitarist whose minute-and-a-half-long video clip became an Internet sensation. Featuring the 72-year-old aloe tapper, it begins with a wide shot of him sitting on a tall slab, probably a road marker (as far as I can judge), on a rough road with rugged mountains in the background. He plays a lilting, uplifting tune on his guitar. The camera zooms in to show him playing in detail—with some surprising results. Coetzee is playing with his fingers and with a spoon in his mouth that he uses much like a slide guitar weight to move between the frets of the guitar. The tune rises to a crescendo, and then moves into a rhythmic beat, before tapering down. The video ends abruptly with the tune clearly unfinished.

The video clip (from all accounts) is from a documentary (*Karoo Kitaar Blues*) by Liza Ke, and features a well-known South African artist, David Kramer, who presents the "eccentric guitar styles of the Karoo, a marginalized people who live in the remote villages and outposts of the semi-desert areas of South Africa. They are descendents of the original inhabitants of southern Africa who were virtually exterminated at the end of the 19th century" (http://davidkramer.co.za/popups/press/karoo.html). The documentary features a number of musicians, including Coetzee. Coetzee became a YouTube star, thanks to this video, and went on to perform at local concerts in South Africa and was invited to a workshop for slide and steel guitar in Port Townsend, Washington.

It is inviting to read this video as a text about subaltern agency, where the voices of the marginalized are brought into global circulation and provide evidence of the democratic impulse of the Internet. However, reading the extensive comments and related videos around the Coetzee phenomenon, there is a much simpler—and perhaps equally important reading—which this video provides. Simply put, this video is about authenticity expressed simply and beautifully through music. I lost track of the number of comments that spoke of how happy they felt listening to this song, how often they listened to it, how they (even) cried, and how it became a touchstone for their lives whenever they felt

depressed or lonely. Coetzee provides proof that musical form and substance need not come from adorned production but can emerge in viral culture. Simply put, its appeal lies in the extraordinary investment that ordinary people put into their music.

Prison Inmates Remake Thriller is an iconic music performance by inmates in the CEBU (Cebu Provincial Detention and Rehabilitation Center), a maximum-security prison in the Philippines. *Time* magazine placed it at number five in its "most popular viral videos of 2007," describing it as "orange jump suited accused murders, rapists and drug dealers paid homage to Michael Jackson's Thriller in a dance performance." The video is all that and more—carefully choreographed and (near) professionally executed, it has generated a fan following for the dancers at the prison, with numerous videos, blogs and mashups of the two main performers, Crisanto Nierre, who plays Michael Jackson and Wenjiel Resane—an openly gay inmate—who plays his girlfriend, appearing in a number of fan videos. Equally important, the prisoners have become celebrity attractions in their own right, performing for politicians, tourists and even a visiting Archbishop. They have created a number of subsequent videos including dances to songs by Vanilla Ice, Philip Oakey, Queen, and from the musical *Grease*. When Jackson died in 2009, the prisoners put together a performance just 10 hours after his death in front of hundreds of spectators who had gathered to see the show. From all accounts the nine-and-a-half-minute dance to a medley of Jackson songs was memorable.

The extensive comments and participatory culture surrounding this video (including a documentary that is available on YouTube) point to three interrelated elements—the identities of the dancers, the motives of the prison administration, and the dance's point of origin, Michael Jackson himself. Working together, they weave a picture of the polysemic and often contradictory nature of viral culture. Discussion of the identities of the dancers is focused on the professional quality, performative index, and ability of the dancers. As often occurs on YouTube, there is considerable focus on the "gay" identity of the "girl" dancer, with extensive discussion, hate-speech, and debate. Discussion of the administration's motives takes on unusual specificity—with considerable vitriol directed at the director of the prison (Byron Garcia) who developed the idea for the performances. Blogs fumed at the fact that the prisoners have to do a dance program for visitors on many Saturdays (often followed by pictures with the visitors). Finally, Michael Jackson's history—with the extensive panoply of emotions and motives that accompany such a master text, runs through this video's participatory culture. Zooming out from the specificities

of the video, this is an important video for students of viral culture to examine. It moves between the local and the global; across mainstream and participatory culture and perhaps most importantly provides an illustration of the role of the disjunctive in viral culture—prison inmates and popular dance—the ready mix of unlikely elements.

I want to jointly consider *Kersal Massive* and *Bert and Ernie do Gangsta Rap*. Both are tied together by virtue of their play with the genre—the former a roughly edited rap song, and the latter, a professionally put together rap music video of Bert, Ernie and a host of other characters. *Kersal Massive* (Kersal refers to the town of Kersal, a county borough of Salford, UK) features two white teenage British boys who thrust their faces into the camera with dramatic energy, rapping about, among other things, "Got on the bus wiv me daysavah, smoked da reefer in dacornah." In the middle of the song, the camera moves to the right and shows a much younger boy, who is introduced as "ginger joe." A website on the group (undeterminable whether it's a fan site or the band) said "the band prides itself on intense Thomas Hardy-like social realism, such as the difficulties associated with mass transit and the omnipresence of drugs."

The video is clearly a parody of gangster rap, with its commodified anger and angst, while at the same time evoking a sense of the boys' own position as (presumably) working class youths in the United Kingdom. *Bert and Ernie do Gangsta Rap* shows excellent timing and narrative development—with characters moving in and out of frame, culminating in a dance where all the characters come together. Cleverly edited with footage from the original show, it presents these icons of American middle-class childhood continuous with the language of gangsta rap (for example, extensive use of the N word). I suggest that we read both videos as viral provocateurs—they are meant to provoke the viewer/listener to respond—and they succeed. *Kersal Massive* has at least a dozen remakes, with everything from gerbils, glove parrots, and Muppets, to remixes with Dr. Dre and Slayer. *Bert and Ernie do Gangsta Rap* has an iconic status—it has been reworked in a range of participatory culture, including remakes, remixes, blogs and discussions on web forums. It's become part of the conversation about music and racial identity, where rap becomes the lightning rod around issues of racial civility, cultural differences, and identity politics. But both videos are also part of the conversation *within* musical popular culture, especially in the extensive online culture of rap and hip-hop, with its rankings, debate, and remakes.

Turning to *12 Days of Christmas*, I want to focus on two versions of this well-known Christmas carol, the first by an acapella group called Straight No

Chaser (first formed as a student group at Indiana University) and the second, a version by a Brisbane-based animated Indian boy band called Boymongoose. Both groups have used the song to launch a musical career. Straight No Chaser first recorded the song in 1998, but it was posted on YouTube in April 2006 (by one of its members), after which it went viral with over 10 million hits. It led to the band signing with Atlantic Records for a five-album deal, live shows all over the United States, and a rapidly growing fan base on-line. Boymongoose has also developed a fan base in both Australia and India, where they are planning a major tour with multi-media performance/projections of their songs.

I want to read both songs as a deviation from the liturgical intent of the original, with some interesting and important differences located in the cultural space and identity politics of each group. Straight No Chaser, like many acapella bands, is predominantly white, with one African-American member (who has an important role), while Boymongoose's identity is diasporic Indian. The lyrics provide important guideposts to the differences in their discursive journey. Straight No Chaser's rendition of the song is both joyous and innovative. It possesses wonderful timing and subtly overlays a version of the original carol, with references to other Christmas songs/carols. For example, they sing "six geese laying—better not shout, you better not cry, you better not— in a pear tree" or "three French hens, two turtle doves—and Rudolph the red nosed reindeer." It is important to note that the textual ambit of the song does not, for the most part, move outside the realm of Christmas and its celebration. This is evident even at the end of the song, when the African-American member sings (as the others join in) "I had Christmas down in Africa." This version reinforces the role of *Christmas as popular culture*, with its multi-part harmonies and beats drawn from other carols and mainstream songs. By contrast, the Boymongoose version is unambiguously a text about Indian identity, reworking the terms of the mainstream culture (Christian, White, Australian) into the language of hybridity so common in diasporic subcultures. The last verse of the song provides clear evidence of such a discursive function (and a sense of all the other verses): "On the twelfth day of Christmas, My true love gave to me, twelve cricket ball tamperers, eleven syllable names, ten minute yoga, nine telemarketers, eight Bollywood films, seven-eleven workers, six IT graduates, five Indian games, four Hari Krishnas (is that Indian?), three butter chickens, two nosy in-laws and a totally insufficient dowry." The song hits on all the common and clichéd elements of diasporic Indian identity— Bollywood, technology, religion, arranged marriages, food and extended family—all rendered using an animated character—an Indian Elvis Presley—to

provide both social commentary and comedy to Indian and diasporic audiences. What connects this version to the original carol is not its religious intent, but its *relational* value, where the carol (as representative of mainstream experience) is reworked within the space of diasporic culture and its politics.

Another iconic video featuring the specificity of the Indian experience is *Little Superstar*. The video stars a dwarf actor from the Tamilian film industry (called Kollywood) who is break dancing to a remix of Madonna's song, "Holiday." The video and its name, *Little Superstar*, have become part of the language of YouTube, with numerous parodies and mashups, but it is an unusual example of a contra-flow, appearing on E!, MSNBC *Countdown with Keith Olbermann*, and G4TV's *Attack of the Show*, and it has also been parodied on *Saturday Night Live*. Making sense of *Little Superstar*, I suggest, lies in its visual/verbal segmentation as in digital culture. There is here a perfect collusion of image and word, where the unusual dexterity of the dancer and its complete resonance with the video's title has created viral magic. While concerns of ethnicity, the global awareness of the Indian film industry, and the exotic, exaggerated nature of the comedic routine is part of its success, these play suitor to its primary symbolism.

I now turn to a brief discussion of artists who are "crossover" texts, working across old and new media—Lemon Demon, OK Go and Lucian Paine.

Lemon Demon is a band led by Neil Cicierega, who is a well-known Internet personality, primarily known for his Flash animation called "Animutation." His most famous production is a comedy series called *Potter Puppet Pals*, which parodies Harry Potter. One episode, called "The Mysterious Ticking Noise," has over 80 million views. Cicierega has used that viral fame to release six albums under the name of Lemon Demon, most of which are available for free download on his website. Cicierega's music plays second fiddle to his animation, but it is important to note his work as an example of the cross-genre and intertextual nature of YouTube phenomena, where such cross-platform creative productivity is (almost) expected.

"Here It Goes Again" is a song by the band OK Go, that reached the Billboard Hot 100 and featured in the UK singles chart in 2006. While the band is reasonably well known in the world of alternative rock, its single "Here It Goes Again" is an Internet meme through the YouTube music video, which features the band dancing on treadmills in a single continuous take. It is a complex, carefully orchestrated performance that is a marvel to watch. The band lip synchs the song as they move between, around and over treadmills, keeping pace with the beat of the song. First loaded on YouTube in July 2006, it has

been viewed over 50 million times and won the 2006 YouTube award for the Most Creative Video, and a 2007 Grammy for Best Short Form Music Video. Its after-life in popular culture has been staggering: it is mentioned/parodied/replicated/indirectly referenced across genres and platforms including references on Television shows (*Monday Night Football, Colbert Report, Scrubs, The Simpsons*), commercials (Nike, iPod, Cingular, College Road Trip) and video games (*Rock Band, Thrill Ville, Dance Dance Revolution X*). Watching the video and its participatory culture there are two emergent themes that inform the video's phenom status—its performative index (combining simplicity and complexity) and its emblematic status as an icon of digital life. It takes an industrial object, an icon of the repetitive, boring but necessary element of modern life, where work and exercise coalesce ("I'm on the treadmill") and turns it into an object of art. In doing so, the video attempts/accomplishes something that few other musical videos can—the remaking of the everyday into something extraordinary.

"RevoLucian" is the Internet name for Lucian Paine, a well-known composer and music producer whose work includes "Hairspray: Soundtrack to the Motion Picture," *Team America: World Police*, and *Pretty Ugly People*, among many others. As RevoLucian, he is well known for his techno-remixes of major movie stars (Barbra Streisand, Christian Bale), and political commentators and politicians (Sarah Palin and Bill O'Reilly). I suggest we read RevoLucian as a "cross-over" text, where his established status in mainstream media is a reference point, and his Internet stories work as a contra-flow, affecting news coverage of the celebrities and politicians and fuelling TV talk shows, daily blogs, and coverage of entertainment. This became especially evident in his techno remix of Christian Bale (who had launched into a profanity-filled outburst against a cinematographer), which RevoLucion used to create an up-tempo dance that showcased the power of disjunction and parody, offering in equal part a critique of Bale's actions, and a viral gesture of understanding, where admiration and admonishment were handed out in equal measure. While such an impulse often governs all of entertainment journalism, what makes RevoLucian's work especially important is the sheer inventiveness of his remixes—his ability to take on and think through the absurdities of celebrity culture.

I want to end this section with a nod to how YouTube itself has become a point of reference for music. This is exemplified in the success of the YouTube Symphony Orchestra. Assembled through open auditions on YouTube, it was a masterful exercise in YouTube's reflexivity and self-promotion. Musicians auditioned through posting a video of themselves playing the Internet Symphony

Number One (written specially for the occasion by Tan Dun, who created the score for *Crouching Tiger, Hidden Dragon*). These videos were then viewed by a team of experts, who chose a set of finalists who were in turn voted on by YouTube viewers. The winners traveled to New York in April 2009 to take part in the YouTube Symphony Orchestra summit and to play at Carnegie Hall. Watching the entire process on the YouTube channel devoted to the orchestra is a revelation. It showcases the making of participatory culture in all its tensions—between the forces of collective action and institutional authority, between fidelity to musical conventions and those of innovation, and finally, in the actual performance itself, which represents in real/virtual time/space the coming of age of YouTube as a musical idiom.

· 8 ·

LIGHTS, POLITICS, YOUTUBE

Politics and YouTube intersect in a number of ways, which minimally include the distribution of videos and associated campaign material, as a constitutive element in the work of social media and using narrative techniques common to YouTube (parody, remixes, kitsch), in the work of political celebrity. Rather than undertake a description of this entire range (for which I don't have space), I will briefly discuss the question of tele-politics—the process where the question of politics is inseparable from the question of visuality—using examples from President Obama's 2008 viral campaign.

Even on occasions when mainstream media initiates the coverage (such as the video of *Obama Swatting a Fly* or *Obama Calls Kanye West a Jackass*) it is its immediate resonance within digital culture that generates its impact. This was especially the case with the fly-swatting video, which was marked by a temporal rapidity in its reuse in a variety of settings—music videos, animation, and even a film from the fly's perspective! The terms of the digital contract remained with the people. There are half-way points in this journey, such as stand-up comics like Katt Williams (a well-known African American comedian, known for his blunt, often profane humor) and the T-Pain Auto-Tune video (this is a video of Obama's voice set to a song by a well-known musician) that mobilize Obama within the discursive spaces of race relations, performance and cultural politics.

The question of visuality in presidential politics is at least as old as television, with well-documented stops along the way—the Nixon/Kennedy debates, Gerald Ford's missteps, Reagan's "There you go again" comment, and so on. With YouTube there are two interrelated processes at work. First, YouTube *extends* the history/use of the sound bite through its practice of highlighting. It keeps the same set of referents developed in traditional news narratives in (continuous) play. This is important for its impact on the political process, where the availability and ready spread through digital culture (YouTube, blogs, vlogs, Twitter, Facebook) of such sound bites changes the equation from a "unitary" relationship ("the media" and "the politicians") to a complex, non-sequential referencing across the digital realms that the sound bite spreads, and is recast, in. Second, participatory culture takes the sound bite and reworks it across the realms of critique, parody, celebration and disjunction, depending on the political/cultural orientation of the producer.

This is of course not unique to politics, but it has unique implications for politics, where the first point of reference may not be (typically never is) the original sound bite, but rather *its* reworking and recasting in its communities of viral reception. The coming apart of the Howard Dean candidacy has often been attributed to a single video—*The Scream*—which when searched for on YouTube brings up both the original clip and its reworking across a dizzying realm—a painting by Monet, SpongeBob SquarePants, gladiators, doctors, Batman, and so on. The Bush presidency and its digital record on YouTube also works in complex ways. A search for "Bush parodies" reveals a wealth of videos—there are clips of Bush speaking inappropriately, making incoherent responses, numerous clips of professional comedians (Frank Caliendo is perhaps the most remarkable) and average viewers copying his style of speaking (see especially *Young Boy Imitates Bush*). What stands out is a process of *reinvestment* of the original into a new realm of political/performative contexts. This recasts the questions of telepolitics from those of referencing an "original" point of reference to a multiple set of nodalities, all of which are recursive. However, this is not a process that is completely open ended. For example, the video of a shoe being thrown at Bush is reworked largely through a chaining out and reworking within a liberal, anti-war, and progressive digital realm. The numerous videos of Sarah Palin and her missteps during the last presidential campaign also resonate in a similar context.

In all these cases (Dean, Bush, Palin), I want to suggest that the work of the viral imagination is a *complement* to mainstream media—rather than a new interpretation—using existing visual material and recasting it *within* the realms

of partisan politics (abortion, campaign finance, transportation, etc.). There is one striking exception to this—the case of Candidate (and now President) Obama's digital life.

Rather than frame the question of Obama's digital life in familiar ways (celebratory vs. critical, Republican vs. Democratic), I think it's far more useful to look at the numerous videos on Obama (his campaign, his presidency, the extensive participatory culture) as an exercise in the working of contemporary charisma through the digital realm. I suggest that Obama has begotten a cultural moment that transcends the specificities of his personhood and make the more preposterous claim that he is only marginally at the heart of his own identity, that it is firmly in the hands of participatory culture.

This journey has many beginnings, but I want to locate it in an iconic video—the *Yes We Can* music video, which occupies an important moment in understanding telepolitics in the digital age. It takes the rhetorical specificities of the African-American church sermon, the uniqueness of its delivery mobilized into American consciousness through the speeches of Martin Luther King, and marries it to the visual language of the music video—with a difference. Shot in black and white, and showcasing America in all its complexity, it presents a cross-stitching of two voices—Obama and the "people" (both ordinary and celebrity) into one. This is more than well-crafted segues—this is a visual marriage, where the voice and agency of the campaign ("Yes, we can") assumes a rhetorical agency all its own. It is important to note that while Obama is at the heart of this message, he is not an overriding presence in this video, he appears alongside, in tandem, speaking with (and often under) the voices of the people that speak with him, and inaugurate an important step in this digital journey—they speak *for* him.

This journey is continued through another iconic video—*Obama Girl*—which has numerous elements that complement the first video. First is its deep personalization. This is a fantasy video, where the Obama Girl—voluptuously suggestive—wants deeply, achingly, to be with her man. The sexual intent is clear—she says "you can Barack me"—but more than the act itself, is the desire, formulated through a range of images, to show the extent to which she will go to get her man (elected). I want to suggest that the video resonates powerfully because it taps into the desires of the moment—a sense of the coupling and coming together with an erotic figure, felt through the body politic. This is a moment of collective desire, but it is more—it inaugurates the mobilization of charisma through the digital realm, where fantasy, politics, and sexual performance come together. In addition, it takes the idea of collective ownership

of Obama (begun in his campaign video) further away from the person, and moves it directly into the realm of participatory culture.

It is not enough to merely track the enactment of digital selfhood (such as through the *Obama Girl* video); to assess its political afterlife, I want to focus on one remarkable Obama mimic that has emerged on YouTube—Alphacat (whose real name is Iman Crosson). While mainstream comics zero in on traditional subjects (health care, the economy, etc.), Crosson embarks on a psychological journey—being Obama—taking on his biraciality, his (perceived) need for fandom, his personal history. One video that exemplifies this journey is *Whatever You Like*, which has Crosson hip-hopping in the Oval office, with lines that seek to capture the political space he occupies ("First Black Prez, ain't that right. I'm in the highest office, that's right"), the sense of agency and purpose he feels ("Now I can do whatever I like. You want it, I got it. You propose it, I'll sign it") and above all, the specificity of his cultural experience ("so what I'm half black and so what I'm half white"). In another video (*Barack Obama Superbowl Commercial*) Crosson explores what it means to be Obama, using a narrative trajectory that deftly walks the line between brazen confidence and self-indulgence. His character gets a call from Rod Blagojevich and Obama asks him a series of test questions: "Who's the coolest president?" "Who is the King? Who's the best? Who's the prettiest?" The answer to each, of course, is "Obama," and Blagojevich readily obliges. He trips up when he is asked, "Who is the meanest?" Obama corrects him telling him, "actually I think of myself as a pretty nice guy." Watching this video, the viewer is left with a sense of something coming undone—the digital persona of Obama (as a creature of participatory culture) is gaining its own agency, where concerns of hope and narcissism mingle unproblematically, in a way that they did not in the beginning. Besides these thematic issues, what stands out more than anything else in the work of Crosson is the nuanced delivery, the assured presence and the sense of inhabitation. Like Tina Fey's surreal imitation of Sarah Palin, Crosson works in the liminal space of possibility—he makes you believe that he is Obama.

· 9 ·

LET'S GET PHYSICAL

The use, placement and deployment of the human body in a range of physical activities (exercise, stunts, accidents and dances) are an integral part of how YouTube functions as a new kind of discursive engine. The videos can relate to parts of the body (face, hands, legs) or the entire body. To illustrate, two iconic videos, *Gunowa* and *Gunowy Morda*, focus on the contortion of the face in a viscerally powerful direction. *Gunowy Morda* shows an African man who pulls out his cheeks, while opening his mouth extra wide. The entirety of the inside of his mouth is visible in extreme close up. We see his gums, his white teeth, indentations in his cheeks, and a large flopping tongue. In a similar fashion, *Gunowa* shows a white man (wearing a white fedora hat) who takes the skin around his throat and pulls it so that it stretches out, and then proceeds to pull the skin upwards and cover his entire mouth with it (much like a bandit wearing a scarf to hide his face). Both videos can be read as variants on a singular theme—the face/body as an object of manipulation, evoking expected responses (disgust, amazement, shock), but perhaps more importantly, they signal a certain willingness through viral culture to present the face as a voyeuristic object, with celebrity as the central motive. I became interested in both the specifics of the performance and in a broader question—the narrative dynamic that the human

body enters into in its intersection with YouTube. What follows is a discussion of a number of videos that were chosen (from many such videos) for their unique use of the body as the site for storytelling (*Guys Backflip into Jeans, Daft Hands, Kobe Jumps over Car, La Caida de Edgar, Fat Boy on a Rollercoaster, Afro Ninja, Grape Lady, Scarlett Takes a Tumble, Zidane Headbutt* and *Old Lady Punch*).

Guys Backflip into Jeans is a viral tribute to the fun of being young—with young bodies. Stitched together with a rising, upbeat tempo that keeps pace with four young men (in their late teens or early 20s) jumping into their jeans from a variety of positions. There is an increasing level of complexity and difficulty with each jump. The conversation between the men is mainly made up of exclamations of "yeah" and is muted under the music. It begins with a man (African American) standing on his bed, holding a pair of jeans and then proceeding to jump into them. This is followed by him standing on a friend's shoulders and then jumping into his jeans (which the friend holds out). The third jump has this same man swinging from the door into his jeans, followed by him standing on his hands and then flipping over into the jeans. A new "jumper" enters the story (he appears to be bi-racial). He stands on the roof of the house and jumps into his jeans (a third man has joined them in holding up the jeans). Now the scene moves to the backyard (presumably this is all shot in the same house) where the last jumper in the video (a white man) jumps into his pants from a swing, followed by a scene of him jumping over a fence (in a scene mimicking an action film sequence) right into his pants, followed by a swing around a Stop sign, and concluding with the finale, where he stands on a see saw, jumps high into the air, does a back flip, then lands right in the jeans. All the men then get together, clap, and walk off.

There are a number of narrative elements that make this pleasurable—the story progresses over ever-increasing levels of difficulty. The music embeds the participants' personality and character into the narrative segment of each jump. The viewer clearly is watching something practiced and nuanced but also everyday. I suggest that this disjunction of the mundane and the athletic is at the heart of this video, even as it presents a new kind of identity politics—where the different racial and cultural backgrounds play suitor to the performance of being young.

Daft Hands is an iconic YouTube video that uses written text on the hands and fingers to generate a "dance" to the words and music of a song by the French duo, Daft Punk. The video features the hands of an unknown person (white,

likely male). The song, which won a Grammy Award and has been reworked by other artists including Kanye West, is sung in a robotic voice. Each word of the song ("work it, make it, do it, makes us harder, better, faster, stronger") appears on one finger or part of the hand, each choreographed in fast, rapid, and expert motion to the beat and rendition of the words in the song. The song's appeal can be located simply in the fact that it is a masterful performance—a marriage of intent and rendition, coupling an unusual song (with its tinny, robotic sound) with an uncanny performance, working perfectly in tandem. The viewer is invited to ask the obvious (how did he do that?) but also to mimic the act, given its seeming simplicity. Replicating the act is, however, difficult—with the participatory culture around the video rising to the task, with for example, detailed instructions about what to write on which part of the hand (Right thumb, "is" right index, "work" right middle finger "make" right pinky, "do" and so on for each hand) and for ways to slow down or speed up the performance. There are even ways to extend the act, with clothes, paint styles, and added sound effects for each curl up or thrust out of the finger. It bears repeating, however, that what matters here is less the iterative nature of this performance than its originality—this is, at its heart, a viral exploration of one (small) part of the human body, working in ways that are unusual, disjunctive and, simply put, creative.

The use of the body to perform acts that border on the superhuman is a recurring element of YouTube videos—these include lifting weights, carrying loads, running up a wall, jumping off roofs, etc. Many of these are clearly spoofs. One such video is *Kobe Jumps over Car*. It begins with Kobe showing his shoe of choice (Nike) to the camera and then telling his (worried) friend not to worry, that he's got this and that he needs to relax and "enjoy the show." Kobe then runs to the middle of the road and bends down, his legs tensing in anticipation as a car comes roaring in from the left side of the screen. Kobe jumps high, and in an incredible feat stays airborne as the car speeds under him. He lands safely and jumps up and down, pumping his fist and bumping chests with his friend and telling his viewers not to do this at home. The Kobe stunt video lit up the viral landscape (and mainstream media, with discussion of the video on TV shows, radio shows and sports coverage), with heated debate about its authenticity, its believability and the sheer audacity of the stunt. It took the relationship between celebrity and physical prowess (an established element in all sports narratives) and reworked it in the cultural space of backyard play, fooling around, and youthful recklessness. At the heart of its appeal was a question: How was it done? Did Kobe not realize that this could have ended his career?

Kobe himself helped the game along by not revealing how it was done, and in one memorable clip just kept saying, "it's Hollywood." However, this search for the "truth" itself is not enough to explain the video's importance. The role of participatory culture was vital. This is a rich video to mine for its depth of reflexive and critical reworking. Some examples: One video had the same video replicated by two suburban white boys, who imitated the style and rhetoric of Kobe and his friend but as parody, overplaying their inadequacy to the task at hand. A second video had two black men and one Asian man performing an exaggerated display of how they were going to show how to "really" do this stunt. At the last minute, the Asian man turned his back to the car, but once the car had passed, shouted and chest bumped his friend as if he had indeed jumped over the car. Finally, two black men performed an unforgettable parody of this video, shouting and gesticulating in perfect imitation of Kobe's performance, followed by one of them jumping over a little Matchbox car. In each of these videos, the shoe worn by the "jumper" was positioned at similar points in the narrative—at the beginning and reinforced at the end. Finally, there was a "spillover" effect of this video, with numerous videos that deal relationally with the subject of jumping over cars. Most of these were videos of real jumps with cars that were either parked or were being driven slowly. Many showed people getting hurt, falling flat on their backs or necks. Other videos showed people jumping "under" cars or being hit by them in a variety of spectacular ways (some real, but most of them clearly doctored).

La Caida de Edgar (the fall of Edgar) is a story about two boys, a log bridge, and a spectacular fall. The video begins with the older of the two boys crossing a stream by quickly and expertly walking across two logs that serve as a bridge over the stream. Edgar, the protagonist, begins to cross, but is clearly afraid at the prospect. He wobbles and steadies himself as he gingerly begins the crossing. The older boy, recognizing that Edgar is trapped and clearly helpless, begins to laugh and make fun of him, and as we clearly expect him to do—starts jiggling the logs. Edgar shouts in panic and starts to sway dangerously, righting himself in time, but then as the older boy moves the logs ever more vigorously, Edgar gives up and falls headlong into the stream, emerging screaming and angry as the older boy continues to laugh.

La Caida de Edgar is one the most iconic videos on YouTube, with extensive participatory culture that takes individual elements of the event—the log being shaken, Edgar's shouting, the fall, his emergence from the stream and the incessant laughter of the older boy—and reworks it through remixes, mashups

YouTube also serves up (very) short videos about the body that mobilize a narrative about the unexpected. Examples include *Afro Ninja*, *Grape Lady*, *Scarlett Takes a Tumble*, *Zidane Headbutt* and *Old Lady Punch*.

Afro Ninja is a short video of an African-American man (with a large afro) looking straight at the camera, preparing for what we assume will be a masterful display of martial arts. He holds in his hand a nunchuck. He begins with a back flip but things go quickly awry after that. He falls flat on his face, but quickly stands up, all the while flailing out with his nunchucks as he falls out of frame. Off screen, there are cries of "are you alright" as the video shuts off. *Afro Ninja* can be read as a text about possibility. It positions the viewer to see something memorable—a Bruce Lee moment perhaps—evidenced in the demeanor of the ninja, and as the video proceeds, in his determination to continue. *Grape Lady* and *Scarlett Takes a Tumble* are two iconic videos where the same act—falling down from a table—is recast in mythic frames, the videos functioning as viral fables about mistaken assumptions and overzealous performance. *Grape Lady* features a white woman stomping around in a big tub of grapes, learning how to undertake this task with the help of another woman who serves as her teacher. The video exemplifies the power of the unexpected, as in the moment of her (approaching) mastery of the task, things come spectacularly undone. She falls wildly off the table, hands flailing, and face drawn in horror—to the ground below. *Scarlett Takes a Tumble* develops in similar fashion—just with a different premise, one of performing a song rather than crushing grapes. Scarlett is a large African-American young woman who climbs onto a small table—begging the question of common sense from the outset—and starts to "perform" for the camera. The narrative arc is long in development, as Scarlett manages to hold steady and stay on "stage" for most of the video, until the moment the viewer has been anticipating is suddenly there—Scarlett leans forward (towards the camera), the table dips and she falls backward, hitting her head and shoulder on the table and crumpling to the ground. The video ends with her lying on the floor, moaning softly about what has just happened. Both *Grape Lady* and *Scarlett Takes a Tumble* have a similar narrative arc—an extended development and a sudden resolution. Part of what they share is questions of effect—the viewer is left wondering whether the participants were seriously hurt or just winded—but beyond effect, it is the personas of the women in question that has led to their viral fame. Both appear to be woman of considerable certainty and candor—clearly enjoying the task they are undertaking. In each case, they fall (literally and metaphorically) from their high perch. Simply put, this is a viral fable about presumptive arrogance and

and response videos. I suggest that there is an epic quality to the fall of Edgar, which speaks to its popularity. It provides, through short, segmented signifiers, a wider story about human gullibility (on Edgar's part), deceit (on the older boy's part), fear, embarrassment and above all, humiliation. While space does not allow for a full discussion of the numerous spoofs and remakes, I wanted to mention one remarkable re-make where a contingent of soldiers appear soon after Edgar falls and promptly arrest the older boy and whisk him away, much to the satisfaction of Edgar!

Read as a modern day fable about the trials and tribulations of childhood *La Caída de Edgar* evokes familiar archetypes: the story of Cain and Abel, Tom Sawyer, and in the context of Hispanic media, storylines about family betrayal that are a recurrent theme on Telenovelas. But beyond these archetypes, the fall of Edgar is a pre-modern narrative about childhood centered on "nature." The video is a place where *childhood itself is the story*—a space before video games and modern media—a place when children played in/with their natural environment and came to terms with themselves through such experiences.

Fat Boy on a Rollercoaster features what the title suggests—a large adolescent boy stuck on a rollercoaster as it careens and rolls in typically heart-stopping fashion. The narrative of the video is developed through two "characters"—the boy in question and a maternal figure next to him (his mother, aunt, or a family friend). The video begins with both characters strapped in, waiting in anticipation for the thrill of the ride. The next stage is a display (by the teenager) of a modicum of thrill as the coaster picks up speed, but soon after things go downhill (no pun intended) as the boy gets squashed into his seat and starts to shout, "help, help." The straps holding him in place start to cut into his chest and head as he keeps sliding down, all the while shouting "stop it, stop it." At one point there appears to be a real fear that he will either choke on the straps or somehow burst out of them and fall out. At this point, the story gets its narrative energy from the maternal figure laughing in loud cackling fashion (reminiscent of the wicked witch in the Wizard of Oz) even as the boy's cries get more and more urgent. The juxtaposition of the two sounds and their disjunctive themes (despair on the boy's side; unadulterated pleasure on the mother-figure's side) provides the narrative energy of this video. It calls into question majoritarian discourses around familial relationships and roles (for example, the mother as a nurturer), in addition to reiterating the idea of obesity as an object of laughter and ridicule (as evidenced in numerous comments about the "poor fat kid").

its aftermath or as is commonly put, "pride comes before a fall." Both videos have an extensive participatory culture surrounding them, but I want to focus on one type of video, the "reaction" video. There are numerous videos of people taping themselves watching each of the "falls." In almost all cases there is uncontrolled, hysterical laugher as the person falls. Two videos with Scarlett especially stand out—the first, where a young boy appears to come unhinged with laughter at the sight of Scarlett falling, and the second, which shows four young people (three boys and one girl) providing extended commentary as Scarlett dances, and then collapsing with laughter when she falls. Such "reaction" videos are an interesting departure from the typical remakes and parodies that characterize participatory culture around Internet memes.

Zidane Headbutt is a viral video from the 2006 Soccer World Cup, which shows the French player and team captain head butting an Italian player in the chest and sending him to the ground. The result of the head butt, as every soccer fan knows, was disastrous for the French team. Zidane was ejected and his departure from the game spelled the end of France's hopes in the World Cup Final. One of the most iconic sports videos of all time, it circulated through mainstream media and has sprawling participatory culture—remakes, spoofs, parodies, mashups and remixes. Viewing a number of these videos, I found evidence of three interrelated "messages." The first was what can be termed the "lessons" of the act, where the video acts as a fable about fallibility, where people with the best of credentials can come undone through a single act. The second message was one of redemption, where comments and videos spoke to the long history of Zidane as a player and as a French icon and how his head butt should not be the only measure of him. Finally, there are numerous critiques of the act, including many cartoons that show Zidane undertaking a number of more violent actions—cutting heads off, running people over with a car, and so forth.

Old Lady Punch is a video of a middle-aged white lady punching another woman violently in the face, leaving her stunned and with a bloody nose. There appears to be little in the way of provocation or argument to warrant such an action. In fact the punch appears to be thrown on behalf of another (younger) woman who is shown talking with the woman who gets punched. Little explanation is offered either about motive or the intention of the act.

Both *Zidane Headbutt* and *Old Lady Punch* can be read as a record of the unexpected in daily life and even as a tale of unpredictability. "Sweet old women" don't throw punches and a player of Zidane's experience does not "lose his head" the viewer may presume as they watch both videos. Both videos rep-

resent the possibility of sudden personal dissolution in the face of the unexpected. They suggest a moral: A lifetime of control, balance and playing by the rules can come undone at the hands of a sudden emotional vortex—a moment that can strike any of us.

· 1 0 ·

MEDIA, MEDIA ON THE WALL

In this section I discuss a small sample of videos that are evidence of the important role that YouTube provides as *a node of mediated connectivity* across all media. Such videos can be seen as a reflexive/celebratory/critical commentary of living in an image/media-saturated world. I chose each of these videos to suggest how complex this relationship across media is—which includes television (*Rickrolling*), independent film (*Immersion*), mainstream film (videos inspired by the *Star Wars* franchise), cell phones (various iPhone videos) and gaming (*Scary Maze Pranks*, *Nintendo 64 Kid Goes Crazy*) and *Leeroy Jenkins*).

Rickrolling is an Internet phenomenon where a person is fooled (much like a bait and switch) into clicking on a link, which opens to a music video by Rick Astley (the song in question is "Never Gonna Give You Up"). When the viewer clicks on the video, they are supposed to have been "Rick rolled." This was a viral phenomenon that peaked in 2008 when a number of such videos appeared on April Fool's day. Later that year a similar video called *Barack Roll* featuring John McCain and Barack Obama went viral. There are numerous other examples of *Rickrolling,* including its use in local news broadcasts, sports shows, the Macy's Thanksgiving Day Parade, and flash mobs.

Rickrolling can be read as a rhetorical element in the reiterative nature of postmodern culture. Used effectively as a device to interrupt coherent/linear

narratives, it has become much more—a celebration about the power of interruption itself. Watching the various clips of *Rickrolling*, I could not resist recalling Homer Simpson's response each time somebody tries to be serious—"boring!" *Rickrolling* functions within this same space, questioning the terms of the narrative contract already underway (news accounts, political speeches, parades and so on). Issues of agency and intention vary across a range of contexts that *Rickrolling* videos appear in (sports, politics and scientology, to give just three examples), but they all share the idea of reflexivity—the looking back at the terms of the narrative contract that each story presumes to own until it is interrupted with a Rick roll. Transmedia storytelling (a concept coined by Henry Jenkins) suggests that postmodern stories are told across various media—film, social media and video games—rather than through just one media. *Rickrolling* exemplifies such a process. The full meaning of the *Rickrolling* phenomenon can only be approximated as one looks at its occurrence *across* the various realms it appears in—and a full account (which is not undertaken here) reveals the ways and means of postmodern textual production where the interruption becomes a discursive tactic in the creation of an always incomplete story.

Immersion (a video by Robbie Cooper) is a visual account/documentary of children playing video games. It is a testimonial to the power and magic of video game play. I read this film as primarily a narrative about surrender—where the individual players (made up of one teen and six pre-teens) are presented as both voyeurs and actors in the immersive context of violent video game play. The games they play appear (from the sound of the game) to be single-player shooter games (typically these are war or conflict themed). This dual relationship to self and game is powerfully captured through mid-shots of the players looking into the camera (or more accurately at the console) as they play. Background noise, typically from the game, but on occasion extradigetically, is introduced to frame the relationship between the players and the game. The richness of this video can be evoked through a brief description of each of the children and the psychological signature they present as they play.

The opening shot is of a young, white girl, her lips pursued, her tongue rolling inside her cheek, her eyes showing in equal part serious intent (at the game's goal) and concern about performance. Shots of gunfire commence as she plays quickly. There are minute twitches of the face signaling her actions (successful or otherwise). In sum, she is a study in concentration, action, and intention and serves as a useful benchmark for the players to follow. The second player is a profusely freckled young white boy, with extravagantly pursed

lips. His tongue lies heavily inside the mouth, emerging occasionally to masticate the lips. This is an elaborate pantomime of what in another context might be seen as ritualized eating. I read him as a text about beginnings—a new gamer whose quizzical look reflects an awkward handling of the psychic/physical space of the game. There is innocence in both expression and (presumed) play, reflecting a sense of coming to terms with the medium, and the kind of play that gaming inaugurates. The third player is a white teenage boy with long black hair, with headphones around his neck. He smiles absently (and repeatedly) as he plays. He is clearly absorbed in the game but is an odd text—he is clearly the oldest person in the video but is the most childlike in his need for success; he laments his failures and his intentions loudly ("Come back, let me stab you"). The fourth player is a short, squat boy whose personality can be easily summarized: Intense. His fixity of expression presumes a mastery of game play and viral performance. Perhaps the youngest child in the video, his placement after the oldest (the teenager) speaks to his rhetorical function within the space of this video—an early appropriation of childhood in the service of game play, a pointed contrast to the teenager, who retains a childlike innocence and a search for validation that only a child typically presents. The fifth player is a young white girl with a blank, stoic expression who stares fixedly at the game. She sits absolutely motionless. Unlike the other players there is no moving of the shoulders, no twitch of the head, not even any movement of the eyes, as she follows the action in the game. She represents a specific vision of gaming— a virtual space where the self is emptied, where the emotive context of gaming is transformative, leaving the person bereft of agency or motivation. The sixth player, a young white boy, repeats the leitmotif of emotional surrender to the terms of the game, representing perhaps the ascendant power of gaming *across* gender. The seventh and eighth player(s) are a young white boy and an African-American girl of the same age. They are a study in contrasts—the boy unabashedly happy and the girl a picture of concern—so strong is the affective contrast, that in a different context this could be a portrait of a mother and child. The ninth player is a tough-looking white boy, his play clearly forceful and direct, his face synecdochically tied to archetypical male figures—the tobacco-chewing cowboy, the Bud-drinking outdoorsman. He completes the picture by muttering at the game, "How do you feel about bullets?" In the frames that follow, several of these young players are shown playing together (in groups of two or three). Perhaps the most poignant segment is the penultimate one, a long close-up of the young African-American girl showing a big tear rolling down one eye, as her lips tighten in sorrow. The concluding sequence

features the older teenage boy completing a gaming session with a child-like croon: "whee, I win, I win," all the while shaking his shoulders in an elaborate gesture of pleasure.

Immersion is a complex layered text—the catatonic, the angry, the merry, the infantile, the sad are placed (unproblematically) alongside each other to build a thick narrative about the nature of game play. In doing so, it provides a script for understanding the role of gaming in the making and unmaking of contemporary childhood. I read *Immersion* as an indictment of the digital age—a jarring, disturbing and visceral account of the psychic space of gaming, a place not pleasant to witness.

The iPhone is an emblematic (perhaps even epiphanic) text in the sprawling culture of YouTube—functioning, I suggest, as a reflexive account of contemporary digital forms and practices. This includes advertisements, commentaries, fan videos, music videos and parody videos. I want to focus on the last as illustrative of YouTube's fascination with the iPhone as a media/cultural technology. There are numerous parodies, often centered on the exultatory rhetoric that accompanies Apple's advertising campaigns. I'll discuss one of the earliest parodies (of the first iPhone), which has functioned as a template for many future parodies. It focused on the phone's ability to perform all kinds of functions. In a narrative that is memorable for its absurdity, the iPhone is hailed as a shower (a woman holds an iPhone over her head as water pours out), a treadmill (a couple run on their respective iPhones), electric razor and hair dryer (images of iPhones performing both functions), lip gloss and mace (a woman applies lip gloss and then uses it to spray an awkward-looking man), a kid's thermometer (a mother shakes the iPhone before using it to test her child's fever), a cheese grater (cheese falls off the iPhone), a mouse trap (a piteous looking mouse is immobilized by the iPhone), a condiment dispenser (mustard is squeezed out of the phone), and hand grenade (a man tosses an iPhone, commando-style, over a wall and then ducks as it explodes). The parody ends with a telling verdict: "It's also a hard-to-use cell phone" showing a man tapping away feverishly to get a better signal. This parody inaugurated an entire language to critically interrogate the iPhone, suggesting that it is a media technology where its discourse has far outstripped its function. A recent iteration of this parody features a conversation between an "old cell phone from five years ago" and the new 3G iPhone. Through their conversation we learn that the latter's camera does not have a flash or a camcorder function; that to see images you have to enter a user name and a password into a website, that it takes an eternity to copy and paste, that it has no Flash support, and finally,

that you cannot erase a single call in your call history without erasing all your calls. What stands out in this parody is the specificity of the critique offered around issues of use, features, and accessibility. The parody ends with a confessional from the new 3G iPhone: "Actually, I'm just like the first iPhone, just more annoying."

Justine's iPhone Bill features "Justine" opening her iPhone bill—a seemingly simple act but one which we learn subsequently has a singular message: responsibility in a digital age. Justine plays the stereotypical blonde young woman who the viewer can safely assume is on her iPhone a lot. The video has three segments—the first where Justine shows the viewer her bill, which comes in a box, the second, which is a collage of Justine opening the box (a longer process than you might imagine), and a final extended segment where she leafs through all the pages that make up the bill, which we learn is over 300 pages long. The video ends with the goal of the video—telling viewers to sign up for e-statements.

While ostensibly about the use of an online payment option a number of latent themes inform this video. This is primarily a gendered reading of cell phone consumption and use, centered on the actions and intentions of a (any?) blonde girl, readily evoking images of endless prattle about love interests, nail polish, hairdos and shoe styles.

Beyond this the video can be read as a parable about digital life, a life needlessly burdened with 300-page bills, her situation easily solved on-line with a click of a button and a credit card payment.

Videos about the iPhone are part of a larger universe of videos that interrogate the "cultural war" between the Apple Mac and the PC, with special creative venom reserved for what some call the "cult" of Apple. A few examples are illustrative of the wealth of discursive work that fuels this war. One video zooms in on a woman's head and then keeps zooming inside her head, past her hair, skin, bones, molecular structure, and DNA and then arrives at the destination—a picture of God, dressed as an Indian Guru—with clear declarative intent: "iPhone, God probably has one." Another video extols the virtues of the iPhone and ends with its presumed arrogance: "The new iPhone from Apple. Go to Hell." Numerous other parodies take the self-aggrandizing language of the original advertisement and substitute alternate text. For example, one parody of the "app" (application) ads focuses on "new" applications of the iPhone: "If you need help with your marijuana plant, there's an app for that" and "If you are trying to steal someone's identity there is an app for that." Finally, the iPhone is the starting point for a chaining out effect, where the orig-

inal advertisement is used to negotiate (primarily using parody) a range of areas including politics (for example, parodies on iPhones for republicans and liberals), popular culture (videos on iPhones for Jedis and Trekkies), and religion (numerous parodies of iPhones for Christians, Muslims, Rabbis, Buddhists, etc.) to name just three. While space does not allow for an individual treatment of these videos, what stands out is the reiterative nature of their narrative elements, drawing from mainstream media coverage and thematics—for example, the Republican iPhone features guns and Rush Limbaugh, the Jedi iPhone has lightsabers and Darth Vader, the Rabbi iPhone has Kosher food, and so forth.

I'm on a Mac is a parody of another video called *I'm on a Boat*, which is itself a critical account of the pretentious gangster chic that pervades hip-hop videos. As a point of origin, *I'm on a Boat* sets the terms of *I'm on a Mac*, with its insider jokes about wanna-be white rappers and its over-the-top black rapper, T-Pain. *I'm on a Mac* begins with an identical set up, except that in place of getting free trips on a boat, the major characters get a free Macbook. What ensues is an extensive, profanity-laden parody of the Apple company's industrial elegance and user-friendliness and a critical statement about its fan culture (which typically draws on a sense of personal agency and aesthetic superiority as compared to the PC). Anchored in mainstream news coverage of the Mac vs. PC battles, evoked wonderfully in the I'm a Mac series of advertisements, the *I'm on a Mac* parody focuses on the gyrations and antics of the main characters, which include a Tellytubby-looking character called PC-Pane. The video is ambitious, taking on a range of issues that inform this cultural war, including the Mac's superior software ("Eat a virus, bro, I'm a Mac Pro") hardware capability ("eight cores hard, super drives, plug in device"), complementary devices ("straight iPhone hard, got the 3G, iTunes") and overall superiority ("This ain't PC, this is as real as it gets"). In addition to this litany of comparable features, the video takes aim at its cult-like following. Two of the performers dressed as Steve Jobs sing "These turtle necks aren't cheap" and parody the idea of success that many Mac vs. PC ads are focused on ("If you're on a PC you're with C.E.B). Accompanying the lyrics are pictures of the characters on an iPhone roaring through space; balanced on an iPod as it surfs over waves; and of course on a boat, where PC-Pane dances (awkwardly) alongside a scantily dressed Asian-American woman (read "slut"). Throughout the song the main refrain is looped frequently ("Take a good hard look at the mother fuckin' Mac").

YouTube's intersection with film narratives such as *Star Wars*, *James Bond*, and *Harry Potter* is impossible to fully account in any systematic manner. I

attempted to do this, by just focusing on early *Star Wars* films (*Star Wars*, *The Empire Strikes Back*, *Return of the Jedi*), but the task was undoable: There were a staggering number of videos for each of these films, which ranged across clips of the films, video commentaries and analysis, music videos, parodies (perhaps the most common type of video), remakes (especially using alternate characters in scenes), animated versions of the original scenes, personal events (parties, costumes, family gatherings, fan clubs). Another point of entry into the wealth of videos was to focus on single characters such as Darth Vader, but the results were the same—an astounding range of fan fiction, impossible to sample.

I emerged from the exercise with a principle—YouTube is virtually bottomless in its output when it comes to the intersection of participatory culture and major pop culture phenomena. All one can do is to identify narrative trajectories (a film scene, a character, a piece of dialogue, a musical score) and choose some interesting videos in an attempt to evoke a sense of the whole. So, for the task at hand, I chose three videos (*Star Wars Acapella*, *Star Wars According to a Three- Year-Old*, *Star Wars Trumpet Solo*).

Star Wars Acapella is a video by Corey Vidal, a well-known Internet celebrity from Canada. His video is a tribute to John Williams (composer for the *Star Wars* movie franchise) and features Vidal lip synching to a song recorded by an acapella comedy troupe, Moosebutter. The video went viral in 2008 and has subsequently been named Canada's number one top-favorited video of all time. It was nominated for a People's Choice Award on CBS as a favorite user-generated video. *Star Wars Acapella* can be read as reiterative text, but that does not do it justice. Vidal orchestrates visual acuity, pat-on timing and irresistible humor into his performance. This is an insider's text, speaking a language of love (for the *Star Wars* franchise) through a digital medium. Like most fan fiction, it asks for close attention to the jokes and arcane references and the pleasure of participation itself. From the responses to the video it is clear that Vidal hit a collective chord, with his "interpretation," not limited by traditional parameters of (assessing) authenticity and performativity, but rather, in the deliberate agency of his work, taking the transformative power of mass culture and extending it in new digital ways.

Star Wars According to a Three- Year-Old is a charm—it features a cherubic, utterly adorable girl telling the camera what the film(s) are about. Completely at ease, explaining the story about good and bad guys with aplomb and accuracy, the video can be read as both a record of childhood and a testimony to the power of the *Star Wars* franchise as primal storytelling. What adds to the impact of this video is its verification of irreducibility. If the *Star Wars* story can

be read as a story about coming of age, this video is a story about childhood col-
lapsing the two stories into one, brought into being through the voice of a child.

Star Wars Trumpet Solo is one of many such videos playing the now myth-
ic *Star Wars* music. There are versions of the music with numerous instruments.
I chose this video because of its perfect syncopation of the trumpet with accom-
panying sound effects (noises of lightsabers and robots) and the consummate
energy of the player as she performs the song. The trumpet player is a young
woman in a Vegas-like club setting. She alternates between playing, dancing,
and clowning around in a complicated act that she makes look easy, but per-
haps more than anything else, she comes to embody (for me) the kind of plea-
sure that such fandom offers to its participants—a sense of belonging to a
story.

Video games are at the heart of youth culture, and it is no surprise that they
dominate YouTube's media-related videos. Much like film, any major video
game (*Halo, World of Warcraft, Resident Evil*, etc.) has innumerable offerings,
ranging from examples of game play (perhaps the most common type of video),
music videos set to characters from the game, machinimas (the focus of anoth-
er part of this book), commentaries/vlogs on different games, discussions of con-
troversies about the game in the mainstream media, technique videos (about
game play, strategy), gaming events (conferences, talks, parties, to name just
three) and of course mashups and parodies. Out of this sprawling culture, I chose
three videos (*Nintendo 64 Kid, Mario Kart Gaillard, Leeroy Jenkins*) that I sug-
gest are illustrative of video games as an important thematic in digital culture.

Nintendo 64 Kid signals the investment (emotional and fiscal) that video
games hold in contemporary adolescent life. The video features a young boy,
aged between six to eight years old, who is opening his gifts (the occasion is
unclear) and goes (literally) delirious with joy. He rips open the big box and
jumps up and down in disbelief, screaming with uncontrollable delight the
words that would gain him viral fame—"Nintendo 64, Nintendo 64." He takes
a brief break to survey his other presents but is clearly unimpressed and returns
to hugging and cradling his new Nintendo 64. His sister watches him with
amazement, joining him half-heartedly in his excitement, but clearly not with
her heart in it. I read this video as a text about the power of gaming as a cul-
tural technology. The kid represents the arrival of this technology as *the* dom-
inant mediated practice in the experience of childhood. The message is clear:
A willing disposition and complete surrender to the immersive wonder of
video game play. Needless to add, this is a reiterative process in digital culture.
Every six months (or shorter) there is a new media technology, game, platform

or add-on feature that becomes a "must have." This video crystallizes this process in a short-segmented narrative that speaks synecdochically to the entirety of gaming culture.

Mario Kart (Gaillard) is a video by French prankster Remi Gaillard, who is dressed as "Mario" and drives his cart through the streets of Montpellier, France, dodging between cars, throwing bananas under their wheels and in general mimicking the actions of the game character. The entire video is shot and edited to look like the narrative universe of the video game, with sounds, graphics and maneuvers that recall playing the game. The video's popularity speaks to a sense of shared pleasure that comes with a ready familiarity with the game (a fact reiterated through generations that play the game), with attendant memories (arcade games, Chuck E Cheese, skating rinks). It can be read as a text about origins—simultaneously personal and cultural—recalling a simpler time when games were about fun rather than bloody battles or complex strategy. This shared pleasure is then transferred to an unexpected realm, the real world. The comments on the video speak to this unusual disjunction, the joy of seeing the dull world of highways, red lights, and stop-go traffic transformed by a happily careening Mario Kart, jostling the bad-tempered drivers for space and throwing bananas for good measure. At the end of the video is a scene where Mario is interrogated by the local police—raising the prospect of his arrest—but there is a happy ending as Mario gets into his kart and races off.

Leeroy Jenkins is a video of *World of Warcraft* game play. It features a group of players detailing a battle plan. One of the players, Leeroy Jenkins, is away from his computer and on returning charges into battle using his name as a battle cry. In the ensuing skirmish all his fellow players are killed. Jenkins, who represents a real-world player, has become famous within the *World of Warcraft* universe, leading to his use as a character in its trading game and his own figurine and trademark. The battle cry has spread from the game to mainstream media with references made in *Jeopardy*, *South Park* and the film *Monsters, Inc.* along with numerous references in other video games.

Making sense of *Leeroy Jenkins* necessitates thinking through the liminal space the video/character occupies in the relationship between old and new media. Unlike *Nintendo 64 Kid* and *Mario Kart (Gaillard)*, where the referential world of gaming is kept separate and distinct, *Leeroy Jenkins* centers the actual act of in-game play as its defining characteristic. It is one of the few examples where an action in the virtual environment takes on the facticity and embeddings of a "real" action, and it is now increasingly read as a symbol for hasty action or poor leadership. Much like the "Charge of the Light Brigade" for a

generation raised on poetry, *Leeroy Jenkins* has become a phrase for the perils of inappropriate action. Perhaps most of all, *Leeroy Jenkins* represents the arrival of gaming as a form of meta culture, where its in-game actors have real consequences for characters and players and the language through which gaming itself is received in the wider culture.

I want to conclude with two other iconic videos that evoke common anxieties around gaming (*Angry German Kid* and *Scary Maze Pranks*). *Angry German Kid* is a video about a teenager trying to start up his computer and having a terrible temper tantrum in the process. It begins with him hitting his desk, followed by the keyboard, then sweeping things off his table as he tries to start the video game (*Unreal Tournament*). As the game refuses to load he starts to scream and rail obscenities at the computer and hits the keyboard with increasing ferocity until he is driven to near madness and smashes the keyboard. *Angry German Kid* has been an important text, with popular media discussion focusing on the effects of gaming. There are different "truths" about the video, claims about its fabricated nature counterposed with others that speak to its veracity. But more than anything else it is the sheer emotive power of the video that has made it iconic for a popular understanding of gaming culture, one dominated by discussions of violence, adolescent rage and the (supposedly) numbing, mind-altering nature of video game play.

Scary Maze Pranks features a young boy intensely playing a maze game on his computer. He occasionally mutters to himself but is generally a picture of focus and immersion. At the end of game, as he completes the maze, a scary face appears, accompanied by a scream. The boy is shocked and scared out of his wits—he hits the computer screen in fear and disbelief and then runs away, completely terrified. As he comes back into frame there are tears running down his face, and he is clearly angry at his parents over the prank. *Scary Maze Pranks* can be read, as its title suggests, as a new media version of a prank. The expected trajectories of reception remain much like any prank—laughter, ridicule, and personal discomfort for the person undergoing the prank—and we may assume satisfaction and amusement on the part of the people pulling off the prank (in this case, the parents, who are wielding the camera). The video's importance lies in its updating of the cultural practice of pranks as an element of digital culture and the role of the computer as a form of familial connectivity, even if it means scaring your kid silly.

· 1 1 ·

THE IDENTITY GAME

In this section, I examine a sample of videos that *directly* engage with "identity politics"—the complex of ways in which race, class, gender, and sexuality intersect. Unlike other videos discussed in this book, where such concerns are often woven through other narrative concerns, these videos provide evidence of how viral culture is undertaking concerns previously handled through television and film. These are a very small sample chosen in equal part for their iconic status and for their direct referencing of concerns of identity, representation and power. These include those of gender (*Lonelygirl 15*, *Miss Teen South Carolina Answers a Question*), sexuality (*What What (In the Butt)*, class (*Winnebago Man*, *The Average Homeboy*), race/class (*Bon Qui Qui at King Burger*, *La Sarah*, *Top 60 Ghetto Names*, etc.) and ethnicity (*Magibon*, *Bus Uncle*, etc.).

Lonelygirl 15 was a web-based series that ran from June 2006 to August 2008. Narrated as a video blog by an anonymous teenager (Bree), it achieved iconic status as an authentic narrative about loneliness and teenage angst. In September 2006, it was revealed to be a fictional account, played by an actress, which led to even more notoriety and the eventual development of the character into a fully fledged series with a number of storylines and supporting characters.

Lonelygirl 15 can be read as both a modern-day fable about fallibility and a lesson in digital performativity. The first step in thinking through its iconic status is the relationship between the character's name (Bree) and her status (lonely)—an elision that has become inseparable (in part by contextually recalling Bree from *Desperate Housewives* with its themes of isolation, boredom, sexual angst, and, of course loneliness) through the performance of the central character—*Lonelygirl 15*. The "girl" in question is a somewhat wan, clearly bored young woman who conveys that affect with distinctive movements—the hunched shoulders, the arched chin and her trademark gesture—a quick dimple. Her face is a study in pathos—with a hint of humor that suggests an awareness of her all-too-common predicament. Lonelygirl 15's eyes are the most arresting feature—large, dewy, and direct, they force her emotional state on the viewer and invite a specific mode of attention—sympathy. While *Lonelygirl 15* is not an overtly sexualized narrative, it invites attention—and this is her attraction. There is a sense of appeal that urges—through digital means—a response. In a real-life context this might be undertaken by entering her bedroom, sitting next to her, taking her in your arms, comforting her. That is not possible, of course, so the comments and sprawling participatory culture provides the next-best thing through viral identification, empathy and support.

Lonelygirl 15 also needs to be read for its mythology and place in digital culture. It represents the coming of age of participatory culture both in its whodunit phase, when the "actress" was outed, and subsequently in its reception as a text of fiction, where viewers made the all-important transfer from critic to consumer.

Two videos that are focused on "white" identity are Danny Blaze's *The Average Homeboy* and *Winnebago Man*. Both videos circulate within a class-centered narrative that eschews claims to exception or special treatment. Danny Blaze is a rapper who produced a demo tape in the late 1980s, which was rejected by the record labels. Over a decade later it was uploaded on YouTube and quickly went viral. Soon after, the video was featured on VH1 and *Best Week Ever*. Blaze has since released two albums. He also features in the work of another Internet phenomenon, the animated talk show, *Doogtoons*. *The Average Homeboy* sets out to separate himself from what he calls "mainstream" rap with Blaze introducing the video saying, "I'm just a middle-class guy trying to express myself." He presents himself as a new kind of rapper, one not poor or African American: "I'm not black. I don't do drugs and I'm not on crack. I don't live in a box and I wasn't raised on the street." At the heart of his persona is an explicit desire to mobilize white identity using the language of rap:

"What's the problem with a rapper who's white? We are all just fighting for our equal rights." He reiterates a Middle American politics, with a script tailor-made for white agency: "I have to work hard every day. My home is not located in Beverly Hills. I am struggling to pay my bills. I don't have a butler or a maid. My exterminator is a can of Raid." These lyrics are accompanied by a montage of Blaze wearing a business suit, which he then changes for rap-appropriate clothing (loose sweatshirts, cocked hat, etc.) and settings (polishing a car, sitting by the pool).

The Average Homeboy lends itself to an unproblematic reading—this is an account of perceived discrimination by the majority population grounded in the cultural politics of the time and finding a popular language (rap) where such concerns are historically grounded by the subaltern. As one of the comments on the video puts it, "it may be assumed that Blaze is one of those guys who is likely to say things like, why is there no white entertainment network?" While *The Average Homeboy* allows for such a reading, there is additional cultural work undertaken by this video—he is often received through a homoerotic lens, a reading anticipated by Blaze's shirtless appearance and sexually suggestive thrusts.

Winnebago Man is a YouTube phenomenon of a middle-class white man having a bad day at work as a spokesman for a Winnebago company. In the middle of a photo-shoot extolling the virtues of a Winnebago, he breaks down and completely loses it—flubbing his lines, gesticulating incorrectly, not finding the right posture. As he fails on each take, his frustration grows. Finally, he gets to a point where everything upsets him—a fly buzzing around, a door not opening properly, the camera incorrectly set up for the shot, and so on. The entire video is punctuated by loud, emphatic assertions of a single expletive—"fuck"—which is used over and over again, in tandem with his anger and frustration at his inability to deliver his dialogue. *Winnebago Man* is a meditation on a common experience—the boring, repetitive part of one's work life, which can drive a person to anger and frustration. Its subtext is self-evident—everyone has had just such a day, when nothing goes right and at any moment one could "lose" it completely. In addition to such a direct reading, I suggest we also read *Winnebago Man* as continuous with *The Average Homeboy*, as an enactment of whiteness—where the concerns of daily life (marginalization, frustration) find voice through their performative actions.

What What (In the Butt) is an iconic gay-themed viral video, sung and performed by dancer/singer Samwell, who has used the video as the launching pad for a career on stage and appearances on the BBC and other media outlets. *South*

Park remade the entire video in its episode, "Canada on Strike," with the character Butters performing the role of Samwell. The video was also an official selection at the Milwaukee Film Festival and the Mix British Film Festival. *What What (In the Butt)* begins with a flaming cross followed by a dance by Samwell, which is explicitly sexual in its style, content, and thematics, including, in one instance, images of anal insertion with the act "blacked out." Shot in an Austin Powers style with elaborate moves, clothes and steps, the video is marked by the simple, monotonic repetition of the song's title and its refrain ("I said what what in my butt, you wanna do it in my butt? Give it to me if you please in my butt. Give it to me if you please"). When it is not repeating the song's refrain it makes its sexual intent even more clear (if that's possible) with a specific request: "Just be gentle, I'm like a flower,"; "I will give you what you need. All I want is your seed." *What What (In the Butt)* can be read as a text about gay agency. Its reiteration of the act of anal insertion—at the heart of homophobic discourse—is placed square and center in the song, and using the power of reiteration it presents in direct unproblematic terms what is viscerally responded to by conservative communities in the United States. However, while it is appropriate to locate this text within the nexus of the culture wars in America, it bears pointing out that this is not a confrontational text—the dancing, the beaming face, the very persona of Samwell is relaxed, happy and in the moment. It is easy to both appreciate and be drawn to his erotic energy. There is also an element of invitation that perhaps speaks to the video's popularity. It offers for heterosexual viewers the erotic pleasure of male-male sex from afar and on one's own terms. Such a reading is borne out by the extensive comments on the video, which rather surprisingly are not full of hate-speak that typically accompanies gay-themed videos. I suggest that *What What (In the Butt)* speaks an unusual language—transgressive and accessible at the same time.

 Miss Teen South Carolina Answers a Question is an iconic YouTube video that serves as a study in identity politics, specifically the construct of the "dumb blonde"—stemming from her response to a question in the interview section of the contest. The woman in question, Caitlin Upton, was asked the following question: "Recent polls have shown a fifth of Americans can't locate the U.S. on a world map. Why do you think this is?" Her halting, convoluted and somewhat incoherent response quickly went viral. It bears full repetition:

> I personally believe that U.S. Americans are unable to do so, because uh, some people other there in our nation don't have maps and uh, I believe that our, uh, education, like such as, uh, South Africa and, uh, the Iraq, everywhere like such as, and, I

believe that they should, our education over here in the U.S. should help the U.S., uh, or, uh, should help South Africa and should help the Iraq and the Asian countries, so we will be able to build up our future, for our children.

The video led to both notoriety and fame. She appeared on a variety of outlets to explain her response (*The Today Show, Tosh.0, King of the Crown*), and a parody of her response was featured at the 2007 MTV Video Music Awards. Jimmy Kimmel's word-by-word analysis of her response stands out for its analytical—and comedic—vigor, pointing out grammatical ("everywhere like such as"), descriptive ("the Iraq") and paradigmatic ("Asian countries need help with their education?") errors in her response.

Questions of race are hard to pin down on YouTube. Unlike television programming on BET or African-American themed shows on the major networks, where race is placed in population and audience-specific formats, on YouTube, identity politics almost always plays suitor to the goals of entertainment. In other words, race is a sub-text rather than a dominant leitmotif. However, there are some videos where race is center stage, and I will discuss five such videos that all draw on the "ghetto" as an organizing frame for understanding race (*Top 60 Ghetto Names, Bon Qui Qui at King Burger, La Sarah, Leprechaun in Alabama,* and *Whistle Tips with Bubb Rubb and Lil' Sis*). I will discuss them collectively after a brief description for each of them.

Top 60 Ghetto Names features two teenage boys speaking/performing a list of "ghetto" names. They begin with relatively common names like "Latifah, Shaniqua, Latoya and Rohendra" before picking up sardonic pace with "Bon Qui Qui, Sha Na Nay, Tay Tay" and then rapidly proceeding to absurdity with a focus on stereotypical food/drinks ("Frichickenisha, Colladgreeniqua, Watermelondra, Koolandria, Cornbreesha"), media habits ("Cellularphoiniqua, KingKongquisha, Spongebobeeshia") politics ("Barackisha, Obamaniqua"), and free-floating referents to Africa ("Elephantisha, Africanishaniqua"). The video ends with some numbingly long names ("Lataniana Bo Vanashri Aniqualinquanice").

The next two videos are *Bon Qui Qui at King Burger* and *La Sarah*. The *Bon Qui Qui at King Burger* video is from a *Mad TV* show where an actress (Anjelah Johnson) plays a self-absorbed, highly irritable, and openly discriminatory African-American cashier from the "projects." The video opens with Bon Qui Qui on the phone, her back turned to a white customer. She is talking to a girlfriend about her boyfriend ("Gurl, Marcus was supposed to meet me and he didn't even show up. Gurl, I will cut him"). When she finally notices the customer, she tells her, "Welcome to King Burger, where we can do it your way, but

don't get crazy." When the customer wants a cookies and cream milkshake, she tells her to get a Coke because fixing a milkshake is too much work ("I gotta get the ice cream and put some cookies all up in it"). The next customer requests a burger without cheese, lettuce or tomato (which she immediately terms "complicated order") and then he changes his mind about having cheese. This upsets Bon Qui Qui who stridently tells the customer, "No huh, sir, do not get loud with me. Do not get loud with me" and then proceeds to call "suh-curi-ty" to escort the customer out. The next customer (a woman) asks for a "bone-less, skinless chicken that is slightly seasoned' and Bon Qui Qui immediately calls security and threatens her ("Gurl, I will cut you"). Luckily the Manager intervenes and mollifies the customer ("I am sorry, she is with our 'out-of-the-hood' program"). The video ends with a good-looking young black man enter-ing the store, who is greeted effusively by Bon Qui Qui who breaks into a rap as she takes his order: "On my mic is a queen, now listen to me sing, He wants a number three, super-sized onion rings. He can come out of the house with no ankle bracelet on, but he's got two strikes, so don't get his order wrong. I'm look-ing cute and there's nothing you can say, but if you get with me, we can do it your way."

La Sarah is a character performed by a white stand-up comic, Sarah Hyland (from MTV's *Punk'd*) who in the blink of an eye and a twitch of the lips trans-forms from a somewhat wan young white woman into a fast-talking, expletive-heavy black woman from the projects. There are a number of videos where she performs as the character of La Sarah, who among other things is highly sex-ual and prone to threatening people. In most of her monologues she cusses out an imaginary friend ("Latisha needs to shut the fuck up"), complains about her small breasts and buttocks ("am trying to put an ass on and up in this bitch") and having sex. She has a trademark line: "Poot poot, hoot, yeah! That's right, that's that's right." Many of her later videos show her pregnant, criticizing veg-etables, praising Crangrape and numerous other unrelated items.

I would like to suggest that all these videos mobilize an *identical* set of iden-tity constructions—the overly aggressive, highly voluble, and sexually available ghetto woman. I suggest we read all the videos as a rhetorical tactic that takes stereotypic images of a minority population and reworks them through come-dy, in ways that are permissible. Their popularity lies in the liminal space they occupy between affirmation of stereotypes and the pleasure that parody offers. The La Sarah videos can also be read as concurrent with the fantasy of being black. Each video begins with her talking in a "normal" voice (white middle-American) and then switching code to become La Sarah. Watching the

moment of transformation is revealing—the curling of the lip, the throwing back of the head, the jutting out of the jaw, all speak to a powerful discursive process being undertaken.

Leprechaun in Alabama and *Whistle Tips with Bubb Rubb and Lil' Sis* reiterate the comedic value of ghetto culture through their placement in the narrative frame of television news. Both stories are part of the local news format, largely driven by crime and weather but enlivened with the odd "human interest story." *Leprechaun in Alabama* is introduced by the news anchors (a white man and an African-American woman) and features a number of young black men (and one woman) talking of seeing a leprechaun. The story features a number of sound bites (in thick, sometimes incomprehensible accents) of eye-witness accounts of seeing a leprechaun and of search parties at night looking for the leprechaun, augmented by frequent loud whoops of excitement and talk of finding a pot of gold. The story ends with both anchors chuckling at the odd nature of the story and (presumably) the antics of its protagonists.

Whistle Tips with Bubb Rubb and Lil' Sis is focused on the story of a "ghetto" couple that has installed whistles in their car's exhaust pipes. The sound the car emits is loud, piercing, and can be heard a long way off. The story features white subjects who complain about the noise, while the exotically named couple speaks of the entertainment the sound provides them. Once again, what marks this story is the substantial differences in the sound bites, with Bubb Rubb and Lil' Sis speaking in thick accents and the white subjects in "normal" English.

Both videos I believe center stereotypical ideas about working-class African-Americans, evident in comments on the videos describing the characters as "dumb," "stupid," and "illiterate." The subtext in each case is hard to miss—what kind of people would believe in a leprechaun and get so excited about it? Why would you want this kind of infernal noise coming from your tailpipe?

I suggest we read these videos as part of a wider conversation about political correctness and race, especially the shark-infested waters around the N word. It is the absent present in these videos, implicit, implied and lurking just at the margins of how the videos can be read. On YouTube these videos appear alongside other videos where the N word is square and center, such as the video *Racist Rant by Michael Richards* (Kramer from *Seinfeld*). Richards was heckled while doing a comedy routine, and the angry exchange included a much-circulated comment about lynching from Richards ("Shut up, 50 years ago, we'd had you upside down with a fork up your ass").

Magibon is a famous Internet celebrity who is known for her short (typical-

ly one-minute-long) videos where she stares at the camera, mouths a few words in Japanese and then says "Bye, bye," with a peace sign. *Magibon* appears Japanese or generically Asian. The back-story on *Magibon* reveals that she is not Japanese and does not speak Japanese, but that has done little to slow down her popularity (both in the United States and Japan), which includes radio and TV appearances and a sponsored trip to Japan.

Magibon is one of the most intriguing texts on YouTube, raising fundamental questions about intention (why would someone want to do this?), effect (a sense of being watched rather than watching), and interpretation (what *is* she doing?). *Magibon* is a huge phenomenon, even by the Internet's standards. The video lends itself to knee-jerk criticism, the word "weird" being the word of choice in the comments section, along with implications of its voyeurism (for example, "I don't know what creeps me out more, the freaking little girl that looks like an anime character incarnate or the many pedophile psycho's that want her").

I suggest we read *Magibon* as a milestone in digital culture—the arrival of a "story" whose fundamental assumptions and narrative trajectories are still being developed. Is she a meta story about childhood, about the presentation of self, or is her story fundamentally interrogative, asking questions of her viewers (using her limpid, questioning eyes) and inviting a response? Having said that, *Magibon* is grounded in its gendered/ethnic certainties. Her impassive "Japanese" face invites erotic attention, encoded within a mask of cultural indeterminacy that allows for male expression and agency—*through* the act of viewership. *Magibon* represents in equal part sexual possibility and repression—an admixture that comes through in her (apparent) childish desire for play, especially in the carefully cultivated use of the body/face in unanticipated but pleasurable ways. She is unambiguously a text about authenticity and ethnicity, mobilizing Japan as a text through preexisting frames for the geisha, the submissive oriental, the exotic and so on.

However, there is more going on with the *Magibon* video. This is also a text about indeterminacy and ambiguity where each part of her face is a riddle. This is especially so with her lips, which remain tightly shut but appear to be on the verge of betraying something—a smile, a frown, a laugh, perhaps even an invitation, but nothing happens—in each case, there is twitching, on occasion even a parting of the lips, but they almost always close up, both physically and metaphorically, to the watching (viral) world. When they do open up, she utters her signature sign off ("Bye, Bye") accompanied by a peace sign. Finally, while her lips are an important part of her textuality, it is her eyes that dominate her

online presence—large, soft and dewy, they animate her story with unspoken themes—childlike innocence, uncertain desire and a come-hither sexuality.

Since "ethnicity" on YouTube is a sprawling enterprise, I conclude with a discussion of a specific trajectory: three videos (*Dog Poop Girl*, *Zhang Ya* and *Bus Uncle*) that interest the identity politics of being Asian with the emergent practice of Internet vigilantism. *Dog Poop Girl* features images of a dog pooping in a Seoul (South Korea) subway, *Zhang Ya* features an obscene rant by a Chinese girl against the victims of the Sichuan earthquake, and *Bus Uncle* features an angry tirade by an older Chinese man against another man sitting behind him.

All these videos can be read as occupying an increasingly crowded space between the viral and the real. This is especially true for the urban spaces of the Far East where connectivity levels are higher, the integration into daily lives more complete, and the relationship between the body and the city is bound through networks of public transportation and wireless networks. It is no accident that what has emerged from these multiple levels of intersection are narratives of connectivity and the implications of constant recording through personal media (such as cell phones) of public life and behavior. While it is appropriate to use terms like "cyber-snooping" or "citizen journalism" to describe these phenomena, it does not do justice to the cultural ramifications that such videos represent. I suggest that we see all these videos as constitutive of a viral liminality where actions take place simultaneously in the realms of the real and the virtual. I am not suggesting a temporal synchronicity here but a pedagogical one; they come into existence, become enacted, so to speak, as they are posted online. As time elapses, the synchronicity collapses in inverse relationship with the actual event. Blogs, commentaries, parodies, remixes and so forth spread the event, recalling the formative event in ever-decreasing levels of relevance. Mainstream media struggle to keep up, often forcing the event into its straight-jacketed categories of genres (typically talk shows, entertainment shows and television news). Such a theorization, of course, is not exclusive to these videos, it can be applied to most of the other phenoms under consideration in this chapter. What is specific about these videos is the cultural realm they resonate in—a realm characterizing the national cultures of China, South Korea and Japan, which offer a complex mix of technology and culture, sometimes dubbed "Zen Net," where patriarchy, Confucianism, colonialism, capitalism and communism have commingled in new and unpredictable ways.

SECTION TWO

OTHER GENRES

· 1 2 ·

THE SHORT

There is no longer any such thing as fiction or non fiction.
There's only Narrative.

—E.L. DOCTOROW

It's all storytelling.

—TOM BROKAW

Introduction

The Short as a genre on YouTube is a complex mix of narrative intentions and contradictions. To begin, the Short is simply what it suggests—a short film. These films follow many of the same structural and discursive trajectories of short films (especially those produced by students and for Short Film Festivals) but also offer new ways to organize storytelling. While short films are marked by a focus on characters rather than history, on intimacy rather than context, they are also characterized by a specific intention; they are *strategies of engagement* rather than just storytelling (Riis, 1998, 1). "Short film acts as a form of currency in an economy of exchange—an exchange of influence and support, of kudos and opportunity (Yeatman, 1998, 1).

Short films have received little or no attention in the field of Film Studies, which has been focused on the feature film (either mainstream or alternative)

as the primary object of its analysis. I suggest that we locate the short film as a key text in the world of digital culture (such as YouTube), mirroring a wider transition from a modernist to a postmodernist form of storytelling. Let me briefly sketch some of the important issues involved in such a transition. The modernism/postmodernism divide in the arena of film resolves around issues of textual uniformity (the Hollywood model for making films), ideological conformity (it must appeal to the largest audience) and production values (high end versus low end) (Hill, 1998). The short film, when produced by big budget production companies (such as the celebrated Pixar shorts) reiterates modernist concerns (narrative, linearity and generalized appeal) even as it may take on postmodern values of play and, on occasion, critique. YouTube needs to be placed within this tension between modernist and postmodernist modes of production. Since there are few theoretically informed accounts of short film storytelling formats—Raskin (1998) for example, outlines five parameters for story design in short film (causality/closure; continuity/surprise; image/sound; character/object—this chapter is an agenda-setting exercise. In what follows, I will suggest there are four broad narrative concerns around short film storytelling on YouTube—along with examples for each of them.

The first is the (re)assertion of a modernist imperative. Here the short film follows the conventions of formal storytelling reflected in both feature film and television. Typically these include those of posing a narrative question and answering it, following the format of complication/resolution, and the establishment of a distinct narrative arc. Audiences readily grasp and understand the context, scope and intention of the story and its presumed message. I discuss the short films, *Black Button*, *My Name is Lisa* and *The Landlord* as examples of such a modernist imperative.

The second is the development of an intertextual language through short film. To illustrate, the online series *Chad Vader* is focused on the life of a store clerk with illusions of living in the *Star Wars* universe. *The Potter Puppet Pals* series works in a similar fashion, except that it works in the world of *Harry Potter* (in its book and film versions). Both series exemplify interesting trajectories; they are both directly referential (to the universe that each mainstream series represents) but also interjective—reworking the terms and contexts of the original series to ask a range of questions that speak to original intent and transgressive reception. It is not enough to only see these as fan fiction—which they of course are—it is equally important to see them as the development of an alternate language around mainstream mass culture.

The third is the creation of what I term generative storytelling, which

reflects the development of a hybrid, postmodern language for the telling of stories. Almost bottomless in their intertextual referents, these stories develop original content—the creation of a "new" story and universe of characters—and a viral inter-referentiality that assumes prior knowledge of, and watching of, similar videos from both online and mainstream media. I examine three such stories—*Charlie the Unicorn* (featuring a gullible unicorn called Charlie who loses his kidney in the first adventure), and the online series *Doogtoons* and *Ask a Ninja*. To give a sense of their complexity, *Ask a Ninja* is an inventive mix of scenes inspired by specific films, comedy routines, slapstick, thriller-style dialogue, over-the-top humor, and the stylized violence of Ninja narratives. However, it is important to note that what is at work is not only bricolage but also invention—these videos are attempts by a new medium to negotiate the terms and categories of storytelling.

Finally, what can be termed *narrative liminality*. Here the focus of the storytelling is on working in the cracks between traditional genre conventions and reaching out through experimentation and paradigmatic recasting of what were earlier seen as cast-iron narrative categories. I discuss three such examples—*Red vs. Blue*, *Trapped in an Elevator*, and the videos of Liam Kyle Sullivan (*Shoes, Txt Msg Brkup*). *Red vs. Blue* is an online series made using gaming software but with entirely new storylines. It does not presume prior knowledge of the game nor does it assume thematic or stylistic convergence with the game. Rather what emerges is a new language, what is now termed "machinimas." *Trapped in an Elevator* is a short film about exactly that (being trapped in an elevator), except that it's based on the actual footage of a person trapped in an elevator. Like reality television, it uses (and reworks) ideas about the "real" and its manufacturing of lived experience. Finally, the music videos of Liam Sullivan are explicitly transgressive of genre—they have a story arc reminiscent of traditional short films but work within the traditions of postmodern cinema. In each of these cases they represent a discursive movement, a shared liminality as to the forms and features of a short "film."

Examples

Black Button is a short film made by Dark Heart Productions, a company run by two friends in Australia who devised the concept on a train ride when they asked each other to come up with situations where a person might be faced with impossible decisions. They settled on the following concept: What would you do if you were given the choice of killing someone by pressing a black button

and in return were paid a million dollars? The film begins with a quote from 1 Corinthians 10:13: "God will not suffer you to be tempted above that you are able…but will with the temptation also make a way to escape." A young man sits in a chair facing an older (male) authority figure behind a big, decorative desk. A stand holds a black button prominently in front of the young man, who is asked to choose between one million dollars and the death of someone. The back story (and the narrative's rising action) is filled through the conversation—the young man has debts, problems sleeping and other common ills of modern life. He is given a choice: Push the button, kill someone, and get one million dollars, or get up from his chair, pick up a key lying on the table and open the door behind him and leave.

The older man makes a strong persuasive argument for the younger man to push the button (mercy is for the weak, survival is the most important thing, morality is a waste of time). As he vacillates between his choices, the older man shouts at him to "push the button." The young man finally gives in, gets up and pushes the button. Once he pushes the button, the older man gives him a suitcase filled with cash, but then tells him, "unfortunately you are already dead." The choice that he was making, the older man tells him, was between heaven and hell, between salvation and eternal damnation. "You had the key," he is told, "and you made the wrong choice." The old man says he is "God's filter" making sure people are worthy enough to go to heaven. The young man learns he has been killed in a car accident, and when he touches his face, bloods starts to pour out from where his skull was fractured. As he begins to die, he pleads and asks, "Tell me who did I kill?" The older man shrugs and says that should not be his concern. The film ends with him getting ready to receive the victim of the young man's choice when he pushed the black button.

Black Button was one of the finalists for YouTube's Best Short Film for 2007, its appeal lying in its subject matter (religious redemption, human morality) and in its effective storytelling. The film uses a mix of close-ups, mid-shots and two-shots to keep the emotional register of the narrative intimate—the tension lies in the quick pacing of the enigma posed at the outset—would you kill for money? The acting is superior, especially the nuanced and assured performance of the older man (they are father and son in real life, as behind-the-scenes interviews reveal), but it is the mis-en-scène that stands out in this film—the room the film is shot in is (almost) entirely white (background, clothes) with brightly lit surfaces. It evokes its archetype—the famous scene in *The Matrix* where Neo and Morpheus first meet and Neo is asked to choose between two pills, one of which will allow him to see the Matrix (and deter-

mine the rest of his life). This inter-textual reference notwithstanding, this is a thoughtful, broadly humanistic narrative that reworks the theological certainties behind religious doctrine into the language of modern life.

Viewer comments were uniformly effusive (the terms "awesome" and "amazing" the most commonly used), with the bulk of the comments focusing on acting, story thematics and resolution, especially the twist ending. Two other strands in the discussion were especially noteworthy.

The first was the reflexive engagement of this video with the wider history of storytelling on YouTube, with a number of comments taking pride that such a video was appearing on YouTube (for example, "I am impressed that something like this would be on YouTube, powerful stuff," "raises the intellectual bar of Utube! Thanks!," "seems like if its not a little kid getting kicked in the head, YouTube users wont watch it, but this deserves mad props" and "better than Hollywood movie I've seen all year"). Such a reflexive engagement also emerges in postings by the producers, who say the film was turned down by a Short Film Festival, citing similarities of the film to a *Twilight Zone* episode called "Button Button" and a new film called *The Box*. Nevertheless, the importance of *Black Button* lies in the fact that it signals the language of critical judgment and institutional accountability within film narratives on YouTube.

The second strand in the discussion was the repeated mobilization of the religious/Christian context of the film, with often-heated debates about the nature of Christianity, the differences between God and Satan, the nature of punishment and redemption in the Christian tradition, and some good old-fashioned pillorying between atheists and Christians. More than the scope and content of the comments was the reworking of the religious into what, I suggest, is the broadly humanistic map of human choices that the film offers—the importance of the self (and selfishness), the necessity of making choices (and learning from them) and of the centrality of a moral code in one's life. In all of these ways, *Black Button* functions within the same discursive frame as the film *The Matrix* or traditional Sci-Fi shows like *Star Trek*—and in doing so, enlarges traditionally religious questions within a wider, humanistic framework.

My Name Is Lisa is a "classic" short film—classic in its adherence to cinematographic standards both visually and in its storyline. Made by brothers Josh and Ben Shelton, it won the 2007 Short Film YouTube award. It is a tightly crafted narrative, especially in its use of sparse, everyday spaces (living rooms, driveways, doorways), with a recurring piano motif that keeps pace with the

inner psychological space of an adolescent girl dealing with her mother's onset of Alzheimer's. Shot composition shows a mature understanding of the power of (repeated) juxtaposition, using three visual elements: a medium/wide shot of Lisa walking home from school; shots of her mother's car left in the driveway; and a two-shot of Lisa (with her mother in the background) speaking into the web cam.

These three narrative elements are repeatedly layered together in ever-increasing levels of poignancy—reflecting a range of emotions that comes with an understanding of the effects of Alzheimer's—irritation, incredulity, anger, and, ultimately, acceptance. The dialogue in the film revolves around the minutiae of daily life as the mother repeatedly makes lunch for Lisa, forgets her keys, piles laundry atop the car, stacks plates near the computer, and gazes emptily into the web cam. Lisa's transformation is made evident through the presentation of the self (before the camera eyes) speaking animatedly (at the beginning) about the relative value of film versus a novel; Tolkien versus J.K. Rowling; Middle Earth versus Hogwarts. Perhaps most memorably, she vehemently says, "I demand an explanation of these shenanigans!" (Which elicited a number of on-line comments and even a video response).

In the middle of the film, a long medium shot of Lisa gazing at the camera, rubbing her nose and almost tearing up is a powerful statement about the loss of her childhood, without any words being used. In the end, both mother and child sit facing the web cam, as Lisa reads a passage from a book. The film's narrative is characterized by a series of rising actions, culminating in the climax, which is focused on the act of naming, of coming to terms with oneself: Lisa returns home from school to find her mother outside the house, looking lost and a little crazy. When Lisa asks her to go inside, her mother flares up and asks, "Who are you?" Lisa very simply answers: "My name is Lisa." This moment of un-recognition by the mother and recognition of herself by Lisa is marked by the visual intimacy of the shot composition. Lisa looks startled by the question, her face (in close-up) is crossed by both pain and awareness, and then resolved by the tight but poised certainty as she understands the completeness of her situation—the loss of her mother and simultaneously, a sense of her own arrival at a point that she may not have wanted but now accepts.

Viewer comments were overwhelmingly positive, speaking to the film's touching, serious and poignant tone, but equally to its effective storytelling. Considerable focus went to the film's use of intertextual elements—the Harry Potter books, the use of the word "shenanigans," the relative value of books over films, and so forth. Perhaps most importantly (in terms of textual elements) was

the persona/construct of Lisa, the young girl. Her acting abilities, her web cam musings, her nuanced performance, were all reflexively engaged with as key elements of successful storytelling, enabling this video to win awards on YouTube. At the heart of this success was the emotive imprint of the film. Numerous comments said this film made them cry (some examples—"I cried…and I'm not one to cry often. Very moving," "Ok, you guys got me. You made me shed a tear at 8am," "I was in tears the whole time").

Outside of storytelling, two points of reception are especially worth pointing out in judging the critical value of this short film. Firstly, the *commonness* of this experience was extensively discussed—viewers had aunts, mothers, and grandmothers all suffering from different stages of Alzheimer's (some representative comments: "Yeah…Alzheimer's sucks. Most of my family has it. It gets harder and harder to deal with as time goes by," and "Wow, I was really moved. I took care of my grandmother while she went through the different stages of Alzheimer's. Near the end I remember her kicking me out of the house on a daily basis because she did not know who I was. You portrayed this very effectively. My grandmother also tried to pay someone with a photo too. Great job").

Secondly, the film's function as a PSA (Public Service Announcement) came up a lot in comments. There are repeated exchanges between viewers who did not understand the thematics of the film until they were told what was causing the mother to be forgetful and aggressive towards her daughter. This prosocial element is perhaps the last thing that most people expect with YouTube videos, but it is square and center in this film.

The Landlord is a comedic short starring Will Ferrell and his two-year-old daughter Pearl as the landlord. The film begins with Ferrell hanging out with a friend, when there is a knock on the door. Ferrell tells his friend that it is probably the landlord, who they agree is very scary. Ferrell opens the door and there is two-year-old Pearl standing unsteadily on her feet, but ready to square off with Ferrell, who starts to explain that his rent is late. She interrupts him with a scream, "You pay rent now." A delirious exchange ensues with Ferrell imploring her with his story ("I'm working two jobs" "Why do you need it now?" "Can you give me two weeks?"), which falls on deaf ears as Pearl keeps demanding her rent (in between frequent renditions of the word "Bitch") and telling Ferrell "I have to get my drink on." Ferrell tells Pearl that she is an alcoholic and that she has to calm down. The film ends with Pearl leaving, muttering "I have three beers" and "I take my beers."

The Landlord is hugely popular and can be read as a text (simultaneously) about absurdity and celebrity. Pearl's acting and delivery are at the heart of the

video's appeal—she manages to retain a child's cherubic charm, even as she
takes on the persona of a highly irascible and unstable adult, veering between
bouts of anger and beer. Of course, Ferrell is central to the narrative as well. His
iconic place in modern American comedy is the perfect foil for Pearl—and his
rendition of the hapless, overworked and harassed middle-class American is spot
on. There is an element of staging at work as well that plays into the popular-
ity of the film—it begs questions about effect—is this what Ferrell is teaching
his daughter? Does she usually talk like this? and so forth. Ferrell has respond-
ed to many of these questions subsequently, even going so far as to make a video
where the character of Pearl is formally retired. *The Landlord* is an unusual video
in that it parlays through comedy a wider conversation about childhood, where
the terms of the parental contract are reworked in ways that animate the post-
modern moment—the taking on of adult roles increasingly by children, even
as adults seek ever younger versions of themselves.

The *Chad Vader: Day Shift Manger* video and its subsequent development
into a series is one of the earliest and most successful examples of what is often
termed fan fiction or fandom narratives. Inspired by the George Lucas *Star
Wars* series, it stars the less-famous brother of Darth Vader, Chad, who is the day
shift manager in a grocery store (Empire Stores). The video was created by Aaron
Yonda and Matt Sloan, two young filmmakers in Madison, Wisconsin, who went
on to create two full seasons of the series, and, most recently, a series of Empire
Market training videos starring Chad Vader. The series is now available via
DVD, Atom Films, and on the creators' website: www.blamesociety.net. The
original *Chad Vader* video won the top prize in the 2007 Official Star Wars Fan
Film Awards, where George Lucas himself chose the video as the best fan fic-
tion of the year. The video is a staple of many MySpace pages, has appeared in
an episode of *Good Morning America*, and the character of Chad Vader has
become part of the intertextual universe of digital media, including being on the
cover of *Isthmus* magazine and featuring as a bit-player in various video games.[1]

Equally important to understanding *Chad Vader* are the specifics of its nar-
rative structure, marked, I would suggest, by sheer inventiveness and a complete
sense of fun. It is a video, simply put, about the absurdity of suburban lives—
focused on the minutiae of working in grocery store—stocking shelves, clean-
ing counters, ringing-up customers' purchases, mopping the floors, fighting for
the best shift (the day shift) and dealing with off-kilter employees trying des-
perately—and comically—to find meaning in a meaningless workplace. *Chad
Vader* coalesces a commonly felt suburban need—to be somebody, to become
somebody, to live elsewhere in the imagination even as the hands are busy work-

ing with the task of the moment. *Chad Vader*, the younger brother of the famous Sith, dresses like him and speaks (uncannily) like Darth, walking the aisles of the Empire Market, hissing in anger at employees who are not stocking shelves as quickly as they should be, dealing with stubborn, rude or truculent workers with a mixture of superhuman power and technical wizardry. He fails in almost everything he attempts, is tripped-up by a casually thrown banana peel just as he is about to unleash his lightsaber on his competition (the night shift manager), and tries unsuccessfully to date a fellow employee. It is, I would suggest, a parable about the state of postindustrial life, where even supernatural powers succumb to the grind of life at the bottom of the corporate ladder. It is a terrain mined (minus the supernatural elements) by films such as *Clerks* and on television by shows like *The Office*.

Viewer comments reiterate themes about the pleasures of fan culture, with the most common comments being about how much they enjoyed the overall concept and video ("*Chad Vader* rules" "hahahahaahah" "freaking awesome"). They zero in on the specifics of the performance of Chad Vader, focusing on how "real" his voice sounded ("that's the best Vader sound I've heard" "absolutely best James Earl Jones impression; "wow, the voice of Vader was flawless"). Recent comments also refer to the fact that Aaron Yonda, who provided the voice of Chad Vader, has been asked to voice Vader in some of the official video games of the *Star Wars* franchise, a singular example of the increasingly two-way connections between user-generated media and old media companies. Viewers especially focused in on three specific lines by Chad Vader in the video, the first where he refers to the store supervisor (Randy) as "Emperor," the second, a song that Vader hums to himself after asking one of the woman clerks for a date ("Chad has a date. I have a date") and the third when he tells a worker that he has plans for a "laser checkout system." In each case, viewers focused in on the absurdity, humor and sheer inanity of working in a supermarket. One comment is especially worth noting: "I loved this video like you have no idea. On a crazy side note, I am sitting here wearing my uniform and I work at a grocery store"). While there was overall agreement with the narrative premise and development of the story, there was one point where viewers sharply argued with the film—the fact that Chad Vader slipped on a banana, something that one could surmise no real Sith Lord would do ("I was laughing all the way up until the banana slip" "I didn't like the lesser vader being pwned by some schmuck with a banana peel"). Finally, a note about the reflexive nature of participatory culture—after almost every comment about the video, was a plea—make more ("More, more, more please" "I demand a sequel and a prequel"

"there'd best be more of this coming. Rock on"). Clearly Yonda and Sloan listened, and made more, fuelling interest in the entire series and their website and, of course, in their own careers as on-line auteurs.

Charlie the Unicorn is a short film that tells the story of a gray unicorn, who is sleeping under a tree in a green meadow when two other unicorns (purple and pink) appear and cajole him to go on an adventure to "candy mountain." Charlie is very reluctant, but after the pink unicorn jumps up and down on him, he agrees to go. The purple and pink unicorns croon his name and other melodies on the journey. They meet a magical leopluridon en route who tells them the way (or so the purple and pink unicorn claim). They eventually arrive at the candy mountain where they are greeted by a dancing bug. Badgered by the pink and purple unicorns to enter the mountain, Charlie finally agrees. As he enters the cave opening, the doors close behind him, as the other unicorns say, "Bye Charlie." The film ends with Charlie lying on his side, outside the mountain cave, with a red gash on his side, as he exclaims, "They took my freakin' kidney."

Charlie the Unicorn can be read as a fable about vulnerability, fallibility and the inescapability of desire. It appears to be clearly influenced by the open-ended, intertextual and disjunctive style of *Monty Python*, especially its attention to apparently arbitrary narrative elements. These include three (interrelated) catchphrases, which have anchored the video's popularity. They are "Charlie" (repeated and elongated in a high nasal tone) "candy mountain," "bridge," and perhaps most importantly, "shun the non believer." The narrative arc of the short film is based on Charlie's identity as a stable, rational, male, modern subject who is skeptical of the other unicorns' plans to visit candy mountain (let alone believe in such a thing), and his eventual succumbing to the infantile insistence of the other unicorns. The video suggests a reading of the other unicorns as both gendered and sexualized (the colors purple and blue, the high-pitched voices), working as perpetuators of a fraud, where through childlike guile, make-believe, and a commitment to their mission, they bring Charlie to the candy mountain where he is (presumably) drugged and then his kidney removed. I read the video primarily as a text about patriarchal desires and choices, where the male subject remains a voice of reason in a world filled with candy and compromise. Read as a fable, the lessons are clear: stay away from the absurd, the unbelievable (and the feminine/gay) or pay the price (a very personal one in the case of Charlie).

The comments to the video suggest that this underlying tension between the modern/postmodern and its gendered/sexualized manifestation is what

gives it popularity. Numerous comments use the term "gay" to both describe the video as irrelevant ("How is this gay video so popular? It's so annoying"; "This is the gayest videos ever") and as a label for the unicorn's identity ("So if I make a video with queers going Charlie for eight minutes, will I become Popular?"). At the heart of this tension is the video's popularity (for example, "Wow, forty million views. This is the most retarded vid ever. How does it have this many views?") and its narrative construction (its disjunctive quality). The choice of words to describe this for most viewers included "weird" and "creepy" (For example, "This is creepy lolz"; "The voices are so creepy, so weird"; "This totally freaked me out"; "Its so weird, it made me uncomfortable"). Embedded in such critiques is the repeated use of "drugs" as an explanatory framework for the video's narrative. To illustrate, "I think the unicorns smoke weed" ; "They sound like they are on coke and weed at the same time, lol, coke for the high voice and weed for the slow voice, lol, lol" ;"Man, you have to be on drugs to have made that.") In sum, the comments tie in two separate realms, sexuality/gender and drug use, in their efforts at explaining the video's popularity, and in doing so, offer a commentary on how viral content that may not have direct themes about gender or sexuality becomes mobilized as the site for the playing out of these wider social tensions.

In addition to these dominant themes, the video's popularity can be traced to the popularity of its catchphrases (see above). These catchphrases, especially "Charlie" and "shun the unbelievers" have become Internet memes in themselves. Numerous comments on the video are chains of the word repeatedly typed in. The phrases appear on merchandise sold on the film makers' website and appear to be selling well (for example, one comment said "I got a belt from the website that has the unicorn on it and says shun the unbeliever"). It is worth spending a little time on the relevance of these catchphrases. "Charlie" repeated throughout the film, often in extended nasal tones, can be read as a modern day siren call, both cajoling and simpering, to convince Charlie to go on the adventure and, in the end, to enter the candy mountain cave. "Shun the unbeliever" can be read as the conundrum that Charlie finds himself in, teetering between the needs of the modern subject to be left alone, and the needs of sociability, to be loved, wanted and part of the story. It is perhaps accidental, but nevertheless revealing, that the language of religion is invoked in prying Charlie out of his sloth and male indifference. Finally, the term "candy mountain" has a rich, intertextual history with songs on the subject (and one featured in the video itself), the fairytale of Hansel and Gretel, and numerous films. The use of this trope may or may not have biblical beginnings (the

apple handed by Eve to Adam) but certainly can be acknowledged as an important intertextual reference to the story.

Since video games are a key element of contemporary digital culture, it is no surprise that clips from video games, promotional material for video games, and a range of fan-produced content litter the texts of YouTube. These videos span an impressive range: first-person shooter games, role-playing games, fandom-based texts and others in related areas—animation, flash fiction, and anime (especially Manga). Of all these, perhaps the single most innovative is the emergent genre of what has come to be called "Machinima." The term Machinima is a combination of two words, "Machine" and "Cinema" with the extra "i" referring to Anime. Machinima is a narrative form developed through the use of gaming animation software like that of the popular *Halo* series. It refers to a range of production techniques that uses CGI (Character Generated Images) in a video game to edit together a narrative, using original imagery but new storylines and dialogue. More specifically, Machinima productions use the tools existing in the game such as demo recording, camera angles, level editing, and scrip editing, and resources such backgrounds, levels, characters, and skins to tell a new story. Generally seen as an example of what is called "emergent game play," where the creation of new, altered narratives from the original game is part of the narrative intent, Machinima is characterized by the desire to create an entirely new narrative. Perhaps most crucially, Machinima takes the role of "cinema" seriously, focusing not on killing or violence but on issues of character development and psycho-social conditions and contexts. Machinima is by far the most "digital" of genres—emerging from the nexus of gaming and anime sub-cultures to address what is often seen as the most problematic aspects of video games—their lack of narrative depth—where the sole intent seems to be to kill and then kill some more.

YouTube has Machinima from a variety of video game sources, but according to most industry estimates the most popular Machinima are from the *Halo* series, the *Grand Theft Auto* series, *Quake*, *World of Warcraft*, and *Call of Duty 4: Modern Warfare*. I focused on an iconic Machinima series called *Red vs. Blue*, developed from the *Halo* video game series. *Red vs. Blue* is a Machinima comic science-fiction series that chronicles the story of two teams of soldiers that are in a standoff state in a canyon called Blood Gulch.

The episodes of *Red vs. Blue* are not focused on violence but on the quirky, eccentric and often thoughtful musings of the soldiers and their life dealing with each other and the canyon they have to fight in. It is often read as a parody of

first-person shooter games (which are focused, naturally on the shooting aspect of gaming) and more generally on the regimented nature of military life. It also parodies the philosophical tone of some science fiction films, with their themes of destiny, morality and the future of humanity. *Red vs. Blue* is credited—often single-handedly—for breaking Machinima out of the gaming culture and into mass media consciousness. Critics have praised the series for its narrative and thematic focus. Darren Waters of BBC News Online called it "riotously funny" and "reminiscent of the anarchic energy of *South Park*." I watched numerous episodes of the first season of the series and will briefly outline the very first episode as an introduction for readers to get a preliminary understanding of the genre.

The first episode begins with two soldiers from team Red standing at the bottom of the gulch, talking about the futility of what they are doing and the ontological question of their existence. It is a searingly comic exchange about the meaning of life, the nature of God, and similar topics. The scene then cuts to the Blue team standing high in the canyon looking at the Red soldiers, with the two Blue soldiers getting on each other's nerves talking about what the Red soldiers are talking about—one of them snaps at the other: "They are doing what they were doing five minutes ago—talking." The scene cuts back to the Red team, as their superior officer comes to see what they are up to. He pokes fun at them, calls them "ladies," and then shows them their new vehicle—a car, which he nicknames "Warthog." When one of the Red soldiers suggests an alternate name, "Puma," he is ridiculed and told there is no such animal. In an extended exchange, the officer pokes fun at the soldier and jokingly asks his partner to kill him if needed. The scene cuts to the Blue team, which has watched the arrival of the new car, and they discuss it saying it "looks like a Puma." The episode ends with the arrival of a new recruit to the Red team, and his inane conversation with both the soldiers about his appearance and responsibilities.

What stands out in this first episode is the absurdist nature of the exchange. It presumes a range of gaming knowledge—references to different aspects of the storyline and game play of *Halo*; the experience of gaming itself, with its focus on acquiring targets and gaining kills over understanding/playing story-line. I kept waiting for *some* kind of action to start in the Machinima—for one of the Blue team to lose patience watching the Red team and just shoot them down (or something less drastic). Rather, the entire first episode of *Red vs. Blue* can be read as a critique of such a narrative premise. Machinima clearly presents a reflexive, post-modern, and critical engagement with gaming narrative.

However, the genre raises the question of whether it would survive without the over- determined discourses of gaming. This is certainly an important point of departure for any fully developed engagement of Machinima as a genre, specifically, and as a site for the relevance of gaming narratives, more generally.

Liam Kyle Sullivan's videos are usually categorized as music videos, but I want to discuss two of his best-known examples—*Shoes* and *Txt Msg Brkup*—and suggest that this work represents an auterial signature that uses the short film as its determining frame (rather than the music video) and which uses an unusual congress of narrative elements, including, most notably, a drag style performativity married to an etiology of consumption, in its most intimate manifestations. Sullivan plays a young woman (Kelly) in the videos—an irreverent mix of Madonna and Ugly Betty who lives with her deeply conservative family, complete with repressed sexual desires and crazy right-wing politics. Her father sits posed next to images of George Bush and Dick Cheney, while her mother can barely keep her boredom (and lack of sexual life) in place. Their favorite child, a nervous, bland young man, and an alcoholic grandmother complete the picture.

Shoes is about Kelly getting what she wants—which it turns out is "shoes"— lots of them. It begins with her brother getting a car for Christmas while she gets a stuffed animal. She stomps out of the home and begins her shoe shopping tour de force accompanied by other shoppers/voyeurs of shoes. They stride through stores and displays deciding which shoes "suck" and which are worth acquiring, even if they cost $300. On occasion, Kelly uses her newly acquired shoes to stomp on people (recalling a theme used in the classic song "These Boots Are Made for Walking," with its unforgettable punch line, "These boots are made for walking, and that's just what they'll do, one of these days these boots are gonna walk all over you…are you ready boots? Start walking"). Towards the end of the video a policeman accosts Kelly and the large stuffed animal attacks the policeman.

Shoes is an over-determined text. Shoes, naturalized as a woman's object, are mobilized as an engine of personal agency—the power of video lies precisely in its power of re-inscription, affirming the terms of the contract between object and identity that shoes represent for women. But more than such a re-inscription is the hyperkinetic energy of the video—drawing on the feminist agency of songs like "These Boots Are Made for Walking," but rendering it a frenetic energy that sweeps us along, pulling the viewer into the paradoxical pleasures of consumption and agency, all rolled into one. Simply put, this is retail therapy with a punch.

Txt Msg Brkup tells the story of Kelly's boyfriend of two years breaking up with her by sending her a misspelled text message about his decision. In the scenes that follow the ex-boyfriend is roundly insulted, criticized, and sometimes assaulted by a range of dancers/singers (across race, gender and age). The central theme of the video is the sheer audacity—and sheer stupidity—of the original act, the "texting" of a decision that should be made in person, with a full complement of sensitivity, understanding, and personal responsibility. Instead it was undertaken in an off-hand, poorly thought-out, and even more poorly articulated (the misspelling) act. It is clear that such an act calls for scorn—which the video piles on in unrelenting fashion, with withering intent showcasing people with expressions of disbelief and anger, sarcasm and disgust. This is a post-modern narrative if ever there was one—it assumes prior knowledge of texting culture, netiquette, numerous popular culture referents, and, of course, the character of "Kelly" from previous videos.

A concluding note—Sullivan's work is a testament to what can be termed "fashion politics," working across a range of totemic symbols—shoes, socks, hairdos, wigs, earrings, skirts, tattoos—and "lifestyles" that go under labels like "townie," "grunge," "alternative," and so forth. These symbols are used to mobilize the defining feature of both videos—its parody of the come-hither sexuality that is common to music videos. Kelly's studied nonchalance is betrayed through her actions. This active marriage of fashion and personal agency is an answer to her predicament: Breaking out of the repressed box that is her home.

Trapped in an Elevator is technically not a short film but rather a documentary on the subject of being trapped in an elevator for 41 hours. The video uses footage from two elevators (one working, one stuck) and edits together a narrative about the ordeal that the office worker in question, Nathan White, underwent. News accounts and comments on YouTube fill in the back story. White went outside the building to take a cigarette break at the end of the day. He took the elevator up to wrap up his work and collect his things when the elevator abruptly stopped. What ensued is every elevator rider's nightmare—being stuck in the closed, oppressive space. The video is set to a deep piano motif and features a split screen, with the video from car 29 (which stays operational) counter-posed with the video from car 30 (where White is trapped) playing in fast-forward. The narrative takes us through each stage of his journey—despair (hitting buttons, shouting frantically), anger (trying to break out, climbing to the top of the elevator) futility (repeatedly opening the elevator door to reveal a brick wall), boredom (reading a dollar bill, examining a ticket to a sports game, arranging pieces of paper over and over again), and

exhaustion (sleeping in a variety of poses—curled up, spread-eagled, lying diagonally and everything in-between). The video from car 30 ends (abruptly) with the elevator moving, the doors opening, White stepping out, and somebody putting an "out of service" sign in front of the door. Counter-posed with this narrative is the video from car 29, which is an ode to normalcy. People come and go, it goes dark for long stretches (presumably the lights inside have a sensor), security officials ride in and out, completely oblivious to the drama next door.

Trapped in an Elevator can be read as a paean to the fear of the everyday—in our appliances, our homes, and offices, and in the daily grind of life. The moral is unambiguous: In an instant, things can come undone. A simple act of necessity (taking an elevator) can turn into a nightmare, the stage set for the playing out of our innermost fears. What makes *Trapped in an Elevator* such a powerful story is the universalism it assumes—this could happen to anybody. It speaks to something primordial in the urban being—a fear of being trapped, a space where breath is rationed and acts of constant communication erased (cell phones typically don't work in elevator shafts), a space where life itself is questioned. Such a reading is borne out by the video's popularity and its viral culture, which calls into question the cost of convenience and the quotient of chance in our daily encounters with the technology that surround us.

Ask a Ninja is one of the most iconic web series ever developed. It features a Ninja answering questions from viewers on a staggering range of topics—from personal help to food choices to the best way to kill a pirate. Rather than focus on any one episode, I want to focus on the figure of the Ninja himself and suggest that he represents a kind of celebrity grounded in digital culture. The series is a testament to the power of the Internet to organize and create a complex subculture that spans fan videos, remakes and parodies (of parodies). Perhaps, most centrally, it is the premise of the show (emailing questions) that centers this web series as an exemplar of participatory culture. Driven by narrative enigmas posed by his viewers, the show moves effortlessly between comedy and parody, action and commentary, and most of all between creator and user. At the heart of the show's success is the Ninja himself. The Ninja is successful because he embodies the dualisms that underlie the show—simultaneously serious and playful; adroit and clumsy; precise and awkward. The Ninja more than any other figure on YouTube (in my opinion) understands the absurdity of his performance and persona. He ends most episodes with the promise of killing the viewer—an act it is abundantly clear that he is incapable of following through on. He is a willing participant in the elaborate ruse of the show. He reworks the con-

ventions of the Ninja narrative in new and disjunctive ways, and in doing so establishes a new language for the Ninja as an object of popular culture—one coterminous with the work of participatory culture.

Potter Puppet Pals is an innovative piece of fan fiction, characterized by its reductiveness: the use of simple, sticklike figures and patently overdramatic voices coupled with a narrative premise easily traceable to the *Harry Potter* novels. Each episode also features a distinctive twist ending. The best-known episodes are *The Mysterious Ticking Noise* and *Trouble at Hogwarts*, each of them a study in the power of short, segmented narratives. The *Mysterious Ticking Noise* has the puppets jumping up and down calling out their names in a frenzy of unnecessary action as the sound of ticking grows—it ends abruptly, with an exploding pipe bomb. *Trouble at Hogwarts* has a little more narrative development, with the three kids (Potter, Ron and Hermione) bobbing up and down in panic as Voldemort prepares to spell doom for Hogwarts. Snape and Dumbledore appear briefly and make half-hearted gestures to stop Voldemort. The three kids push Voldemort to one part of the stage (screen) and then suddenly appear from the other side with machine guns, riddling him with bullets. An extended group hug ensues with Snape and Dumbledore joining in. *Potter Puppet Pals* can be read as continuous with the narrative and ideational premise of the novels, but this does not do justice to the inventiveness and the fun of these short films. They presume a level of participatory investment in the signified value of each of the characters—Harry as the chosen one, Ron as everybody's best friend and Hermione, the figure in between, working as equal part foil and attraction. Simply put, the series is *not* derivative but can be best described as an analogy, where the presumptive trajectories of the characters and their life histories are placed within the narrative arc of the unexpected— the pipe bomb, the drive-by shooting—and realign these stories along lines that are strikingly contemporary (paralleling similar acts in the real world) and synecdochical in their segmented nature, driving the needs of both parody and comedy.

Created by Doug "Doog" Bresler, *Doogtoons* is a well-known animated series on YouTube widely recognized as a pioneer in cartoon podcasting. The series has been featured on the front pages of Yahoo, MySpace, iTunes and of course YouTube itself. Mainstream media coverage of the series includes stories in the *Washington Post, Business Week, Rolling Stone,* and *Animation Manger.* There are a number of different series that together make up the *Doogtoons* canon. One is the *Nick and Haig* parodies, which were created to animate conversations Bresler had with his friends at the University of California,

Santa Barbara. After the video went viral and won several awards at Short Film Festivals, Bresler signed a deal with G4 television to air the episodes. Another series is *In the Studio* (clearly a reference to the TV show, *The Actors Studio*), which broke ground as the first animated talk show, featuring "Weird Al" Yankovic and the comic Tommy Chong. Perhaps the most popular series is *Eli's Dirty Jokes* which is the most developed with over 40 episodes. It features a ribald take on the mundane and not-so-mundane life of an accountant named Eli. In November 2008 *Eli's Dirty Jokes* was picked up by HBO for its Cinemax cable channel, making it one of the few original Internet shows to move to a TV network. In addition to the four series, *Doogtoons* also produces the occasional music video parodying iconic film scenes (for example, *Star Wars* and *Indiana Jones*) and other Internet celebrities (such as the Average Homeboy).

Doogtoons can be read as a poster child for the thoroughly intertextual space of postmodern digital culture that websites like YouTube have given birth to. The "episodes" (for lack of a better word) are between two to five minutes long and are often ruminative meditations on other memes or arcane bits of viral culture (such as references to minor celebrities, catchphrases and scenes in various video games and videos). Many of these episodes are fragments of scenes without resolution, a dialogue without a purpose, an abrupt ending, and seem to be best captured by that phrase so dear to adolescents—"random." For example, in one episode of *Eli's Dirty Jokes* (featuring the humdrum life of an accountant) there is an intriguing conversation between the accountant and his wife. As they lie in bed, he keeps tapping her on the shoulder for sex, and she tells him that she has to see her dentist the next day. Eventually, he sighs and says that he too has a dentist appointment. The scene ends at that point, leaving the audience with a range of unanswered questions—Is the dentist a lover to both of them? Is dental work a metaphor for something else—oral sex (as some comments seem to imply) or a reference to *David after Dentist* (some comments reference this iconic video in responding to this story). The possibilities seem endless—and that perhaps is the point, the series offers an open-ended number of narrative trajectories and questions.

This open-ended and continually referencing process is what makes *Doogtoons* an important example of digital culture. Each episode of *Doogtoons* is a thick, layered text, working through several levels of intertextuality (often with no original point of reference). What becomes clear in attempting to read *Doogtoons* is the considerable investment of time and emotional energy to viral culture itself that is needed if the viewer is to fully enjoy each series. The story of *Doogtoons*, I would suggest, mimics the story of virality itself, where a

new generation of storytellers, each building on the textual and meta/intra textual referents of each other (along with readily available fragments in mainstream popular culture) construct a towering pile of meanings, each piece having no clear point of entry or closure, but all held together by the power of participatory culture.

Notes

1. The appeal of the *Chad Vader* video series can be tied to two interrelated developments in the creation and consumption of digital culture. The first is the coming of age of fan fiction accompanied by quintessential postmodern values, such as the pleasures of irony and intertextuality, and the second deals with the specifics of the characters and the narrative arc of the video/series and its reception. Both of these can be discussed in thumbnail fashion.

 Fan fiction and fandom has a long history, anchored in the archetype of *Star Trek* fans, enumerated in documentaries like *Trekkies*. What the *Chad Vader* series represents is the maturation of the process of fan-based creative activity, by moving beyond a mere reflexive engagement with the original text to a concrete, mediated process of meaning-making where fans not only create new original content, but have (through the web), a process of distribution, consumption and reward within a community of fans. In sum, what the *Chad Vader* series represents is an institutionalization of fan fiction and fandom. This becomes readily discernable when you examine the *Chad Vader* video against (and with) other award winners of the George Lucas Selects (Christmas Tauntauns (2002), Escape from Tatooine (2004).

· 1 3 ·

THE MIRROR

Love the person in the mirror before anyone else.
—From a Dove candy wrapper opened by the author

The thing that moves us to pride or shame is not the mere mechanical
reflection of ourselves, but an imputed sentiment, the imagined
effect of this reflection upon another's mind.
—Charles Cooley, On Self and Social Organization

Introduction

Writing in 1902, the sociologist Charles Cooley suggested that the way in
which we come to a sense of our identity is through a complex and conscious
act of engagement with the "self." He called it the "looking glass self," a soci-
ological process where what we see in the mirror is a reflection of the sum of
our symbolic interactions. As he put it, "the social self is simply any idea, or
system of ideas, drawn from *the communicative life*, that the mind cherishes as
its own" (emphasis mine) (1902, 197). Retrieved from http:// www.sociologyin-
dex.com/looking_glass_self.html accessed 9/15/10).

At the heart of this conceptualization was a tension between personal agency and sociological determination, a process that he put so eloquently:

> As we see our face, figure, and dress in the glass, and are interested in them because they are ours, and pleased or otherwise with them according as they do or do not answer to what we should like them to be; so in imagination we perceive in another's mind some thought of our appearance, manners, aims, deeds, character, friends, and so on, and are variously affected by it (Ibid.).

Numerous scholars have used this original insight to probe and understand the dance between self and society, and to develop a perspective—symbolic interactionism[1]—that offers considerable value in understanding the role of YouTube in daily life. Specifically, I suggest that the popularity of a type of video, which I call the "Mirror," can be readily understood using such a perspective. The Mirror refers to the posing, placement and recording of the self over time, with the central idea of keeping a public memory of personal change (and continuity) available on-line. While video blogs do some of this, it is present in its most segmented form in the way that people have kept still-picture diaries of their faces.

Such diaries, I suggest, can be usefully interrogated using a symbolic interactionist frame, which sees society as the sum of individual interactions *socially* mobilized. As the mission statement for the Society for the Study of Symbolic Interactionism puts it, "People's selves are social products but these selves are also purposive and creative" (http://espach.salford.ac.uk/sssi accessed 9/15/10). In contemporary times, such purpose and creativity is intimately tied to the rapidly closing gap between the real and the virtual. Herbert Blumer who first coined the term "symbolic interactionism" suggested "there is no *empirically observable* activity in a human society that does not spring from some acting unit" (emphasis mine) (1963, 186–7). Retrieved from http://uregina.ca/gingrich/blumer.html accessed 9/15/10). Such empirically observable acting units, I suggest, are increasingly those mobilized through contemporary modes of delivery such as computers, cell phones and other personal media. In each case, what needs to be emphasized is that this is a deliberate process—a process succinctly evoked by another scholar in this tradition, Erving Goffman, whose notion of "the presentation of self in everyday life" appears to be fully realized in genres such as the Mirror on YouTube.

Goffman suggested that individuals relate to others through the creation of what he called "sign-vehicles," which are sociologically determined. The

receiver "can rely on what the individual says about himself or on documen-
tary evidence he provides as to who and what he is" (1959, republished in
Newman and O'Brien, 2010, 117). Such documentary evidence was (and still
is) presented through daily encounters, routines, practices of presentation
(clothes, accents, postures, etc.) but now increasingly takes digital means.

I suggest that the Mirror as a genre is, if nothing else, a profound invest-
ment in the daily production of the self—it requires an enormous amount of
time, emotional commitment and personal will. This is of course not a
process unique to YouTube. The creation of "avatars" online, the uploading
of distinct ring tones, the creation of "directors" on YouTube, the entire
work of participatory culture in fact is part of this process of how the self is
increasingly drawn into coherent (and simultaneously disjunctive) strategies
of representation online.

As a class, we have watched numerous videos of this type, which have
titles like *Amanda Takes a Photo of Herself Every Day for Three Years*, *Noah
Takes a Photo of Himself Every Day for Six Years*, *Evolution of a Beard*, *41 Years
in 60 Seconds* and so on. There are two general themes of such videos that I
term "the mirror effect."

First, the mirror effect appears in all these videos as a representation of
the self. In other words, this is not just a functional relationship of the self
to the mirror (the combing of hair, adjusting the collar, etc.) that most indi-
viduals undertake in the morning before setting out to school or work but a
carefully crafted one. It represents a process of *actualization* that media tech-
nologies allow for in the (continual) presentation of self. Rather than mere-
ly getting ready to work (or to party), these videos present something far more
complex—they have a life of their own—both the expressive medium in
which they come into place (the placement of the self before camera) and the
real/virtual space in which they are fully actualized—the comments, commen-
tary, and virtual celebration that such accounts of self are located in. It
makes you want to put your camera on a stand, and stand before it as often
as you can get away from the other inconsequential parts of your life, so that
you too can be part of the mirror that we appear collectively to be holding
up to ourselves.

Second, the mirror effect offers some interesting paradoxical trajectories
about cyber-communication, i.e., the kinds of relationships being entered into.
Here I want to focus on the specifics of the emotive, expressive construct that
people offer in the Mirror. What kind of person emerges from these carefully
crafted constructions of self? Not a very friendly one, is the answer. Quite

remarkably, in each video, there is a consistency in the face being presented—the persons vary by ethnicity and gender, but they are all singularly stoic in expression. Their eyes never twinkle, a smile never escapes from their lips over the weeks or month, eyebrows are never raised in skepticism about the exercise they are undertaking, a shrug never shows up to signify boredom, and the head never shakes. A person enters (it appears) into an emotive and psychological denial of the vicissitudes of daily life—what emerges is a clear commitment to the idea of presentation itself—where a sense of agency about *what is being communicated* is always held in tight control. The mirror that is being held up for us all to see is uniformly of a certain kind of psychological containment, which can easily be read as a manifestation of structural alienation of modern life, but I would suggest it is even more profound—it is the taking on—and celebration of—such taciturnity as *the* defining characteristic of the self.

Examples

There are "stars" within the Mirror as a genre, and I will examine one of them—"Noah" (and his heirs), as a stand-in for many others. *Noah Takes a Photo of Himself Every Day for Six Years* offers a nearly six-minute-long visual record of changes to the subject's facial composition, accompanied by a soft-but-resonant piano score. Key changes occur with changes in hairstyle—a completely shaved head, the emergence of a beard and then its swift removal, accompanied by rapid, often-colorful changes of clothes. In the final minute of the video, a beard starts and then grows steadily along with a dancing wisp of a moustache that soon jiggles across his face. Long hair appears and a very different Noah emerges from the clean-cut person at the beginning of the video. In as much as facial hair is an index of counterculture—especially in its unkempt, hippy rendition, Noah's changing face may be read as an index of such presumed cultural/political transference. Perhaps to accentuate that transfer, the last frame in the video is of Noah at the beginning.

Guy Takes a Picture Every Day for Six Months is interesting in that it reproduces the premise of Noah with its fixity of expression, the use of dramatic music (from the film *Requiem for a Dream*) and background (his bedroom) with the subject sitting in exactly the same spot, the edge of a picture frame showing over his left shoulder. The video offers a brief departure in that a faint smile appears on the subject's face on a few slides, and he appears bare-chested on occasion (only the face and shoulders are visible). A slightly different approach

is taken by *Kotla Takes a Picture of Himself Everyday for Six Months*, in which the speed and pacing of the video is faster, with the music tinny and somewhat shrill, but the approach stays true to the genre's focus on fixity of expression (there is a minor departure from convention in that the colors of the shirt change, and on a few occasions, the background also changes).

In similar fashion, *800 Days—A Daily Photo Project* offers a stoic, expressionless, account of a young man's journey. The changes in the visual register of the story come in the shape of the man's hair, which works as the primary agent of change in the narrative—beginning with a flopping, twirling gorgon-like structure. At two moments this mess disappears under a hat, and about midway through a dramatic change is introduced—a crew cut—which the rest of the video then works to repair, with the reemergence of the curly abandon of before—ending with an epitaph: "to be continued," suggesting even greater hirsute exuberance to come. In sum, hair works as a diacritical marker, showcasing a wider story of personal change and growth.

Amanda Takes a Photo of Herself Every Day for Three Years extends the narrative premise of Noah but adapts it to a visual history of adolescence. It shows the personal and psychological change from the age of 14 to 17. The visual progression marks these critical years of growth, mirroring both wider sociological categories (teenage angst, hormonal change) and those of a personal nature (a rapid cycling of hairstyles, clothes and facial adornments). This is a remarkable video, directly inspired by Noah (she credits him at the end) and speaks to the power of an emerging genre and to the considerable investment in a visual record of the self. Even as Amanda's expression remains stoic and fixed, the changes she is undergoing are writ large and are quite stunning in places—the elongation of the face, the harshness of the skin, and the adoption of cultural "values" synecdochically represented by the hats/beads/jewelry she wears in quick succession. In sum, I suggest that Amanda's video is a use of the Mirror as a record of inner change visualized through an account of physical/facial growth and development.

The face is also the focus of other videos that extend the narrative premise of the Mirror in related ways—one of which is a growth of gendered narratives—such as "beard" stories. *Evolution of a Beard* and *Growing a Beard* show how the face can be used to paint a portrait of change and continuity—within a wider narrative about masculinity. *Evolution of a Beard*, with its upbeat honky-tonk music, is the richer of the two texts, undertaking a story about aging and masculinity. It features a young-looking, clean-shaven man who, through the progression of the story, morphs into a much older man with a salt-and-pep-

per beard, looking alert and engaged in the beginning and thoughtful and poignant at the end. The video ends with a fast rewind of the man's face back to the beginning, when he was without a beard, and markedly younger. The contrast is striking, an effect emphasized by the background, which changes often but does little to challenge the overall narrative arc of this story, which remains a portrait of age and aging—and equally importantly, it evokes a question about how we see one element of such a process (hair) as the important marker. *Evolution of a Beard* is marked by the rapid progression of backgrounds while the face remains center stage. It adheres to the genre's norms of stoic expression even as the referents of daily life—bedrooms, offices, restaurants, and living rooms—cycle through in rapid progression mirroring the mundane and repetitive nature of our routines as seen in the seven weeks of images that this video represents. *Growing a Beard* is similar in form and style with one exception—the camera is positioned so that it is looking up at the person, and the background never changes from the only space it is shot in, presumably the bedroom.

It bears reminding (once again) that across these videos, the emotive register of the face never changes; race, ethnicity and gender—the bedrock of the symbology of daily life and interaction—take second place to the wooden, blank stare that is inaugurated by Noah. The subject, it is clear, does not look at the viewer, but at a point beyond him or her, to a point of personal and sociological interrogation that presumes invisibility. The subject, much like the viewer, it is clear, *lives in the gaze.* The act of looking, the fixity of expression, and the experience of looking is what centers the mirror moment.

I want to end my discussion of Noah with some examples of parodies of Noah. *Ben Takes a Picture of Himself Every Day* is a clear jibe at the purported self-importance of the Mirror as a record of daily life. It begins with the requisite stoic expression but then quickly rejects that mode of address with a range of expressions (rage, fear, despair, depression) that Ben provides as he undertakes a number of tasks—making and losing a large sum of money (a clear reference to the economy and stock market fluctuations); finding a girlfriend, cheating on her, getting dumped; experimenting with drugs; chasing a thief through numerous countries and eventually catching him. He changes clothes and identities often. This is a critique of Noah (and the genre itself) at many levels—of the genre's self-absorption, its (purported) lack of narrative depth (especially at developing a storyline), and perhaps above all, its focus on the singular subject (the person looking into the mirror). *Ben Takes a Picture of Himself,* in contrast, is a study in excess, filling every frame with all kinds of

autobiographical riff-playing to an upbeat street tempo that is a studied departure from the moody, somber, and reflective music that we have come to expect from the genre.

Phil Takes a Photo of Himself Every Day for Two Days is a different kind of parody. It alternates between an overly serious and wide-eyed stare (mocking the catatonic look of Noah) and an elaborately staged comic expression, which includes the tongue sticking out prominently. Both images fluctuate rapidly, with little change in speed or direction. The music—Henry Mancini's *Baby Elephant Walk*, a peerless referent for childhood and carefree play—plays suitor to this technique. Through its simplicity (the two images cycling through) and its use of an iconic song about childhood, it sends a direct message to the makers of the Mirror—don't be so serious, chill out.

Deena Takes a Photo of Herself brings the full force of parody to its point of origin—Noah. Set to the same music, it begins with the following text (in the same font as Noah): "Every five minutes for two hours" and shows Deena stuffing her face with donuts. By my count she eats ten donuts, showcasing the power of concentrated effort in an act of sublime gluttony. She takes big bites and small delicate nibbles, shoving the donuts in from all sides of her mouth, licking off every last bit. The donuts are more than props; each of them has a personality and a color (pink, chocolate, marbled, among many others). Deena does not take a break to drink anything or even to catch her breath, so single-minded is her devotion to the effort—and her expression never changes—it retains the glass-eyed stare that characterizes the genre. It ends with a promise of more to come: "A snack in progress."

Finally, *Parody of Noah Takes a Photo* shows a young man (Asian-American) taking a photo of himself every five seconds for one-and-a-half hours. He turns his cap around his head and jiggles his glasses on his nose, over the course of 450 frames, at the end of which he thanks his glasses and his hat. The sense of self-importance and the idea of presentation is taken apart at both the semantic and ideological level—poking fun at both the time that the original video takes, and its intent, that the subject considers himself worth examining over that time period. Instead, what is offered is a short, minute-long rendition of a wasted hour-and-a-half, with an accompanying pop song, bereft of substance and meaning, adding nothing to another meaningless day. The tone and intent of such a post-modern exercise in irony, I would like to suggest, is not separate from the other "serious" exercises in self-presentation but is rather *continuous* with it, drawing sustenance from the same culture of textual representation and intent that drives the original videos—a highly consistent form of textualiza-

tion that has, at its core, the presumption of viewer interest in the most personal of moments and in the face as the template on which ideas about self are consciously mobilized.

I want to end with some examples of the Mirror as a genre where the entire body rather than just the face is the focus of narrative development. *Nine Months of Gestation in 20 Seconds* takes a young woman's growing belly as a text, mobilizing ideas about growth, wonder, and childbirth. It ends with the mother holding the baby, and the concluding image is of the couple with their child. The mother's face is never fore-grounded, it's shot with the belly as its primary focus, which provides for a narrative frame where the unseen child and its arrival is the expected endpoint of the story. The video does not disappoint, delivering (no pun intended) a happy mother/child at the end. Interestingly, the side-bar videos accompanying this video are largely informational (various medically oriented videos about childbirth and conception) and political (video commentaries against abortion). It speaks to a central truth about digital culture and personal agency, where the original video, which is a straightforward visual record of pregnancy, can be recast in the digital realm, appearing alongside stories that are a recurrent thread in the culture wars of America.

Finally, *84 Days in 48 Seconds* is a video about weight loss and muscle development. Remarkable as a record of physical transformation, it is focused on the midriff and upper body of a white man, showing the rapid disappearance of a bulging stomach and its replacement by a hardening of the muscles, which by the end of the video are in the requisite "six pack" shape. Unproblematically positioned as a text about hard work and personal agency, the video tells a ubiquitous American self-help story, beginning with the first slide which speaks of being "sick, broke, stupid, depressed and obese," and proceeds through its transformative narrative to mobilize a story about personal will, discipline and hard work.

Note

1. For a contextual review, see Shore (1997); for an understanding of the role of symbolic interactionism in the history of sociology see Knapp (1994), Turner (1991) and Wallace, (1995). For contemporary reiterations (and useful abstracts/reviews) see Plaummer (2000) and Newman and O'Brien (2010).

· 1 4 ·

THE MORPH

The more things change, the more they remain the same.
—Jean Baptiste Alphonse Karr

You're perfect, now change.
—From the musical, *I Love You*

Introduction

The Morph is a genre on YouTube that recasts a common editing function (available on most computers) into a defining tactic of digital storytelling. It involves morphing different images, typically those of the human face or body. The Morph differs from the Mirror in its undertaking of a fundamentally different rhetorical action—one of manipulation rather than a record of the self.

Theoretically, the Morph is a quintessentially postmodern text (Kellner, 1989; Scott, 1992) using the representational strategy of bricolage.[1] The Morph as a form of bricolage has four recurring features. Firstly, it is a discourse about resemblance, taking as its starting point (and pedagogical motive), the animation and mapping of hitherto unrecognized similarities. Secondly, it is

a strategy about representation, specifically the nature, form and (often) critical intent of mass media images. Thirdly, the Morph is a rhetorical tactic about cultural difference and convergence. It typically uses binaries (black/white; old/young; beautiful/ugly) and then works through their contradiction, seeking to align them within the same (visually) linear space. Forthly, the Morph is relatively restricted in its realms of (digital) operation, largely focused on celebrity culture (from TV, Film and Sports).

Working as/through bricolage, the Morph is characterized by the free imbrication of signifiers, the plasticity of signified referents, and an inherent plurivocality. At the heart of the Morph is a central postmodern tactic—*that everything is in play*, that there are no irreducible forces of social structure (race, class, etc.) that ground any single referent. By foregrounding such a semiotic plasticity, the Morph allows for the development of a range of thematic, cultural, political and ideological positions (see examples below).

In addition to bricolage (and the above-defined features), I see the cultural work of the Morph as continuous with an earlier form of postmodern representation—the Collage. "Collages take ready-make texts and images and reassemble the fragments into a new composition" (Banash, 2004, 1). The collage represents (like all postmodern texts) a "major cultural shift from the time-honored aesthetic of permanence to an aesthetic of transitoriness and immanence, whose central values are change and novelty" (Ibid., 9). The important difference between the Collage and the Morph is, of course, its location. The Collage was (and remains) the domain of the personal (posters, scrapbooks, family displays). It is oriented by its "private context and sentimental application" (Ibid., 1), while the Morph, while often motivated by the same highly personal themes, is, by definition, an open text received (and reworked) in the public space of YouTube.

Examples

There are hundreds of personal morphs showcasing the growth and development of individuals at different points in life. To briefly illustrate: In *Human Face Morph* the Morph consists of pictures from family albums showing the growth and development of a person's face, and evoking through that sequence a portrait of personal change and transformation. Other interesting examples are *41 Years in 60 Seconds 1966–2007* and *85 Years in 40 Seconds*, each of which use the face as the palette for understanding/representing the complex process-

es of growth. *41 Years in 60 Seconds 1966–2007* is a series of morphing images of a white man as he grows from a quizzical and wide-eyed boy to a ruminative, serious teenager, to a direct, centered, middle-aged man. His hair functions as an important diacritical marker, growing to a tangled web in his teenage years, melting into studied control in mid-life. It ends with a tantalizing tag line: "to be updated in 2048." *85 Years in 40 Seconds* is a series of morphs by a young boy aging from childhood to old age. Less a visual account of the same individual and more a story about aging itself, the video is visually arresting, focused on the seriousness of the person, the sense of agency he has, and an indefinable sense of strength—physical, moral, and ethical in nature.

Since "fame" in all its complexity is a recurrent theme of YouTube use, I will focus on examples of the Morph as a language to celebrate, critique and comment on celebrity culture—in the process offering a typology of morphs. After looking at nearly a hundred morph videos, I have identified four distinct types of video (with some overlap). The first is the "individual narrative," focused on the life, development and personality of a person. The second is a "thematic narrative" usually focused on a subset of popular culture icons (from sports, TV shows, a music genre) with the use of multiple faces to develop an overall story, typically celebratory in nature, but on occasion, critical or ironic. The third type is a "dyadic narrative" consisting of the pairing of celebrities across distinct realms, typically from film and music, to create a range of outcomes: surprise, critique, confirmation, and, on occasion, wonder. The fourth type of video consists of examples of existing morphs on mainstream media (TV and Film). I will discuss each of these video types using examples in illustrative fashion.

I will use Michael Jackson to discuss the individual narrative morph. I counted at least 30 different morphs of Jackson, almost all focused on his face. This intense and concentrated attention to Jackson's face is symptomatic of a broader thematic surrounding his cultlike status, where his face is chained to a negotiation of race, sexuality and performativity (along with topics like children and animals). For example, *Michael Jackson Morph* is a video that is over six minutes long, which functions as a musical biography of the artist. It is made up of a compilation of his pictures from about five years old to his death at 50. There is little in the editing or the placement of any image that is critical of Jackson. This is clearly the Morph doing the work of fandom and fan culture. By contrast, another video with the same title, which is only three minutes long, speeds up the process, embeds it with dark, ominous music and ends with the following text: "If this is happening on the outside then what is happening on

the inside?" The comments on this video readily take the bait, with an over-flow of hate-speak around race and sexuality. Another video takes Jackson's shortened life and extends it using a song from the Beatles ("When I'm 64"). Here Jackson grows beyond his age at death (50). We see Jackson as what he might have looked like at 64, growing old and wrinkled. The video reverses the aging process at the end, reflexively engaging with the idea of his premature death, forever caught in mid-stride with no resolution possible. The bulk of the videos on Michael Jackson's face morphing are very short, between 15 and 30 seconds, and focus on the rapidity of his changing visage. Jackson's face in most videos is represented in four distinct phases, a small cherubic boy, an impish teenager, a sexually dangerous young man, and an extended final phase, where his face undergoes a profound transformation—his skin bleached to white, his eyes arrestingly open, his long, curly hair crawling all over his face, and above all, the most distinctive change, a thinning and pinching of the nose. Almost all the videos end with his eyes covered by glasses, hair carefully akimbo and lips creased in red. I suggest that Jackson's face is a canvas on which the Morph works to mobilize a range of sociological concerns. The first three phases are clearly located within a race-based performativity, where clearly recognizable (and expected) enactments of black masculinity (from admiration to fear to envy) are represented. The final phase is where Jackson's face moves outside this set of concerns and becomes a text about perverted outcomes, manifest in the odd mix of beauty (eyes, hair) and grotesque (nose, chin, the shrinking of the face) that most videos highlight. Jackson's emergent whiteness can also be read as a morality tale about racial passing, a journey with considerable costs.

The thematic morph is the viral equivalent of the "top ten" or "all-time best" that are a staple of entertainment media (especially in realms like sports). There are important differences, especially in the orientation and narrative expectation they engender for viewers. I'll examine three such videos. *Magical Morphing Faces of Top 50 Athletes* is less than masterful in its technical quality but makes up for it with the paradigmatic task it undertakes, sifting through all of American sports (football, basketball, baseball, tennis, boxing and athletics) before coming up with its list of 50, all of who are ranked. The list only has three women and one non-American (Roger Federer). What is striking about such an exercise is the broad historical analytic that is being undertaken and the nuanced, weighted decisions around each choice. Most of all, this is fan cul-ture at its best, pushing choices, seeking debates, fostering argument—above all, encouraging participation in the work of fandom itself. Such lists and debates have always existed but were restricted by locality—a local fan club or

discussion in a peer setting (such as a bar). The Internet now allows for such debates to be both expansive and global. Through comments, response videos and vlogs on the subject, each video becomes one link in an extensive chain of fan culture. *Famous Faces Morphing* (there are two separate videos) is made up of famous actors and actresses morphing. The first one is a morph of six major actresses (including Angelina Jolie, Keira Knightly, and Scarlet Johansson) and the second one is of 11 male actors (including Heath Ledger, Brad Pitt, and Sean Penn). Here the thematic motif is not the individual actor or actresses but celebrity itself. Both videos certainly reify each of these figures in the pantheon of popular culture, but they also function discursively, by mobilizing a discussion around mass-mediated standards of beauty and good looks, with many viewers bemoaning the cookie-cutter, predictable vectors of sexual appeal. This is self-evident in the way the videos are edited, with each cheekbone, nose, and jaw line merging with the next one, the chins aligning in syncopation, and so on until the message is over determined—this is how Hollywood wants you to look (interestingly issues of race lie just below the surface in these videos. Non-Caucasian actors or actresses are entirely absent).

The third thematic morph I want to discuss is *From George Washington to Barack Obama*, which is well-produced and tells an interesting story about masculinity and American political culture through portraits of each President. It is easy to read this video as a text about race, patriarchy and power, but I suggest that doing so does this video a disservice. More than anything else this is a story about personhood; its editing allows us to read from the face of each individual the face of presidency itself. An amazing concurrence emerges—the size of lips, the turn of cheeks, the creased smiles, the shape of the ears, and even the gaze of the eyes, melt into each other. They tell a wider story about the American presidency, and, in doing so, about America itself. Smiles are few and far between, this is a story about individual will, strength, power, resolve, and above all, determination. Race provides a bookend to this narrative, an unexpected twist at the end (with Obama) but is not the primary narrative force in the video.

The "dyad"—morphing of two faces—is a recurring type of celebrity morph on YouTube. I suggest that it undertakes a different discursive task from the other morph videos because it focuses on the mobilization of a *relational* equation between two faces, each individual face typically a thick text based on their location in popular culture. I want to illustrate different elements of this relational equation with some examples. First, it is important to reiterate that celebrity culture is at the heart of the dyad; most videos take popular cultural

figures in film, television, sports, etc. and connect them to other figures from those arenas. Dyadic videos exist for many such figures, of who I will use Angelina Jolie as an example. A popular dyadic morph uses Angelina Jolie and Brad Pitt. The morph shows Jolie with her trademark enigmatic smile morphing into a long-haired Pitt looking into the distance at a point beyond the viewer. Obviously, the fact of their real-life coupling provides a narrative frame for this video, but the video also evokes a complex set of reactions in the viewer—an acknowledgment of the central place they occupy in tabloid media as the "it" couple (and the weekly fodder they provide) and perhaps most importantly, a sense of wonder in their visual collusion, working through specific vectors of jaw lines, cheekbones, foreheads, and, above all, their smiles. It is this close attention to detail, to tracking the specificities of a person's architecture, that marks the working of the dyadic morph.

The cultural work involved in undertaking such a close reading changes with the faces being used. *Angelina Jolie to Michael Jackson* shows a change in visual focus. Here the attention is centered on the elision between the sunken eyes, the loose hair, and the nose. Simply put, the video transposes Jackson's abnormality with Jolie's cultivated beauty. A third morph *Angelina Jolie to Laura Croft* puts into play a conversation about the plastic nature of Jolie/Croft as a cinematic/gaming presence; the enigmatic mutability that is at the heart of her appeal and the undeniable agency that she brings to her real/digital life.

While the dyad takes individuals like Jolie as starting points, multiple points of reference are possible. Such dyads establish a relational equation between multiple figures, each working to animate a sub-theme or concept. To illustrate, in the video *Celebrity Morphing,* Al Pacino and Robert De Niro are morphed as symbols of a gritty masculinity; Gene Hackman and Humphrey Bogart exemplify hat-wearing, smooth-talking exceptionalism; Jack Nicholson and Russell Crowe convey an unconventional masculine aesthetic, focused on their non-traditional good looks and rakish demeanor. Other examples have fun with the relational equation they suggest—Antonio Banderas and Puss in Boots (from *Shrek*), which recalls for viewers the film; Cher and a lion, which suggests convergences in personality and public identity; Superman and Batman, where a conversation about the very different "powers" of these two heroes (one human, one superhuman) are brought into the same arena for discussion.

Morphs from mainstream media that have been become popular on YouTube are important to an understanding of the genre. There are numerous examples of these including videos from the *Terminator* films and numerous

vampire films. In the case of television, a popular one is the introduction to *Roseanne*, where each character is shown as they change through the years/seasons, along with scenes from the show *Charmed* where the three women with witch-like powers periodically switch between their identities. Finally, there is an iconic (and technically accomplished) morph at the end of one of Michael Jackson's videos where people from different racial and ethnic backgrounds morph. Each of these videos, I believe, serves an important function on YouTube. They provide validation for the practice of morphing, legitimise the use of this technique as an acceptable form of storytelling, and, most importantly, provide models for referencing as people make their own thematic morph videos.

Finally, a brief discussion of how the celebrity morph is being used in one thematic area—politics (as a stand-in for the morphs used in many thematic areas, such as media, arts, pets, etc.), using President Barack Obama as an example. There are numerous morphs of the faces of Barack Obama and Osama Bin Laden. There are quick morphs like *Obama 2 Osama,* which takes pictures of Obama and Osama and morphs them in a few seconds, while a video like *Is Obama really Osama?* is an extended (five-minute) video that maps with text and visual markers the "identical" nature of Obama's eyes, nose, cheekbones, hair, etc. with those of Osama. At each point of the latter video the text is repeated over and over to confirm that this is not an accidental visual match, that indeed Osama has somehow managed to become the American President. Another video (*Osama and Obama*) uses a digital eraser to "erase" Osama's beard and moustache and "reveal" the face of Obama underneath. Numerous other photoshopped images (compiled into videos) show the two sitting together eating a meal, discussing strategy, cradling guns, taking part in training missions, etc.

I became less interested in the specifics of each video as in their pedagogical intent. What is remarkable about these videos is not the patently false insinuation and the virulent hate-speak around Obama that surrounds these videos but rather their use of a journalistic rationale—the investigative report, the exposé, the undercover story working as a tool of political argumentation. The Morph here becomes part of the political rhetoric of engagement with cultural difference, especially around the key area of Muslim identity and culture. The participatory culture surrounding these videos reiterates familiar narratives of fatwa, infidels, Arab, and other markers of religious difference.

Note

1. *Bricolage* is a French word, which is loosely defined as "tinkering or playing with." It refers to both a type of textuality (made up of different, often contradictory elements) and a way of working, as in the *bricoleur* who puts objects, words, images together to create something unexpected and often subversive. Scholars who have developed the concept include the anthropologist Claude Lévi-Strauss, who used it to explain lived tribal experience; Jacques Derrida, who suggested that all discourse is constituted as bricolage; and the sociologist Michel de Certeau, who focused on reading as a form of bricolage. Postmodern scholars see most contemporary texts, but especially media texts, as constituted by bricolage, as the dominant methodological practice at work (Milner, 2007; Hovorka & Germonprez, 2009).

· 1 5 ·

THE WITNESS

Journalism is history on the run.
—THOMAS GRIFFIN

Introduction

The Witness refers to the intersection of mobile video technologies with concerns of reportage—commonly referred to as I-Witness News. Properly delineated from other more selective, random and often trivial recordings of daily life, the Witness is characterized (through its placement within a wider journalistic frame) by the recording of *public* experience. There are two intertwined concerns that distinguish it from mainstream television news: Witness videos are almost always low quality (acoustically, visually) and characterized by little or no storytelling elements. Rather, they are explicitly experiential—recording the *act of newsmaking* (a car explosion or accident). Typically recorded on cell phones (and other more complex mobile communication aids, like iPhones), such moments are then readily absorbed by television news into their prescribed modes of storytelling (voice-overs, packages, stand ups). They have also become a staple of news websites with their interest in "citizen journalism" in all its contradictions and possibilities.

Theoretically, the Witness can be unproblematically placed within a realist, empiricist tradition. Realism attempts to describe subjects, situations and settings using a third-person objective frame. Empiricism is based on the "claim that sense experience is the ultimate source of all our concepts and knowledge" (Rationalism vs. Empiricism, *Stanford Encyclopedia of Philosophy* http://plato. stanford.edu/entries/rationalism-empiricism accessed 9/22/10). Journalism is fundamentally informed by such a normative/theoretical orientation. Hartley's sense of Journalism as a "textual system" is an important point of entry: "The most important textual feature of journalism is the fact that it counts as a true" (1996, 35). This has central relevance to the Witness as a genre, which almost always is focused on ethnography immediacy through being a "witness" to a situation.

Examples

While Witness videos emerge daily on YouTube across a dizzying range of contexts—war, accidents, public events—I chose to focus on a few samples that provide evidence of the genre at work, across local (*Baltimore Cop versus Skateboarder, Destruction of the Kingdome, Whale Blows Up, Office Worker Goes Insane*), national (*Virginia Tech Shooter*), and global context (*Neda, Saddam Hussein Execution*). I also discuss *The Last Lecture*, as an unusual example of the Witness—working in the context of personal life and presenting a humanistic language for understanding one's life.

The video of the UCLA student taser incident and the shooting at Virginia Tech share a number of similarities—their primary impact comes from their sense of auditory access to the event (rather than visual immediacy). Both videos were shot by students at those universities on their cell phones and then placed on YouTube and other sites for public distribution. What stands out is the narrative urgency that both these videos provide for viewers. Paradoxically, this sense of urgency is created *not* by visual immediacy but by the power of anticipation—of what *may* appear on the screen. The UCLA taser incident involved an Arab-American student who was without his student ID card while studying in the library. When security police asked him for his ID, a long confrontation ensued, where the student lay on the ground as they tried to remove him from the library. The campus police began to tase him, whereby he screamed in protest, shouting, "Here's your justice. Here's your Patriot Act." The police meanwhile kept ordering him to "Stand up, Stand up" and kept tasering him when he refused to do so. Students surrounded the scene, some

of them protesting, with one of them asking the police for their IDs. The video in question on YouTube was taken by a student with her/his cell phone, and tracks the scene from one end of the library, as the student gets up and walks to the scene. The camera weaves through desks and shelving, and cutting away to shots of the library roof, as it nears the action. What gives the scene its power is this simultaneous sense of impending arrival at the scene (the student's screams in the distance, the crackle of the taser, the jerky, off-balance video) and a fear of what may happen in the interim, both to the student being tasered and to the photographer. At the very end of the video, there is a brief shot of the student on the floor (later he stands up shakily) surrounded by the policemen—but what is relevant is not so much the specifics of the scene's visualization, as its anticipation—in the creation of its narrative urgency.

In a similar vein, the Virginia Tech video was also shot by a student on his cell phone in the quad outside one of the buildings where the shooter was killing students. The rattle of gunfire inside the building, the shaky video, and the voice of the student, who is responding with both fear and anticipation, characterize it. In this case, the viewer participates in the event through the aural experience of being there—and a willful desire to run away. This dual tension—immediacy and withdrawal—characterizes both videos and is part of how the Witness as a genre works. In addition, both videos became part of mainstream media's coverage of the event, being recycled through news reports, talk shows, blogs and commentaries and used as bookends to the necessary conversation that follows the act, centering around issues of cause, explanation, and reconciliation.

The execution of Saddam Hussein is one of the most important examples of the Witness as a genre—in this case, the defining element is not one of narrative expectation but of fulfillment. Shot by an unidentified member of the Iraqi army, who was inside the room where Saddam was hung, it shows Saddam being taken to the gallows by his captors, his last argument with them, and then the actual hanging. There was supposed to be no visual record of Saddam's final moments, yet the video circulated through YouTube and other websites (and on the mainstream media), becoming an enormous public relations problem for the American army in Iraq. While some of the key elements of the video are verbal—there is a long and hostile exchange between Saddam and his captors just before he is led to the noose, and another one when Saddam refuses to wear a mask—the defining experience of the video is its visceral experience of the real. When we watched this video in class, the room was filled with the tension of waiting for Saddam to fall, and the waiting seemed to be forever—there is a lot of crackle, shaking and shouting that comes before Saddam's body sud-

denly drops in a blur of black (the color of the jacket he is wearing) followed by a shot of his face, distorted but clearly recognizable as Saddam. The shaking of the camera and the shouting continues and then is abruptly cut. Many students averted their eyes, others forced themselves to look. In the discussion that followed, there was considerable division about whether this helped or hindered a journalistic account of the event—what there is almost no argument about is that this is a powerful video—that the Witness, when the stakes are high enough, can function as raw, primal narrative.

Another example of the power of the witness as a genre is the video *Neda*. Neda Soltan, a young activist in Iran, was shot to death by a member of the Basij paramilitary force during an opposition rally in Iran. She crumpled to the floor and was helped by her father, her music teacher, and several bystanders. A cell phone video captured her dying moments on the street. The video went viral, dominating online conversation (it was the number one trending topic on Twitter) and soon became part of mainstream media coverage internationally. Neda's death emerged as a rallying point for the opposition, her image was used in rallies, and every act involving her became a political flashpoint (for example, the Iranian government did not allow her a formal funeral service or a prominent burial spot). In the days that followed her death she became a potent symbol of resistance in Iran, often referenced as "the angel of Iran."

I want to suggest that reading *Neda* as a political text—along lines established by both social and mainstream media—is an important primary point of reference, but not the only one. *Neda* opens up a number of other important questions around nation, gender and modernity. First to politics: Undeniably *Neda* is first and foremost an example of the Witness working as an agent of political transformation. This comes from its context (the opposition rally), the agents of violence (the paramilitary), and manner of death (in the street). It is important to examine the last in all its gruesome detail since it is at the heart of *Neda's* work as a political text. The camera shows Neda lying on the street, sprawled between visibly panicked men who are shouting and exhorting her to stay alive. As the camera closes in her eyes roll back and blood flows out of her mouth and nose in a swift, uncontrollable stream. This is the visual center of this story. People shout and scream in disbelief. It is clear that we are witnessing something inhumane—a young woman dying in the street for her beliefs. Adding to the impact are Neda's last words, "I am burning, I am burning" and the last words Neda hears before she dies are "Neda stay with me." These words become part of the video's mythic framing—providing the Iranian opposition with a language for their own predicament and a rallying cry for the future.

Beyond the political context, Neda's death is a narrative about the Iranian nation-state, especially around issues of gender. The Western lens on Iran is made up of staple images—posters of the Ayatollah, women clad in black, fists clenched in protest against the great Satan, etc. Neda is none of these, she is unambiguously modern, wearing jeans and leaving her head uncovered. *Neda* must be read alongside the candidacy of Hossein Moussavi, whose wife broke new ground as a campaigner (Ahmadinejad criticized her in direct confrontational terms in a TV debate with Moussavi). *Neda* provides a script, a handy reference for the work of gender in the (continual) making of the Iranian nation-state, and the video emerges as a poster child for such a gendered modernity, replacing the burqas of old with the face of an undeniably young woman, lying and dying in the street as the world watches.

Don't Tase Me Bro is a video of a journalism student (Andrew Meyer) at the University of Florida being tased by police in September 2007. The student was asking a question of U.S. senator John Kerry. During his question he asked Kerry to explain his concession of the 2004 presidential election, his lack of support in efforts to impeach George W. Bush, and his involvement in the Yale secret society, Skull and Bones. During his question his microphone was cut off and the police dragged him away. During this process he implored them with the phrase that has defined this video—"Don't tase me bro," but to no avail. Meyer continued screaming for help as he was removed from the room. The video became a viral phenomenon with over five million views, and spawned the phrase's use in popular culture (including songs by the bands The Clash, Devo and MC Lars).

I suggest that *Don't Tase Me Bro* is an important example of the political role of the Witness working outside the narrative conventions of traditional American journalism, which are firmly tied to the institutionally structured dualities of left/right and conservative/liberal. Mainstream news media's coverage of politics is so Manichean in its framing that it rarely—if ever—allows for a voice that questions the very terms of the political contract it has signed onto. *Don't Tase Me Bro* is that exception—and it succeeds (ironically) precisely because it is political theatre. It is fitting that the questions the student is asking never get answered—because they contravene the terms of the narrative of political coverage defined by mainstream media. At the heart of *Don't Tase Me Bro* is the question of the social formation (by which I mean the structural arrangements of power that undergird American society), a question posed unproblematically as: Can a voice that questions the social formation be allowed to speak? The answer, very simply, is "No." It is only through open-

source providers like YouTube and emergent genres like the Witness that such voices speak, albeit haltingly, and fundamentally compromised by the use of spectacle and theatre, but still evidence of a process-in-formation that has begun to question the paradigm of mainstream political news coverage.

The Last Lecture is a video based on a talk given by Randy Pausch, a professor at Carnegie Mellon University, in September 2007. The official title of the talk was "Achieving Your Childhood Dreams," and it focused on stories of his childhood, lessons learned, and a focus on finding fun in everything one does. Pausch was diagnosed with terminal pancreatic cancer a month before giving the lecture, and this gave it special poignancy and power. It became a viral phenomenon, an unusual use of the Witness as a genre in addressing not daily life or events but existential questions of living and dying.

There are three interrelated elements that have made this an iconic video on YouTube—its dramaturgical certainty (around the personality of the speaker and his message), its unusual elision of humor and philosophy, and finally—and paradoxically—its length (over an hour long). The speaker's performative index is at the heart of this video's appeal. He is erudite, self-effacing, and clearly transformed by his forthcoming death with a clarity of vision and mind that is, for lack of a better word, arresting. He presents a language for approaching the end of life, but even more, a language for living life. Pausch connects a number of threads—an understanding of childhood as a point of beginning, but also a place of return—where the shape and scope of one's dreams are formed and then goes on to connect those dreams with the act of living. It takes a cliché—having fun in everything you do—and turns it into a truism. This is an exercise in practical humanism married to performance and theatre. We can read into his performance a range of mediated references from television and film about the "professor" and the role of the academy in general. He accomplishes the enviable—holding our attention over an extended period of time but even more, provides a language for understanding a taboo subject—death in all its certainty. Pausch's death is not just the elephant in the room—a fact that he jokes about early in his talk—but is the narrative frame that determines the intent, thrust and direction of his talk/persona. At the heart of his success is the disjunction between his clear enjoyment of the moment and the inevitable end at hand. At one point in his talk he does a number of push-ups to show how strong he is. This act of demonstration is the video's defining moment (its climax in a sense). As an example of the Witness, The Last Lecture undertakes a task that few mainstream media texts attempt—a deeply informed discourse on dying and death. Almost absent in popular culture, except as a corollary to vio-

lence, death remains largely unproblematized. *The Last Lecture* puts it center stage as a vehicle for personal change through daily (viral) consumption.

The "Lootie" is a still image of an African-American man in the aftermath of hurricane Katrina carrying a crate of beer as he walks through waist-high water. Published on August 25th, 2005, by the Associated Press as one of a number of images illustrating a story ("Cries Grow as Flooded New Orleans Looted"), the image quickly spread through the internet as a photoshop thread, morphing into videos on YouTube in several forms—as posters, parodies, commentaries and response videos. *The Best of Lootie* is one such video, which I will draw on to address how the Witness (as a genre) mobilizes issues of identity politics (around race) and citizenship.

While the Lootie is photoshopped across a dizzying range of popular culture contexts (for example, the Lootie appears on Wheaties boxes, the cover of *Vanity Fair*, as Frankenstein and Darth Vader) the most recurring images are those around race and race relations. Three themes are emergent: criminality (the Lootie steals beer from someone sleeping in a car; Lootie appears on the cover of a video game—Grand Theft Auto: New Orleans), entitlement (a staple of Lootie videos is a poster with the following text: "Opportunity: Because earning it is for suckas," which can be read as a reference to debates around welfare and affirmative action, such as an image of God handing the Lootie a beer—using the Sistine Chapel painting as inspiration), and race, which dominates the Lootie's participatory culture, with the Lootie being reworked in images of Tiger Woods, Oprah Winfrey, Morgan Freeman, Johnny Cochran, and Sidney Poitier to name just a few. There is a veritable cottage industry of images linking the Lootie and President Barack Obama; some of the most popular ones show him in family pictures (with his daughters holding beers), at a KFC stand on the White House lawn, and as one of the presidents on Mt. Rushmore. In an interesting departure from race, the Lootie's image was also superimposed on Hispanic figures (carrying coronas, wearing sombreros), extending the logic of race-based identity politics to those of ethnicity—a viral commentary on real-life politics in New Orleans, which has seen a large growth in the Hispanic population, post-Katrina. In sum, the Lootie can be read as an unproblematic assertion of race-based hate-speak—and it is all of that—but it is also a vehicle for the work of identity in viral culture, using a language that draws on discourses of post-political correctness and post-racialism.

The Witness as a genre also includes the personal recording of news events or public acts. In this concluding section, I want to discuss how the genre is also organized by action-oriented themes like street battles, public demonstrations,

police assaults, jay walking, drinking, fighting, crying, shouting, threatening, destroying, running, and so forth. While impossible to cover all these topics, I'll focus on two such themes (threats and demolition) as illustrative of a wider process.

"Threats" as a category of viral consumption can be illustrated through two iconic videos—*Cop versus Skateboarder* and *Office Worker Goes Insane*. *Cop versus Skateboarder* is a raw, visceral experience, a testimony to fear. It shows a Baltimore policeman accosting a 14-year-old boy who is using a skateboard in the inner-harbor tourist area. The policeman, completely unprovoked, shouts, berates, insults and degrades the young boy and towards the end of the video pulls him to the ground. The video is powerful both for the surrender he inspires in the boy, and for the fear of the violence that it appears he might unleash at any moment. I could not help recalling Ray Liotta's character from *GoodFellas*—trigger-happy and out of control—as I watched this video. The boy's helplessness and palpable fear can be felt at every point in the video. Built into this interaction is also a commentary on the uneasy relationship between Middle America and the counter-culture represented by the young skateboarder. The policeman appears infuriated when he is called "dude" (as in "What did I do, dude?"). The term becomes a litmus test for identity, arraying on the one side the world of baggy jeans, bandanas, necklaces and skateboards, and on the other side, the mainstream culture of policemen, bankers and office workers.

Office Worker Goes Insane is a video that fulfills the narrative premise established by *Cop versus Skateboarder*. It shows an extended rampage by an office worker who completely loses it. Simply put, it is a portrait of a man who "snaps" and goes crazy. The video begins innocently enough with a humdrum office scene with the protagonist sitting at his desk. A co-worker approaches him and they appear to talk and then it happens—the man stands up, grabs a keyboard and smashes it over his co-worker's head. He then proceeds to systematically destroy the office—throwing computers, standing on tables, hitting objects with a lamp and pushing down office shelving and even cubicles. People cower in fear. One man manages to disarm him briefly before his rampage continues. Captured on a CCTV camera the video can be read as a fable about modern-day alienation or as a portrait of the seething anger that lies just under the surface in many offices. When this video went viral it was eventually revealed that it was a scripted video made as a viral promotion for a film—which did little to stop the use of the video as a starting point for on-line discussion of office culture and work.

"Demolition" is a staple of Witness videos. It appears not just as the expres-

sion of teenage angst and love of pyrotechnics but as a full-grown adult obses-
sion with the destruction of objects, walls, cars, houses, and just about anything
else. Two iconic examples of demolition as a thematic are *Whale Blows Up* and
Destruction of Kingdome. A caveat: unlike most of the examples in this chap-
ter, these two videos were shot and produced by professional newsmakers but
have achieved iconic status through YouTube and related social media.

Whale Blows Up (also known as *Exploding Whale*) is a 1970 local news seg-
ment by a TV station in Oregon (KATU) that tells the story of a beached sperm
whale in Florence, Oregon. The authorities decide to dispose of the rotting car-
cass by blowing it up rather than burning it. The whale is destroyed in spec-
tacular fashion—but with unexpected consequences. In place of neat
destruction, the whale's blubber is thrown high in the sky, falling in dangerous
chunks as people run for shelter. A large piece falls on a car, squashing it, while
drenching people in rotting flesh and a powerful odor. Told in a rich, clever,
and evocative narrative style (all but absent in local news today) by a bemused
correspondent who jokes about how "land-lubber newsmen" became "land-
blubber newsmen" and uses extended (tongue-in-cheek) alliterations ("The
blast blasted blubber beyond all believable bounds") the story of the explod-
ing whale is as much about its telling as it is the actual event. What is remark-
able about this video is its long intertextual journey over a period of 25 years.
It remained the stuff of urban legend until humor columnist Dave Barry wrote
about it in a column in 1990. The column led to renewed interest. Somehow
the video of the story surfaced on YouTube and other websites and soon went
viral. Today, it serves as an important example of demolition as a thematic—
and equally importantly of the work of viral culture in the making (and recall-
ing) of public memory.

The Demolition of the Seattle Kingdome is an iconic video on YouTube—read
variously as a text about the removal of an urban eyesore or a beloved public space,
but almost always as a place of memories. All of these discourses surround the cen-
tral image of this video—a primal, spectacular act of destruction. Watching the
video, what stands out is the sudden resolution to its narrative arc. The video
begins with the barely visible movement of the dome, followed by a vision of sub-
terranean power—cracks of light appear simultaneously along the beams that sup-
port the structure, followed by a short, awe-inspiring sight, the appearance of a
huge cauldron of boiling smoke that billows out, like a scene from a second-rate
disaster film, wreaking destruction in its wake before the quiet ending. The
smoke subsides relatively quickly, revealing the death of a stadium.

· 1 6 ·

THE WORD

In the beginning was the Word.
—JOHN 1:1, THE BIBLE

Introduction

The Word is a YouTube genre where there is little textual commonality across different examples of the genre, rather the commonality comes from the singular resonance of a set of words (phrases, song titles, conversations) across different online realms (videos, blogs, forums) and eventually into the parlance of popular culture. Simply put, these are catchphrases, which take on a powerful syntactic and semantic unity that makes them an important element in the ongoing process of participatory assemblage that is viral culture. They become free-floating texts used in a number of different contexts, each usage often ignorant of their point of origin. These catch phrases emerge from a range of sources—TV shows, video game play, music videos, and of course other YouTube videos themselves.

I suggest we read the Word as a genre as a "discourse" in the tradition of Michel Foucault (McHoul & Grace, 1993; Howarth, 2000). For Foucault,

discourse refers to the "systems of thought that systematically construct the sub-
jects and the worlds of which they speak" (Lessa, 2006, 284). While discourse
as a method has traditionally been used to study institutions (such as the hos-
pital and the prison), I am suggesting that the concept can be used to under-
stand the work of the Word as a genre, since these sentences take on a structural
function, constructing what Foucault would call regimes of understanding—
they powerfully frame a specific set of normative expectations and behav-
iors—all stemming from the "meanings" that each term connotes. This
connotation is historically informed by its initial setting (game play, music
video, TV news report) but then takes on a life of its own. This makes it sim-
ilar to the idea of "genealogy" in Foucault's work where "a given system of
thought is the result of contingent turns of history, not the outcome of ratio-
nally inevitable trends" (Michel Foucault, *Stanford Encyclopedia of Philosophy*,
pp. 5–6 http://plato.stanford.edu/entries/foucault accessed 9/22/10). I also draw
sustenance for such a reading drawing on the media ecology tradition (Marshall
McLuhan, Harold Innis, James Carey, Joshua Meyrowitz, Paul Levinson to
name just a few people) of understanding the role of representation in an
image-saturated world, where *the word becomes the world* gives credence to the
idea that we live in an age where words have an agency all unto themselves,
fashioning the nature and intent of human action. This appears especially
true of daily life in wired societies where the link between the real and virtu-
al is rapidly disappearing, especially in a digital context.

Examples

I will restrict my discussion of the Word as a genre to examples from Television
News (*Boom Goes the Dynamite* and *I Like Turtles*), Gaming (*All Your Base Are
Belong to Us*), Music (*I Want It That Way*), politics (*You can Vote However You
Like*) and viral culture (*Very Erotic, Very Violent*)

 Boom Goes the Dynamite is an expression uttered by Brian Collins, a stu-
dent sports reporter at Ball State University, to describe a basket scored by
Reggie Miller of the Indiana Pacers. Collins, who was filling in at the last
minute for another student, appeared out of sorts and mumbled through most
of his narration, at times wearing wearying of the task, barely able to keep up
with a malfunctioning teleprompter. He perked up as Jones' clip played and
adlibbed the famous lines: "Boom goes the dynamite" as Jones scored. The video
quickly went viral with numerous re-mixes, parodies and even a song. It mor-

phed over to mainstream popular culture when Will Smith, speaking at the Oscars, used the phrase to cover up a stumble in his monologue. Soon there were references to the phrase on *Family Guy, Veronica Mars, Keith Olbermann, Bob Costas,* and *ESPN SportsCenter.* Collins also made an appearance on the *David Letterman Show.*

Boom Goes the Dynamite can be read as a text about youth, ineptitude and performativity. There are long pauses in the voiceover when Collins says nothing, at other moments he struggles mightily to match the video, at one point it appears that he might just get up and leave, but in the end he sticks with it, forcing himself to finish the job—albeit haltingly and painfully. It's not just the inventiveness of the key phrase but its delivery that has become iconic—the cleverness of the line with the strangulation of the on-air delivery all comes together in an inimitable way and makes Collins a symbol of a moment that strikes fear in so many—on stage, before a camera, in the spotlight.

Much like *Boom Goes the Dynamite, I Like Turtles* emerges as a disruption in the straight-jacketed narrative structure of television news, this time through a sound bite of a young boy being interviewed. The news reporter is covering a local event for children, where many of them are dressed (and painted) like zombies. The reporter approaches one such boy, who is asked about his experiences at the event and his views on being a zombie. In place of responding along appropriate lines—such as how cool it was to be a zombie or how much fun he was having at the event—the boy, looking stone-faced and determined, memorably utters, "I like Turtles." The reporter is taken aback, clearly nonplussed, but completes her stand up, ignoring the boy's response.

I Like Turtles is a testament to the power of the absurd, but even more than that, it is an example of the role of the disjunctive as a rhetorical element in digital culture. The boy's response is so completely inappropriate to the question being asked, and he is so oblivious of the narrative frame he is positioned within (that of the television news sound bite, which typically precludes any deviance from a narrowly constructed set of responses) that the words he uses take on an agency of their own, becoming a shorthand for the power of interruption and the unexpected.

In addition, what's iconic about the video is that it's sheer fun—the boy looks perfectly composed, at ease with his passion for turtles, and more than happy to take this wonderful opportunity to tell the world that he likes turtles. Any parent can attest to how young children bring "random" topics into a conversation—clearly it takes them time to understand the rules and conventions of a structured conversation.

All Your Base Are Belong to Us is arguably the most important example of the Word as a YouTube genre. When YouTube was taken down temporarily in 2006 (for maintenance) the phrase, "all your video are belong to us" appeared as a placeholder. It speaks volumes that this phrase—above all the other user-generated referents—was chosen, signaling an assumption about its ready recognition by YouTube users all over the world. *All Your Base...*as it is usually referred to, is an "old" Internet meme (from 1998) and refers to a cutscene from the 1991 side-scrolling arcade shooter game *Zero Wing*. The phrase appears in a conversation between the Captain, the operators and the enemy (referred to as CATS). The line is uttered by CATS as a follow-up question after he politely enquires, "How are you gentlemen?" The phrase spread through numerous channels, as a piece of Flash animation, and as a thread in discussion and online video game forums. Further spread happened through related websites such as Newgrounds and Something Awful. Mainstream media coverage followed with accounts in *USA Today*, Salon.Com, *San Francisco Chronicle*, *The Guardian*, and *Wired* magazine. There are images on various websites of the phrase carved into monuments, sand dunes and appearing at school rallies (it is unclear if these are actual images or photoshopped ones).

*All Your Base...*can be read as a text about viral literacy—its resonance across a staggering range of referents—videos, books, comics, clothing, radio shows, songs, television shows, other video games, webcomics, and of course websites. Its origin in video game play, while important, is only one point of reference. With each use (and re-use) the meme chains out the semantic and sociological context of the phrase, eventually leading to its use in the entire project of viral culture.

I Want It That Way is an Internet meme that originated in mainstream media as a song by the Backstreet Boys (from their 1999 album Millennium) but has since been reworked in a dizzying range of popular culture texts. Some examples include parodies by Howard Stern, "Weird Al" Yankovic, Tim Hawkins and OhBoyz. It has also been sung by different competitors on *American Idol* and *Britain's Got Talent*, and there have been numerous remakes by different artists as well as many references in TV shows. A sense of the meme's intertextual complexity can be evoked with two references—a video by two Chinese students who lip synch the song (they are referred to as Asian Backstreet Boys) whose performance was parodied in the first season of the TV show *Heroes*.

Despite this complexity of representational contexts, this meme shows a remarkable resilience in its discursive intent—a suggestion of sexual predilec-

tion and desire is retained through many (though not all) subsequent remakes, parodies and spoofs. The question that is consistently addressed either explicitly or through innuendo is "What way does he like it?" Anchored within this tactic is the question of sexuality, with a plethora of comments and discussion on whether or not the Backstreet Boys are gay, questioning if this is a song about "the gay way," or, as is common on the Internet, heated hate-speak around gay performativity and identity.

You Can Vote However You Like is a video by students at Ron Clark Academy in Atlanta, which became an Internet meme during the 2008 election campaign. Inspired by the rapper T.I.'s hit, "Whatever You Like," it speaks with passion and verve for both candidates. The title of the song became a free-floating text used in a range of online referents, from other videos, to spoofs, to viral commentaries on the election. *You Can Vote However You Like* is often read as a paean to the political process with the "however you like" signifying the prospect of free choice and will. However, I believe this misses the work of identity politics that this video performs. I suggest we read this video as coterminous with the rise of Obama as a new kind of African-American text, functioning outside the realms of traditional enactments of race in America—music, sports and religion. This new identity is one that is anchored in themes of personal will and unlikely success (Obama's well-documented journey).

As members of Ron Clark's academy the singers are already positioned within a celebrity narrative—one anchored in their personal life stories, typically from poor unprivileged backgrounds. The school provides a script for their lives, which includes both academic success and global awareness (students go on trips to six continents by the time they graduate). It is equally important to note that while the singers speak in this new African-American voice, they use a language at the center of contemporary popular culture—hip-hop. There are marked differences with the original video, which tells the story of a cashier who daydreams about another kind of life (with the musician in question) before she returns to reality. In choosing this language the video retains a sense of discursive continuity of race/pleasure-based discourses while forging a new alliance with the identity politics that Obama inaugurates.

Very Erotic, Very Violent was an Internet meme/phrase that originated in China in 2007 and then spread through repeated use across multiple contexts. Originally the phrase was a quote from a report on a Chinese TV program (called *Xinwen Lianbo*). In the report a young girl complained about the explicit nature of some Internet content, calling it "very erotic, very violent." The quote became a rallying point around critiques of state-controlled news broad-

casts and Internet censorship in China. There were online calls and investigations into the girl's identity, with numerous claims about the interview being manufactured rather than real and about the nature of journalism in China more generally.

Very Erotic, Very Violent can be read as a text about the subversive, subaltern power of participatory culture, especially its relationship to the work of the state. China's unique role in global capitalism—an enormously successful capitalist engine run by a socialist state—leaves questions of individual agency, freedom and accessibility unaddressed. Internet memes like *Very Erotic, Very Violent* work in this liminal space, working the terms of the contradiction that is contemporary China's role in the world today. If Chinese use of the Internet can be read as a complex allegory about working behind the lines and reading between the lines, then this meme can be read as a subaltern gesture finding expression through viral culture. Going further—and more speculatively, this meme is part of a *language of invention* that captures the complex admixture of national pride, public will, personal agency and a commitment to being/living through the viral that is shaping contemporary China today.

· 1 7 ·

THE EXPERIMENT

Everybody's a mad scientist and life is their lab.
—DAVID CRONENBERG

There is no such thing as a failed experiment.
—BUCKMINSTER FULLER

Introduction

The Experiment is a genre on YouTube that is focused on a recurring narrative element—the mobilization of an object (or objects) in new disjunctive ways in order to assess/enjoy unexpected outcomes—but such expectations are almost always accompanied by (in)direct control and safety—in other words, an ability to enjoy the show from afar. The Experiment as a genre is not unlike reality television. Reality television's "overarching characteristic is its claim to the real which it underscores through its aesthetic strategies—use of cinéma vérité, surveillance video, low-end production values or natural settings" (Murray, 2004, 1900). In addition to such aesthetic techniques, the Experiment fulfills two other functions that reality television usually undertakes: it mobi-

lizes a conversation about cultural surveillance, what Ouellette and Hay (2008) call "placing television in an analytic of government" (17), and also specifically is a discourse about control of the environment—a wider process where "objects of science only come to us in hybrid forms affected by power and meaning" (Friedman, 2002, 206). Ouellette and Hay's book, *Better Living Through Reality Television*, addresses the role of reality television in the work of citizenship, in a culture "where citizenship education is privatized" (2008, 16). Reality television becomes an expression of citizenship by presenting a (controlled) examination of identity through the placement of racial, sexual and gendered others in spaces of contestation and collaboration. In doing so, it shows television's ability to "link practices of self-cultivation and self-fashioning to the lessons and tests of citizenship" (Ibid.). In a similar vein, the Experiment on YouTube puts into play different objects, artifacts and concepts around daily life and abstracts from them observations about the value (civic or entertainment) of such objects. Such observations may be mobilized as fables about office life (*Sticky Note Experiment*), the built environment (*The Fun Theory*), industrial design (*Will it Blend?*), media culture (*Squeeze Me*) or performativity (as in *Diet Coke and Mentos*). Miller's (2002) analysis of the Weather Channel as a reality narrative about environmental control is invaluable for understanding the Experiment as a genre. He suggests that "TV weather embodies the desire of modernity to know and control" (203) and the Experiment works similarly—finding (viral) ways to represent that same discursive intent—one of control and surveillance. In the examples that follow, I will suggest that such an analytic—control of the human environment—mobilized through the use and placement of industrial objects in experimental situations, is the dominant leitmotif of the genre, and in doing so it extends the logic and participatory intent of reality television to the Internet.

Examples

The *Diet Coke and Mentos* video shows two men in lab coats (Fritz Grobe and Stephen Voltz) conducting an experiment with Diet Coke and Mentos. The experiment consists of putting Mentos into the bottle, which results in a huge geyser foaming out of the neck of the Diet Coke bottle. The science behind the experiment is a frequent point of discussion ("mixing the caffeine, potassium benzoate, aspartame and C02 in the Diet Coke with the gelatin and gum Arabic in the mentos creates a chemical effect, with the foam from the Diet

Coke to shoot in the air" http://www.urlesque.com/the 100-most-iconic-internet-videos accessed 4/13/09). The two "scientists" set up the storyline of the video with what is called "experiment four," where they use two Diet Cokes and four Mentos, followed by the centerpiece of the video, experiment 137, which is an orchestrated display of 101 Diet Coke bottles and 523 Mentos. The display uses the famous fountains in front of the Bellagio Hotel in Las Vegas as its reference point and is spectacular. The video is often discussed as one of the most influential viral videos ever made. It won the 2007 Webby Award and was also an Emmy Award nominee (for outstanding broadband content) the same year. The experiment has been copied (or used intertextually/ironically) in a number of television shows, including *Numb3rs*, *Bones*, *Mythbusters* (which devoted a segment to explaining the experiment) and in an episode of *The Simpsons*, entitled "The Debarted." A segment on *Late Night with David Letterman* also replicated the experiment.

The *Diet Coke and Mentos* video resonates in three interrelated realms—performativity, science, and competition. The video explicitly draws on mass-mediated themes around science (the mad scientist, the crazy experiment, the joy of basement rocket science, among others). A range of films have used this narrative device (*Back to the Future* being the most famous) to frame popular understanding of one kind of science—the backyard, have-fun-with-chemicals, variety. It is this underlying discourse about science as counter-culture, a place for adolescent angst and attention-seeking display that speaks to the popularity of this video. Vegas, in all its cultural referents, especially excess, is certainly part of the context that the video needs to be read in but even more so is the idea of science as performance itself, created through the "role" of the mad scientist, mixing chemicals and fun in equal measure. This is reflected in comments on the video, which overwhelmingly embrace this reading ("oh, my god, sexily awesome," "awesome man, I am going to try it" "awesome!!!!!!!!"). Tied into this reading of the video is its ready accessibility, with a large number of people posting videos of setting up their own Diet Coke and Mentos experiments. These videos in turn are surrounded by discussions and comments about the relative value (and effect) of different sodas and different candies and the success (or lack of) of individual efforts in carrying out the experiment. In sum, the actual act of experimentation (mobilizing science as performance) is a key element in reading this video. The other element that needs to be emphasized is competition—the original *Diet Coke and Mentos* video has sparked a global competition around the largest number of Diet Coke geysers that can be simultaneously launched. This is a constantly updating competi-

tion. The current record is held by students at the School of Business Administration in Turbia, Latvia, who launched 1911 geysers in June 2008. They eclipsed earlier attempts in the year by students in Leuven, Belgium (1,360), and Louisville High School, Kentucky (1,800). I want to focus on the Belgian competition, for its visual resonance with an older discourse about science and experimentation—the alchemist. Photographs of the Belgian experiment, widely distributed by fans of this video, show three key images: The first is of a plaza full of students identically dressed in huge raincoats, their heads cloaked monk style. They bend over long tables each lined with bottles of Diet Coke. There is an air of mystery and deceit as they await the order to drop the Mentos into the bottle. The next image is a wide shot of the geysers erupting, as the students stand straight up (rather than recoiling), a vision of controlling a strange energy, known only to the initiated. The last image shows the students milling happily together in an image strikingly reminiscent of a cult-like gathering, with members taking part in a strange, arcane performance. Read alongside the other themes discussed before, what is mobilized in the Belgian experiment is a historical grounding of the narrative of science as performance, in associated realms of alchemy and wizardry, a reading already present in key filmic texts, like the *Harry Potter* series.

The *Will It Blend?* videos are an example of a phenomenally successful viral marketing campaign (with over 100 million views) for the company Blendtec that makes high-end blenders. The brainchild of Tom Dickson, the creator and founder of the company (and the star of the videos), the videos have blended everything from pork and beans to cheese to oversized lollipops, and Dickson has emerged as a viral celebrity in his own right, appearing in a range of commercials, late night television shows and even music videos.

The *Will It Blend?* videos can be read as a parable about technology, as a means rather than as the end, of consumption. Focused narrowly on the performative power of technology, it structures the narrative in specific ways—the exposition focused squarely on incredulity—they will blend *what?*—followed in rapid progression by rising action—the placement of the object to be blended and the clanking, whirring, stirring action of the object as it starts to break apart. The narrative climax is predetermined (the object gets blended), but the possibility of failure remains. This simple formula has rendered iconic status to the *Will It Blend?* videos—at their heart a narrative about possibilities (blending anything) and questions (Why would you blend that expensive item?). However, I suggest that beyond that, the *Will It Blend?* videos also offer an epistemic about the role of technology in postmodern/digital life—centering an

industrial object (the blender) as the vehicle for wider discourses about consumption. Going further, I suggest that the *Will It Blend?* videos are about technology *itself* as an object of consumption.

Perhaps the most iconic—and popular—of the *Will it Blend?* videos is that of the iPhone. Read as an ironic, in-your-face dig at the obsessive fetishization of "macheads" everywhere, the video also offers an unstated but powerful sermon about the means and ends of technology. Once again this is mobilized through a narrative arc that underlies all blend videos. The storyline unfolds as follows: Tom Dickson, the main character (he serves as the voice of the series, acting as a "scientist"/spokesman) decides to blend his old iPhone since has just purchased a new iPhone 3G. He puts the phone in the blender with great deliberation (but it is clear to the viewer that he has "accidentally" put his new iPhone in and not the old one). It is a moment suffused with (ironic) meaning—here is a media object unlike any other—expensive, and beyond the reach of most consumers but also an undeniable work of art. The iPhone represents the consumptive end of technology like few other objects before it. Reading viewer comments (for example, "he must be loaded if he can go around blending iPhones" "why did u not give ur iphone to me?") it becomes clear that the sheer audacity of the act and its willful disregard for the monetary/aesthetic value of the iPhone is what has made this the most important *Will it Blend?* video. Once the blender is started the narrative takes a while to unfold. There is an extended rising action where the iPhone joggles around and bounces off the sides of the blender for a long, long time, and in doing so poses a (narrative) complication—is the iPhone after all too strong? Will the blender be able to blend it? The answer comes soon after, a powerful climax in a moment of pure annihilation as the iPhone disappears into a thick cloud of black gas and soot. The resolution follows swiftly—and dramatically: Dickson opens the blender and pours its contents into a wine glass. The viewer is left with what appears to be the final exclamation point in a viral commentary on the consumptive ends of technology. But there is more. Dickson now realizes that he has "accidentally" put his new 3G phone into the blender in place of the old iPhone. This narrative bookend provides closure, adding in elements of human fallibility and providing an additional counterpoint to the overall theme of the video (A final note—there is now a *Will It Blend?* iPhone application, which allows viewers to see the videos in a higher resolution!).

The iPhone blend video needs to also be read alongside a wider discourse around the "cult of Mac" which animates a broader "culture war" between PC and Mac users. Viewer comments to the iPhone video suggest that this is a rich

source for a contextual reading of the video. The comments expectedly range from the celebratory ("Why don't you blend a Macbook, that would be cool" "It is so nice to see apple products get ripped to shreds";"finally, a good use for that crap phone"; "that was awesome") to the pained ("I started to cry—what did the iphone ever do to you?"; "that was painful to watch") and those in the middle, serving as a form of reflexive commentary ("I'm sure apple fans cried after that. Even so, I found it oddly satisfying"; "who doesn't like expensive gadgets blended to death?").

The Fun Theory is a series of videos of which the most popular are *Piano Staircase*, *Bottle Bank Arcade Machine* and *The World's Deepest Bin*. *Piano Staircase* is a video that shows what happens when steps leaving an underground location (either a store or a metro station) are turned into piano keys. In place of just walking up the stairs, people actively engage with the steps, jumping up and down and "playing" the piano. In a similar vein, *Bottle Bank Arcade Machine* has recycling bins that are shaped and function like a video arcade. People push, throw and press different parts of the bin as they distribute their recycling. Finally, *The World's Deepest Bin* is a garbage can which mimics the noise of an object falling into a deep well (or shaft) as you throw your garbage in. People respond to both these experiments readily, actively running up the stairs, throwing things energetically into the bin and pushing/pressing different parts of the arcade with enthusiasm.

I suggest we read all these videos as a testimony to the power of mediated performativity of daily life. As people encounter each of these wonderfully constituted experiments, they provide ample evidence of the ways in which the aural, visual and kinesthetic experience of media can work in simple yet profound ways to structure urban life and experience. The experiments do considerable cultural work through enacting strategies for the consumption of urban spaces and industrial objects that extend their meaning outside of their utilitarian context. These strategies function in the realms they readily suggest— the value of exercise for *Piano Staircase*, recycling for *Bottle Bank Arcade Machine* and garbage disposal for *The World's Deepest Bin*—and it is appropriate to read such functions into these texts—but it does not do full justice to the pedagogical and creative impact of these experiments/videos.

All three experiments embody success—they provide a language for the reimagination of urban spaces. *Piano Staircase* works through the action of "mobility" as an aural and sonic experience. The flow of people from the escalator to the piano stairs provides a visual marker of such a reimagination. *Bottle Bank Arcade Machine* marries the viral and the real using the language of video

games—and in the process reworks the "recycling" message using a new language. It introduces the act of "playing" (the central constitutive element of video games) *into* the urban landscape. By turning an industrial object into a console it brings the "players" outside—from their bedrooms and viral dens. Of course, the experiment also begs the question—how does such a mediated transfer affect our understanding of both spaces. For the Luddite, a dystopian reading suggests itself—that the experiment takes away the best of street life—its laughter, hustle and bustle—replacing it (eventually, if the experiment keeps growing) with rows of video monitors inhabited by sullen, unmoving, unblinking and near catatonic gamers. *The World's Deepest Bin* resonates (pun intended) in a number of ways. It mimics the sound of a stone (or any object) being thrown into a deep shaft (for example, a well or a canyon, or as the title of the experiment suggests, a bin). It succeeds admirably in conveying its overdetermined message—don't dump your garbage on the street, go for the dumpster. Its richness lies in the pedagogical connections it undertakes—it brings into play a related set of referents—hiking, throwing pebbles in the water, skipping stones, and above all a specific image/experience—throwing stones into a long-forgotten well, half covered with moss, and dangerous for children to play around, lest they slip over its crumbling walls and plunge into the abyss. Such a psychic grounding in the exploration of nature (and human habitation) underscores the success of this experiment. It makes an industrial object (the garbage bin) continuous with nature, and in doing so undertakes important cultural work—reconfiguring the urban in the terms of the natural environment—a place where garbage meets grandeur.

I want to conclude with a few thoughts on the organizing rubric of all three videos—the fun theory. "Fun" orients all three videos and their intentions (exercise, recycling and garbage disposal) within the rubric of pleasure, each act presenting a new way to have fun for fun's sake. However, this is fun with agency, it is about the creation of an environment that creates a certain kind of inhabitant—a healthier, cleaner and more conscientious one. It is a rhetorical gesture, taking the message of health and environmental activism and reworking it in new ways, primarily by taking human will out of the equation. In place of asking humans to do the right thing (recycle, be clean, etc.), it creates an environment where such acts become the fun thing. This transference from right to fun is at the heart of the success of these experiments. The word "theory" could easily be substituted by the world "psychology"—the experiments assume a vision of humanity as incapable of selfless, collective action unless it's wrapped in something "fun." Such a reading is all the more appro-

priate given the sponsors of the experiment, a car company (Volkswagen) whose identity is built on a vision of 1960's counter-culture.

Squeeze Me is a video made by a band from Holland called Kraak and Smaak. Its soundtrack has a retro upbeat and somewhat tinny sound. It features images from flipbooks with a variety of actions superimposed on the actions of a man. The key technique is an alternation between actions in the flipbook and in "real" life. It begins with a shot of stairs, followed by images from the flipbook with somebody walking down. A man appears and then turns his head in the flipbook. The narrative then develops to take account of a number of actions in the kitchen (the primary environment that this video is shot in). Toast pops up from a toaster and onto the pages of a flipbook where it turns into a large sandwich and then pops out to the image of a man eating it. In addition to images of expected actions there are unexpected turns in the narrative—the flipbook is superimposed on the chest of the man and a hand reaches into it and pulls out his heart (a large, pink, heart-shaped balloon) and squeezes it. In another instance the man takes off his shirt and the flipbook reveals a bird-cage inside. Later in the narrative the scene moves to the living room where the man watches TV with the action occurring in the flip book (rather than in "real" life). The video ends with the man's bedroom at night where he applies toothpaste (in real life), brushes his teeth (in the flip book) and then falls asleep first in the flipbook and then in the bed.

Squeeze Me can be read as a text about the very *act* of representation. In its sophisticated layering of the real and the textualized, it presents a language for understanding both the mobility of identity and its utter obedience to (mediated) change. This is a complex video. On the one hand it provides a reductive lens to action—people move objects in determined directions, they themselves move similarly: get dressed, work at tasks, get organized and fashion their immediate environments in expected trajectories that fulfill the unstated goals of such predictive actions (getting ready for bed, eating food, wearing clothes, etc.). But the video is much more—it presents inner spaces, emotions and motives. New objects that don't belong in the environment appear (as do people) representing, animating, inner discourses—and in so doing present a parallel text that works disjunctively with the narrative. Daily action, the video suggests, has inbuilt, hidden paradoxes that shape who we are and how we function. There is a normative vision that underlies the narrative—it is the idea of the built environment as a straightjacket, putting a constraint on creativity and poetic license—a task then undertaken by the inner space of expression.

What gives *Squeeze Me* such analytical depth is its use of a simple representational technology—the flip picture book—which is simultaneously representational and reverential of an age before visual media, where the image had to be pulled into action with the flip of a thumb and the drawing of carefully choreographed action of ink-drawn figures on the edge of a page. At the heart of the appeal of the video is the central narrative action—the act of flipping. This central act evokes a world of action *within* the environment even as it uses a force for action (the flipping of the pages) *outside* the environment. I believe this reductive action condenses several layers of simulation—at times the two spaces (outside/inside) collapse where the act of representation *is* the action. At other moments, the two spaces work disjunctively, animating a duality of performance and narrative.

Sticky Note Experiment features the creators of *Diet Coke and Mentos* (EepyBird Productions) taking on the boredom of office work and recasting it through their weapon of choice—the humble sticky note (or rather sticky notes, all 280,951 of them). The video begins with close ups of busy workers at boring jobs. A woman has a whole pile of files dumped in front of her. The camera zooms in on two employees in a corner who look up and are immediately recognizable as the creators of *Diet Coke and Mentos*. In the same style as their earlier experiment, they first do a simple act—the unraveling of a stack of sticky notes on the side of a table (experiment number 1). The video then cuts to "experiment number 182," which is a dazzling display of pyrotechnics (if that's the right word) with sticky notes. Sticky notes in a range of colors (yellow, green, pink, orange) are stacked and then flipped over tables, shelves, chairs, computers, lamps, drawers, and the numerous industrial objects that are common to offices. As the sticky notes are flipped, they cascade down in undulating waves (the sticky notes have been stuck together at the ends). Soon the complexity of the experiment is taken several notches up with notes coming down from windows, doors and overhangs. There are waves upon waves of sticky notes coming down from above. In one remarkable sequence, sticky notes bounce from one shelf to another just below it, giving the impression of running sticky notes. In another sequence, an office worker is trapped as "lasers" of sticky notes surround her and render her immobile. My favorite was the image of a sticky note "ball" rolling down a sticky note "bridge." It is a masterful display where the sticky note assumes an agency of sorts—running, rolling, curling, bouncing, as if animated by some inner purpose. There is a final crescendo in the narrative as the entire office is drenched in a "rain" of notes.

Sticky Note Experiment can be read as paean to creativity animating a space

as soulless as the modern office. The video ends with the "boss" coming in and disapprovingly surveying the mess as the "workers" raise their arms in triumph. However, there is a twist ending. In place of recrimination, the boss pulls on one of the sticky note piles and watches it curl away in an attractive motion—after watching this, he appears convinced and walks away shrugging indifference—and tacit approval. He turns away from the camera, and we find there is a note stuck to him, the camera zooms in and we read (in place of the expected "Kick Me") the name of the creators: "EepyBird Productions." Read as a text about agency in the modern workplace, *Sticky Note Experiment* suggests the possibility for self-expression through even the most uninteresting of industrial objects—the sticky note—and in doing so provides a script for the remaking of office life, and, to extend the analogy, to the idea of work itself, from "just a job" to something more.

Do Try This at Home! is a series of videos (by the same company, EepyBird) all focused on taking everyday objects and reinvesting them with the language of science. *How to Make Fire* shows how easy it is to start a fire using steel wool and a battery; *Flying Tea Bag* shows how you can set an empty tea bag on fire so that it "blasts off"; *Defying Gravity* shows how you can balance two forks on the side of a glass without any support, and finally *How to Make Hot Ice* shows how the mixing of certain chemicals leads to instant "ice."

The Experiment as a staple of popular representations of science is the common leitmotif in all these videos. They offer similar points of entry into the work of science—as continuous with backyard fun *and* as a scholarly language that explains eye-opening phenomena and, most of all, the ability of science to turn the objects of daily life—tea bags, forks, steel wool—into, for the lack of a better word, instruments of magic. While they share these overall narrative similarities, each video offers specific narrative trajectories.

While *How to Make Fire* marries household objects to easy functionality, it is underwritten by a more complex question—that of nature generally and a reworking of the "outdoors" question in particular. It recalls images—some expository, some comedic—of boy scouts (and grown men and caveman before that) rubbing sticks, hitting stones, aligning mirrors against the sun, and so forth, all with the goal of starting a fire—and usually failing. The message from this video comes through clearly—if only they had steel wool and a battery! Even without a laugh track, this is a video that makes light of the project of the outdoors—which is one of shaping (urban) boys and men into some semblance of what they once were—creatures of the forest. Instead it offers a shortcut that industrialism makes possible and in doing so cuts through the tedi-

um and boredom of daily survival. Who needs to work hard at making a fire when it's just a rub of a steel pad away?

Watching *Flying Tea Bag* reminded me of the pleasure derived from a toy that typically comes with a McDonald's Happy Meal—a cheap, quickly forgotten thrill. The tea bag launch is a stand-in for a space shuttle, where the thrill of take-off is a poor imitation of watching a spectacular liftoff at Cape Canaveral. It is, however, animated with similar narrative questions—Will there be a faultless liftoff? Will it disintegrate as it rises shakily from the ground? In each case, success is typically assured, but it is the paradigmatic question of possible failure that keeps me watching numerous examples of the tea bag videos. Along the same lines there are other videos that were similar in narrative intent but lacked the inventive energy of *Flying Tea Bag*. For example, *Do Try This at Home! Rocket Engine* takes the viewer through an extended (and quite tortured) set of instructions for making a paper engine that fires off the table, but without any of the panache of the tea bag.

Do Try This at Home! Defying Gravity is a marvel in simplicity, showing how two forks on the side of a glass can be held up without any support. Each step of the experiment is easy to follow and the payoff complete—a sense of pleasure at its ease and wonder at its implication—how easy it is (apparently) to cheat gravity. *How to Make Hot Ice* is an experiment that represents the working out of two intertwined themes—science and wonder. Both these themes come together in a singular moment—the pouring of the white liquid into a container and the creation almost instantly of "ice." There is a hypodermic quality to the image, where in one arresting moment water turns to ice, liquid into solid—it is an act, simply put, of magic. The rest of the video works different elements of this equation—the explanation of the scientific process, the carving of the ice into sculpture and so on, but in the end, these elements play suitor to its visual centre—the making of hot ice.

Finally, I want to end with an experiment that spoke to a certain classicism, a timeless appeal to tradition, a rendition of an experiment known to many and often cited as a trope of backyard science—*Reuben's Tube*. The experiment features a flame bobbing up and down in time to the music being played. While there are numerous examples of this experiment, I chose the most popular, which featured a shaggy-haired science aficionado who takes us through the experiment. The narrative is marked by an easy, assured pacing that is well suited to the video's low-end production quality. A pared-down home video with little (visual) decoration, it has the air of watching your fun-but- somewhat-eccentric uncle showing off his favorite science project. It evokes a simpler time

and sense of fun—the tube lights up and shoots up and down in syncopation with the sounds of jazz and rock and roll. The flame and music work in tandem, evoking joy and wonder in equal part. The video's ending is memorable in its simplicity—the eccentric uncle/science aficionado turns it all off and amiably asserts, "and that's Ruben's tube."

APPENDIX A

List of Video Entries

The primary video entry is listed singly and remakes are indicated in brackets after the entry.

Section One: Fame

Chapter 3: Icons

Star Wars Kid (Star Wars Kid and Yoda, Star Wars Kid South Park), Numa Numa, (Numa Numa Syncesta, Numa Numa Osama Bin Laden), Chocolate Rain (Vanilla Snow), Susan Boyle (Britain's Got Talent), Paul Potts (Britain's Got Talent), Where the Hell Is Matt?, Free Hugs, Guitar, Leave Brittany Alone (Leave Chris Crocker Alone), Crank That/Soulja Boy, Achmed the Dead Terrorist, Tron Guy.

Chapter 4: A Viral Childhood

Ha Ha Ha, Charlie Bit My Finger, He's Gonna Kick My Ass, Asian Baby Sings Hey Jude, David After Dentist (David After Donuts, David After Swimming, David After Drugs, David After Divorce, David After Diabetes), Dancing Baby, Evian Dancing Babies.

Chapter 5: Where the Domesticated Things Are

Cat Flushing Toilet, Shiba Inu Puppy Cam, Hamster on a Piano (and Popcorn), Skateboarding Dog, Two Talking Cats, Otters Holding Hands, Dramatic Chipmunk, Sneezing Panda, Dog Rescues Dog from the Highway, Christian the Lion, Puppy Throwing, Battle at Kruger, Baidu 10 Mythical Creatures, Raptor Jesus.

Chapter 6: A Viral Dance

Peanut Butter Jelly Time, Badger, Badger, Badger, Frozen Grand Central, Fat Kid Dancing, Fat Kid Dancing to Ms. New Booty, Fat Aerobics, Fat Kid 2007 Easy Rider Bike Show, Shakira Hips Don't Lie (parody), the Evolution of Dance.

Chapter 7: There's Music in the Machine

Terra Naomi, Hurra Torpedo, Back Dorm Boys, Hannes Coetzee, Prison Inmates Remake Thriller, Kersal Massive, Bert and Ernie do Gangster Rap, 12 Days of Christmas Straight No Chaser, 12 Days of Christmas Boymongoose, Little Superstar, Lemon Demon, Here It Goes Again, YouTube Symphony Orchestra.

Chapter 8: Lights, Politics, YouTube

Howard Dean Scream, Bush Parody Frank Caliendo, Young boy Imitates Bush, Yes We Can, Obama Girl, Whatever You Like, Obama Swatting a Fly, Obama calls Kanye West a Jackass.

Chapter 9: Let's Get Physical

Guys Backflip into Jeans, Daft Hands, Kobe Jumps over Car, La Caida de Edgar, Fat Boy on a Rollercoaster, Afro Ninja, Grape Lady, Scarlett Takes a Tumble, Zidane Headbutt, Old Lady Punch, Gunowa, Gunowy Morda.

Chapter 10: Media, Media on the Wall

Rickrolling (Barack Roll, Immersion, Justine's iPhone Bill, iPhone Parodies, Star Wars Acapella, Star Wars According to a Three-Year-Old, Star Wars Trumpet Solo, Nintendo 64 Kid, Mario Kart (Gaillard), Leeroy Jenkins, I'm On a Mac, Angry German Kid, Scary Maze Pranks.

Chapter 11: The Identity Game

Lonelygirl 15, Miss Teen South Carolina Answers a Question, What What (In the Butt), Winnebago Man, Average Homeboy, Bon Qui Qui at Burger King, La Sarah, 60 Ghetto Names, Magibon, Bus Uncle, Leprechaun in Alabama, Whistle Tips with Bubb Rhubb and Lil' Sis, Racist Rant by Michael Richards, Dog Poop Girl, Zhang Ya.

Section Two: Other Genres

Chapter 12: The Short

Black Button, My Name is Lisa, Chad Vader, The Landlord, Potter Puppet Pals, Charlie the Unicorn, Doogtoons, Ask a Ninja, Red vs. Blue, Trapped in an Elevator, Liam Sullivan.

Chapter 13: The Mirror

Girl Takes Picture of Herself, Noah Takes a Photo of Himself Every Day for Six Years, Evolution of a Beard, 41 Years in 60 Seconds, 800 Days—A Daily Photo Project, Amanda Takes a Photo of Herself Every Day for Three Years, Nine Months of Gestation in 20 Seconds, 84 Days in 48 Seconds, Phil Takes a Photo of Himself Every Day for Two Days, Deena Takes a Photo of Herself, Parody of Noah Takes a Photo.

Chapter 14: The Morph

41 Years in 60 Seconds 1966–2007, 85 Years in 40 Seconds, Obama 2 Osama, Is Obama Really Osama, Michael Jackson morph (multiple videos), Magical Morphing Faces of Top 50 Athletes, Famous Faces Morphing, From George Washington to Barack Obama, Roseanne Morph, Charmed Morphs, Angelina Jolie to Brad Pitt, Angelina Jolie to Michael Jackson, Angelina Jolie to Lara Croft, Celebrity Morphing.

Chapter 15: The Witness

UCLA Taser Incident, Virginia Tech Shooter, Saddam Hussein Hanging, Neda, Don't Tase Me Bro, The Last Lecture, Lootie, Cop versus Skateboarder, Office Worker Goes Insane, Whale Blows Up, Destruction of the Kingdome.

Chapter 16: The Word

Boom Goes the Dynamite, I Like Turtles, All You Base Are Belong to Us, Music Is My Hot, Hot Sex, I Want It That Way, You Can Vote However You Like, Very Erotic, Very Violent, Impossible Is Nothing.

Chapter 17: The Experiment

Diet Coke and Mentos, Sticky Note Experiment, The Fun Theory videos, Will It Blend?, Squeeze Me, Do Try this at Home Videos, Reuben's Tube.

APPENDIX B

Notes on Classroom Use

Homework Assignments

1. Using the theoretical framework offered in Chapter One, track the architecture, use and impact of a YouTube phenomenon of your choice.

2. For each of the YouTube genres outlined in this book find recent examples—for example, the latest "Icon" or the most popular "animal" video and write a textual analysis of that video, using this book as a template.

3. What are some other "genres" of YouTube that this project has not uncovered? Develop your own typology of genres (for YouTube stories) and, using this book as a reference point, discuss some of the similarities and differences with the genres suggested here.

4. Keep a weekly "YouTube diary," bookmarking on your computer all the videos that you watched, taking special note of videos that were forwarded to you. Make notes on how these videos related to one or more of the topics/themes/genres covered in this book (such as identity politics or media culture) and share those insights with the class.

5. Develop a "memory bank" of YouTube stories over the entire semester. In the last two weeks of the term assess the cultural import of what YouTube offered over that time period, focusing on the relationship of these stories to the project of consumer-generated content and digital culture.

In-class Assignments

1. Watch each video discussed in this book during class and use the textual analysis offered here as a *beginning* point for discussion. What are some of the alternate readings that could be made for each video? What are the limitations of the readings offered in this book as they relate to this video?

2. Conduct an informal "survey" of YouTube use during class. Each student should make a list of the five most recent YouTube videos he/she watched and five of the most memorable YouTube videos. A sample of these videos can be watched in class and discussion (along lines outlined in the book) begun.

3. Develop a creative concept for a YouTube video using the genres/themes offered in this chapter as a reference point. This can be done individually or as a group project. The central goal of this concept is to develop stories that fulfill the goals of critical media literacy. These include developing empowering cultural narratives, furthering democratic communication, and providing a language for personal expression. Examples of such videos could include those that provide a better understanding of gendered differences, those that provide a critique of the commercial content of media culture, or ones that bridge cross-cultural histories and differences, to name just three.

REFERENCES

Adler, P. & Adler, P. (1989). The gloried self: The aggrandizement and the constriction of self. *Social Psychology Quarterly, 52*(4), 299–310.

Askehave, I. & Nielsen, A. (2005). Digital genres: A challenge to traditional genre theory. *Information Technology and People, 18*(2), 120–141.

Banash, D. (2004). From advertising to the avant-garde: Rethinking the invention of collage. *Postmodern Culture, 14*(2), 1–41. Retrieved from http://muse.jhu.edu/journals/postmodern _culture/v014/14.2banash.html Accessed 9/16/10.

Best, S., & Kellner, D. (2001). *The postmodern adventure: Science, technology and cultural studies at the third millennium.* New York: Routledge.

Blumer, H. (1963). Society as symbolic interaction. In A. Rose (Ed.), *Human behavior and social processes: An interactionist approach* (pp. 179–192). Boston, MA: Houghton Mifflin.

Boler, M. (2008). *Digital media and democracy: Tactics in hard times.* Cambridge: The MIT Press.

Boler, M. (2008). Introduction. In M. Boler (Ed.), *Digital media and democracy* (pp. 1–50). Cambridge: The MIT Press.

Boorstin, D. (1961). *The Image: A guide to pseudo-events in America* (republished 1992, New York: Vintage).

Bruns, A. (2008). *Blogs, Wikipedia, Second Life, and beyond: From production to produsage.* New York: Peter Lang.

Buckingham, D. (2007). *Youth, identity and digital media.* Cambridge: The MIT Press.

Burgess, J., Green, J., Jenkins, H., & Hartley, J. (2009). *YouTube: Online video and participatory culture.* Cambridge: Polity Press.

Burgess, J. (2008). 'All your chocolate rain are belong to us'? In G. Lovink & S. Niederer (Eds.), *Video vortex reader: Responses to YouTube* (pp. 101–110). Amsterdam: Institute of Network Cultures.

Collins, S. (2010). Digital fair. *Journal of Consumer Culture, 10*(1), 37–55.

Cooley, C. (1902). *Human nature and the social order.* New York: C. Scribner's Sons, 179–185.

Corneliussen, H., & Rettberg, J. (2008). *Digital culture, play, and identity.* Cambridge: The MIT Press.

Crowston, K., & Williams, M. (2000). Reproduced and emergent genres of communication on the World Wide Web. *The Information Society, 16,* 201–215.

Deuze, M. (2006). Participation, remediation and bricolage: Considering principle components of a digital culture. *The Information Society, 22,* 63–75.

Dyer, R. (1998). *Stars.* London: BFI.

Foster, T. (2005). *The souls of cyberfolk.* Minneapolis: University of Minnesota Press.

Friedman, J. (2002). *Reality squared: Televisual discourse on the real.* New Brunswick, NJ: Rutgers University Press.

Gere, C. (2002/2008). *Digital culture.* London: Reaktion Press.

Giltrow, J. & Stein, D. (2009). *Genres in the Internet.* Amsterdam: John Benjamin.

Giroux, H. (1992). *Border crossings: Cultural workers and the politics of education.* New York: Routledge.

Glynn, K. (2000). *Tabloid culture: Trash taste, popular power, and the transformation of American television.* Durham, NC: Duke University Press.

Goffman, E. (1959). *The presentation of self in everyday life.* New York: Anchor/Doubleday.

Han, S. (2010). Theorizing new media: Reflexivity, knowledge and Web 2.0. *Sociological Inquiry, 80*(2), 200–213.

Hartley, J. (1996). *Popular reality: Journalism, modernity, popular culture.* London: Arnold.

Hartley, J. (2009). Uses of YouTube: Digital literacy and the growth of knowledge. In J. Burgess & J. Green (Eds.), *YouTube: Online video and participatory culture* (pp. 126–143). Cambridge: Polity Press.

Hauser, G. (1999). *Vernacular voices: The rhetoric of publics and public spheres.* Columbia: University of South Carolina Press.

Haythornthwaite, C., & Wellman, B. (2002). The Internet in everyday life (Introduction). In B. Wellam & C. Haythornthwaite (Eds.), *The Internet in everyday life* (pp. 3–35). Oxford: Blackwell.

Hess, A. (2007). In digital remembrance: Vernacular memory and the rhetorical construction of web memorials. *Media, Culture and Society, 29,* 812–830.

Hess, A. (2009). Resistance up in smoke: Analyzing the limitations of deliberation on YouTube. *Critical Studies in Media Communication, 26*(5), 411–434.

Hill, J. (1998). Film and postmodernism. In J. Hill and P. Gibson (Eds.), *The Oxford Guide to Film Studies.* Oxford: Oxford University Press.

Hillis, K. (1999). *Digital sensations: Space, identity and embodiment in virtual reality.* Minneapolis: University of Minnesota Press.

Hovorka, D. & and Germonprez, M. (2009). Tinkering, tailoring, and bricolage: Implications for theories of design. 15th Americas Conference on Information Systems (AMCIS 2009). San Francisco, United States. Aug. 2009. Retrieved from http://works.bepress.com/dirk_hovorka/29 Accessed 9/16/10.

Howard, P., & Jones, S. (2004). *Society online: The Internet in context.* Thousand Oaks, CA: Sage.

Howarth, D. (2000). *Discourse.* Philadelphia: Open University Press.

Jarboe, G. (2009). *YouTube and video marketing: An hour a day*. Indianapolis: Wiley.

Jenkins, H. (2006). *Convergence Culture: Where old and new media collide*. New York: New York University Press.

Jenkins, H. (2009). What happened before YouTube. In J. Burgess & J. Green (Eds.), *YouTube: Online video and participatory culture* (pp.109–125). Cambridge: Polity Press.

Kellner, D. (1989). *Jean Baudrillard: From Marxism to postmodernism and beyond*. Stanford,CA: Stanford University Press.

Kellner, D., & Kim, G. (2010). YouTube, critical pedagogy and media activism. *The Review of Education, Pedagogy and Cultural Studies, 32*, 3–26.

Kessler, F., & Schäfer, M. (2008). Navigating YouTube: Constituting a hybrid information management system. In P. Snickars & P. Vonderau (Eds.), *The YouTube reader* (pp. 275–291). Stockholm: National Library of Sweden.

Kinder, M. (2008). The conceptual power of on-line video: 5 easy pieces. In G. Lovink & S. Niederer (Eds.), *Video vortex reader: Responses to YouTube* (pp. 53–62). Amsterdam: Institute of Network Cultures.

Knapp, P. (1994). *One world—many worlds: Contemporary sociological theory*. New York: Harper-Collins.

Lange, P. (2007). Publicly private and privately public: Social networking on YouTube. *Journal of Computer-Mediated Communication, 13*(1): 361–80.

Lange, P. (2008). (Mis)Conceptions about YouTube. In G. Lovink & S. Niederer (Eds.), *Video vortex reader: Responses to YouTube* (pp. 87–100). Amsterdam: Institute of Network Cultures.

Lastufka, A., & Dean, M. (2008). *YouTube: An insider's guide to climbing the charts*. Sebastopol, CA: O'Reilly Media.

Lessa, I. (2006). Discursive struggles within social welfare: Restaging teen motherhood. *British Journal of Social Work, 36*(2) 283–298.

Levinson, P. (1999). *Digital McLuhan*. London: Routledge.

Levinson, P. (2009). *New new media*. New York: Penguin.

Levy, P. (2001). *Cyberculture* (translated by R. Bononno). Minneapolis: University of Minnesota Press.

Lister, M., Dovey, J., Giddings, S., Grant, I., & Kelly, K. (2003/2009). *New media: A critical introduction*. New York: Routledge.

Losh, E. (2008). Government YouTube. In G. Lovink & S. Niederer (Eds.), *Video vortex reader: Responses to YouTube* (pp. 111–124). Amsterdam: Institute of Network Cultures.

Lovink, G. (2007). *Zero comments: Blogging and critical Internet culture*. London: Routledge.

Lovink, G. (2008). The art of watching databases (Introduction). In G. Lovink & S. Niederer (Eds.), *Video vortex reader: Responses to YouTube* (pp. 9–12). Amsterdam: Institute of Network Cultures.

Lovink, G., & Niederer, S. (2008). (Eds.), *Video vortex reader: Responses to YouTube*. Amsterdam: Institute of Network Cultures.

Manovich, L. (2008). The practice of everyday (media) life. In G. Lovink & S. Niederer (Eds.), *Video vortex reader: Responses to YouTube* (pp. 33–44). Amsterdam: Institute of Network Cultures.

McHoul, A. & Grace, W. (1993). *A Foucault primer: Discourse, power and the subject*. Melbourne: Melbourne University Press.

Miller, M. (2007). *YouTube 4 you*. Indianapolis: QUE.

Miller, T. (2002). Tomorrow will be risky and disciplined. In J. Friedman (Ed.), *Reality squared: Televisual discourse on the real*. New Brunswick, NJ: Rutgers University Press.

Miller, C. & Shepherd, D. (2009). Questions for genre theory from the blogosphere. In J. Giltrow & D. Stein (Eds.), *Genres in the Internet*. Amsterdam: John Benjamin.

Milner, A (2007). Bricolage. Blackwell Encyclopedia of Sociology. Retrieved from http://www.blackwellreference.com/public/tocnode?id=g9781405124331_chunk_g9781405 1243318_ss1–50 Accessed 9/17/10.

Mitchem, M. (2008). Video social: Complex parasitical media. In P. Snickars & P. Vonderau (Eds.), *The YouTube reader* (pp. 273–281). Stockholm: National Library of Sweden.

Montgomery, K. (2007). *Generation digital*. Cambridge: The MIT Press.

Mosco, V. (2005). *The digital sublime*. Cambridge: The MIT Press.

Mossberger, K., Tolbert, C., & McNeal, R. (2007). *Digital citizenship: The Internet, society and participation*. Cambridge: The MIT Press.

Murray, S. (2004). Reality television. In H. Newcomb (Ed.), *Encyclopedia of television* (pp. 1900–1902). New York: Fitzroy Dearborn.

Newman, D. & O'Brien, J. (2010). *Sociology: Exploring the architecture of daily life*. Thousand Oaks, CA: Pine Forge/Sage.

Ouellette, L. & Hay, J. (2008). *Better living through reality TV*. Oxford: Blackwell.

Plummer, K. (2000). Symbolic interactionism in the twentieth century. In Bryan Turner (Ed.), *The Blackwell Companion to Social Theory*, second edition (193–222). Malden, MA: Blackwell.

Raskin, R. (1998). Five parameters for story design in the short fiction film. Retrieved from http://pov.imv.au.dk/Issue_05/section_4/artc3A.html Accessed 9/17/10.

Renzi, A. (2008). The space of tactical media. In M. Boler (Ed.), *Digital media and democracy: tactics in hard times* (pp. 71–100). Cambridge: The MIT Press.

Rheingold, H. (2000). *The virtual community: Homesteading on the electronic frontier*. Cambridge: The MIT Press.

Richard, B. (2008). Media masters and Grassroots Art 2.0 on YouTube. In G. Lovink & S. Niederer (Eds.), *Video vortex reader: Responses to YouTube* (pp. 141–152). Amsterdam: Institute of Network Cultures.

Riis, J (1998). Toward a poetics of the short film. Retrieved from http://pov.imv.au.dk/Issue_05/POV_5cnt.html Accessed 9/17/10.

Ryan, M. (2006). *Avatars of story*. Minneapolis: University of Minnesota Press.

Scott, L. (1992). Playing with pictures: Postmodernism, poststructuralism, and advertising visuals. *Advances in Consumer Research, 19*, 596–612.

Sherman, T. (2008). Vernacular video. In G. Lovink & S. Niederer (Eds.), *Video vortex reader: Responses to YouTube* (pp. 161–168). Amsterdam: Institute of Network Cultures.

Shore, M. (1987). *The science of social redemption: McGill, the Chicago school, and the origins of social research in Canada*. Toronto: University of Toronto Press.

Silverman, D. (1998). *Qualitative research: Theory, method and practice*. London: Sage.

Snickars, P. & Vonderau, P. (2009). *The YouTube reader*. Stockhom: National Library of Sweden.

Strangelove, M. (2010). *Watching YouTube: Extraordinary videos by ordinary people*. Toronto: University of Toronto Press.

Strate, L., Jacobson, R., & Gibson, S. (2003). *Communication and cyberspace: Social interaction in an electronic environment.* New York: Hampton Press.

Thiel, T. (2008). Curator as filter/User as curator. In G. Lovink & S. Niederer (Eds.), *Video vortex reader: Responses to YouTube* (pp. 181–188). Amsterdam: Institute of Network Cultures.

Turner, J. (1991). *The Structure of sociological theory,* fifth edition. Belmont, CA: Wadsworth.

Turner, G. (2004). *Understanding celebrity.* Thousand Oaks, CA: Sage.

Ulmer, G. (2005). *Electronic monuments.* Minneapolis: The University of Minnesota Press.

Uricchio, W. (2008). The future of a medium once known as television. In P. Snickars & P. Vonderau (Eds.), *The YouTube reader* (pp. 24–39). Stockholm: National Library of Sweden.

Wallace, Ruth A. & Alison Wolf (1995). *Contemporary sociological theory: Continuing the classical tradition,* fourth edition. Englewood Cliffs, NJ: Prentice Hall.

Wardrip-Fruin, N., & Montfort, N. (2003). *The new media reader.* Cambridge: The MIT Press.

Wellman, B., & Haythornthwaite, C. (2002). *The Internet in everyday life.* Oxford: Blackwell.

Yeatman, B. (1998). What makes a short fiction film good? Retrieved from http://pov.imv.au.dk/Issue_05/section_4/artc2A.html Accessed 9/17/10

Wikipedia & Web Sources

Note on use: The videos chosen for discussion in this book (for the most part) do not appear in mainstream media journalistic accounts (except for the "Icons" section of the book). So Wikipedia and other online sources had to be relied on for some of the background on each video. However, given the nature of open source knowledge, this comes with considerable risks. Generally speaking, I have not quoted material from Wikipedia and other open source sites, and hence these do not appear in the list of references above. What follows is a list of the Wikipedia pages that were read. I am not listing the entire web link for reasons of space and redundancy.

List of Wikipedia entries:

Star Wars Kid, Numa Numa, Chocolate Rain, Paul Potts, Susan Boyle, Where the Hell Is Matt/Matt Harding, Free Hugs, Chris Crocker, Achmed the dead terrorist/ Jeff Dunham, Tron Guy/Jay Maynard, Soulja Boy, Chad Vader, Rickrolling, lonely girl 15, Danny Blaze/Average Homeboy, Star Wars, Remi Gaillard, Corey Vidal, Leeroy Jenkins, Lootie, Salvatore Rivieri, Exploding Whale, Seattle Kingdome, Tom Dickson, Skateboarding Dog, Lim Jeong-Hyun, Free Hugs/Juan Mann, Diet Coke and Mentos, Charlie the Unicorn, Peanut Butter Jelly Time, Terrra Naomi, Back Dorm Boys, Hurra Torpedo, Jonti Picking, Badger Badger Badger, YouTube Symphony Orchestra, Here It Goes Again, Lucian Paine, Straight No Chaser, Little Superstar, Cebu Provincial detention and rehabilitation center, Neil Cicierga, Christian the Lion, Battle at Kruger, Raptor Jesus, Baidu 10 Mythical Creatures, Lemon Demon, Inman Crosson, Samwell, Magibon, Rev vs. Blue, Liam Sullivan, Ask a Ninja, Doogtoons, Don't Tase Me Bro, All Your Base Are Belong to Us.

INDEX

General Editor: *Steve Jones*

Digital Formations is an essential source for critical, high-quality books on digital technologies and modern life. Volumes in the series break new ground by emphasizing multiple methodological and theoretical approaches to deeply probe the formation and reformation of lived experience as it is refracted through digital interaction. **Digital Formations** pushes forward our understanding of the intersections—and corresponding implications—between the digital technologies and everyday life. The series emphasizes critical studies in the context of emergent and existing digital technologies.

Other recent titles include:

Felicia Wu Song
 Virtual Communities: Bowling Alone, Online Together

Edited by Sharon Kleinman
 The Culture of Efficiency: Technology in Everyday Life

Edward Lee Lamoureux, Steven L. Baron, & Claire Stewart
 Intellectual Property Law and Interactive Media: Free for a Fee

Edited by Adrienne Russell & Nabil Echchaibi
 International Blogging: Identity, Politics and Networked Publics

Edited by Don Heider
 Living Virtually: Researching New Worlds

Edited by Judith Burnett, Peter Senker & Kathy Walker
 The Myths of Technology: Innovation and Inequality

Edited by Knut Lundby
 Digital Storytelling, Mediatized Stories: Self-representations in New Media

Theresa M. Senft
 Camgirls: Celebrity and Community in the Age of Social Networks

Edited by Chris Paterson & David Domingo
 Making Online News: The Ethnography of New Media Production

To order other books in this series please contact our Customer Service Department:
(800) 770-LANG (within the US)
 (212) 647-7706 (outside the US)
 (212) 647-7707 FAX

To find out more about the series or browse a full list of titles, please visit our website:
WWW.PETERLANG.COM